ON THE BEATEN TRACK

ON THE BEATEN TRACK

TOURISM, ART, AND PLACE

LUCY R. LIPPARD

THE NEW PRESS, NEW YORK

page vi–vii: **Gretchen Garner,** *This Is It!* 1992, color photograph.
Billboard advertising a sea shell attraction in Michigan.

"Trespassing on Common Ground" was first published in
Harvard Design Magazine, Winter–Spring, 1998.
A shorter version of "Surprise Packages" was first published
in *Sculpture* magazine, November, 1998.

Published in the United States by The New Press, New York
Distributed by W. W. Norton & Company, Inc., New York

The New Press was established in 1990 as a not-for-profit alternative
to the large, commercial publishing houses currently dominating
the book publishing industry. The New Press operates
in the public interest rather than for private gain, and is committed
to publishing, in innovative ways, works of educational, cultural,
and community value that are often deemed insufficiently profitable.

www.thenewpress.com

Book design by BAD
Printed in the United States of America
9 8 7 6 5 4 3 2 1

To Samuel Justice Ryman as he begins his tour of the world,

because he chose just the right one of his then-few words ("Wow!")

when confronted with the towering red walls of Canyon de Chelly, Easter 1997;

and to his parents, Kyla Adams Ryman and Ethan Ryman,

much loved fellow travelers.

CONTENTS

ACKNOWLEDGMENTS

SEVERAL IMPRESSIVE BOOKS on the fascinating phenomenon of tourism inspired these idiosyncratic essays. I was introduced to the field by the eye-opening writings of Nelson Graburn and Dean MacCannell, who provided my basic education therein, along with books by Alexander Wilson, Martha Norkunas, Caren Kaplan, Mary Louise Pratt, and John Urry. I wrote about being a tourist in China and Cuba in 1980–81, and on photography and "political tourism" for Z magazine in June 1990. On the art front, the Whitney Museum Downtown presented *SITE/seeing* in 1991 and Dana Augaitis and Sylvie Gilbert curated/edited a groundbreaking exhibition and catalogue, *Between Views*, at the Banff Centre for the Arts in 1991. In 1995, Robert Buitrón asked me to be on a College Art Association panel that spurred my interest in the subject (as did a lecture trip to Hawaii and conversations there with Debra Drexler in 1995) and *Whitewalls* (#37) published a version of that paper in 1996.

Thanks also to the following friends who have either suggested sources or commented on the manuscript: Anne Twitty, James Faris, Jan Brooks, David Craven, MaLin Wilson, Coco Fusco, Moira Roth, Rebecca Solnit, Tim Drescher, Mark Sloan, John Ravenal, and the late Chelsea Miller Goin. Thanks, too, to Grace Farrell, my editor at The New Press, designer Hall Smyth, and copy editor Ted Byfield; and to Peter Woodruff for his photographs, clipping service, and constant support.

page 1: **Hiroshi Sugimoto,** *Marmara Sea, Silivli,* 1991, black and white photograph, 20" x 24", (photo: courtesy Sonnabend Gallery, New York). The Japanese photographer Sugimoto became known for his photographs of old theater interiors with light-filled blank movie screens, begun 1976-77; around the same time he began a series of dioramas and one on seascapes, which expand his preoccupation with space and two-dimensionality, a Buddhist conjunction of the ordinary and the marvelous.

Only emptiness can fill a space with possibility.—DEAN MACCANNELL

Introduction:

ON RUBBERNECKING

About two years ago, I rode along with my daughter and her friend to the coast and we saw tourists. There's not much I can say about them. They all looked identical. —CAROLYN CHUTE

The tourist is the other fellow. —EVELYN WAUGH

RUBBERNECKING. It's not acrobatic lovemaking (though the automobile is crucial to both). When I was a kid, it was a somewhat derisive term for tourism, the antithesis of the sophisticated travel to which my own family aspired. But I've become fond of the notion of rubbernecking, which implies a willingness or desire on the part of the tourist to stretch, literally, past her own experience, to lean forward in anticipation, engagement, amazement, or horror.

For the most part we see travel as escape, getting away, going somewhere "else"—often inhabited by "others" whose dissimilarities will be exaggerated and exoticized, and whose similarities will be dismissed or hidden, although for them, "somewhere else" is home. Most literature about tourism is written from the viewpoint of the visitor (the supposedly "fresh eye"), rather than that of the visited. Immigrants and the internally displaced are rarely asked how they see their surroundings. Yet every place is both local and foreign. The same place is the site of two very different experiences. Domestic tourism—the focus of this book—rests precariously in the gap between the familiar and the strange, the close at hand and the far afield. It is a metaphor for multicenteredness, offering experimental approaches to change.

These essays began with a chapter that fell out of my last book, *The Lure of the Local: Senses of Place in a Multicentered Society,* and, as such, they remain primarily focused on the United States. I make no attempt to cope with rain forest crunches, Euro high-culture shopping, "cannibal tours," or other exotica. I also remain more or less within my own experience, so extreme adventure and hedonist temptations are omitted. (My own touristic preferences run to history, ruins, conversation, funky culture, and heading out into new landscapes by

2

Ellis Island National Monument,
Baggage Room Exhibit (photo: courtesy Panorama)
This marvellous collection of trunks, bags, and baskets
evokes every point on the globe.

Elizabeth Diller and Ricardo Scofidio, *Tourisms: Suit Case Studies,* 1992, mixed media installation, 24' x 60' x 12' h
(photo: Dick Loesch, courtesy the Wexner Center for the Arts, Columbus, Ohio).
Diller and Scofidio are maverick architects who see building buildings as merely one of their "hybrid strategies."
In this installation, they commented on high and low culture and high and low technology, "revealing the
sophistication with which 'sightmakers' manipulate space and vision for 'sights'…"
(interview with the artists by Kyong Park in *Flash Art,* May-June 1996.) They are literally "unpacking"
the meaning of sights seen and unseen.

car or on foot.) For some, travel simply proves the solidity or desirability of home base; for others, it provokes unsatisfied longings for the grass on the other side of the fence. Actually, all visitors and all newcomers are tourists. So are many who have lived in a place for years. This can be a positive experience (as in constant curiosity and depth of learning) or a negative experience (as in lack of interest in the locale). Even the few dedicated travelers who get under the skin of a place are parasites to some degree — their pleasure, compassion, empathy, homework, or even respect notwithstanding.

Some 400 million of us voluntarily scurry around the globe each year, and that doesn't count the involuntarily displaced and dispossessed. Since World War II there has been an unprecedented movement of people through regions and countries not their own. In the 1950s and '60s, tourism grew about 10 percent annually. Seduction and hyperbole are our drugs of choice. Some sources suggest that tourism will soon be the largest global source of employment; others say it already is. Add that to the subcategory of armchair tourism via print and electronic media, and we're on our way to becoming a society of visitors and voyeurs on one hand, and commodified actors or targets of strangers' fantasies on the other.

The beaten track may run right past our door. All the more reason to give it some hard looks. Critical tourism may sound like an oxymoron. We don't "tour" to exercise our brains. A vacation is literally an emptying out, a voiding of daily experience and responsibility. Vacations are supposed to be fun, but then some of us get off on critical thinking. It raises questions about other people's lifestyles and about our own. At best it shakes up belief and value systems and opens us up to reciprocity with nature and with unfamiliar cultures, even as we re-invent them for our own delectation.

John Urry suggests that the "tourist gaze" uses "difference to interrogate the normal," whatever that is. This is of course what artists do as a matter of course. Artists have always traveled and provided a lens through which the rest of us look around. Court artists, scientific artists, itinerant portraitists, and later expeditionary and documentary photographers have "objectively" documented many of the major excursions and incursions of Western society. They participated in a booming business in guidebooks and tourist literature, which began around 1820 in the United States. Before that, information and travel tips were passed on by word of mouth and social networks, and scenery was purveyed by paintings and prints — major cogs in the propaganda and development wheels, as was photography later on, as are postcards and calendars today. In New Hampshire's White Mountains in the 1840s, artists were given discounts on room and board if they simply titled all their mountain sketches after North Conway. When a place becomes known as an artists' colony, it still suggests something rare and refined. "Where the fine arts are not steadily cultivated... there cannot possibly be much hearty admiration of the beauties of nature," wrote Captain Basil Hall in 1830.

Since teaching people how to see is the artist's business, it seems odd that tourism as activity (rather than as an image or a symbol) has piqued so few progressive artists' imaginations, despite its heady vortex of cross-culturalism, mixed signals, disjunctive codes, faked authenticity, deterritorialization, and other hot topics. While scholars in anthropology, sociology, and cultural studies have feasted at this classic pomo trough, artists with ambitions outside the current market system have only sporadically recognized the affinities, realizing that they could have some effect on these ways of seeing. Photography and

public art operate most effectively in the gap between art and life where I too like to work.

If there is little art about tourism, there is still less art *within* tourism. Monuments, museums, parks, and tourism itself have hitherto been thought of more as frames than as forms. But they can easily be seen as covert art forms, effectively practiced, like advertising, by official and commercial "non-entities" rather than by celebrities more interested in art fame than in social power. The current art system, for all its "critical" trajectory, encourages this kind of real-world timidity. Just as tourists often deplore situations brought on by their own presence, so artists are complicitous in the way the world is seen.

Tourism (like art) has been touted as a form of transformation, even cannibalism—the consumption of other places, other cultures, or the digestion of their powers. Tourists make ordinary places extraordinary by their presence, but travel changes the traveler as well; it is a speeded-up counterpart of ordinary life. As Albert Camus said, travel is "a grander and deeper process of learning which leads us back finally to ourselves." Lawrence Durrell added a reciprocal angle: "All landscapes ask the same question: 'I am watching you—are you watching yourself in me?'" Tourists may go places to see people who are not like them, but they prefer to go there with people who *are* like them in order to have someone to "share with" or comment on the oddity of the new in a familiar vocabulary. Complex cultures, wildly oversimplified for mass production/consumption, are celebrated with a certain relief and disappointment. ("They're really just like us!")

Traveling alone, on the other hand, we are far more likely to interact with both places and people on an unselfconscious or at least less self-conscious basis. We are not who we think we are when we are elsewhere. We can even become another person entirely. Who will ever know? Traveling can be a kind of performance piece. We can tell our airplane seat-mate or one-night stand almost anything. We can reinvent ourselves instead of our surroundings. We can surprise ourselves as well as of being surprised.

Travel stories are the stuff of myth and legend—great hunts, vision quests, explorations of other worlds. Travel is between a beginning and an end, a circular form in which the point of departure is as influential as the destination. Victor Turner and Nelson Graburn have pointed out that the structure of tourism resembles all ritual behavior—a beginning, a change, and a return to the normal. When we travel, we "cross over," as in Turner's notion of liminality—the experience of being on the threshold, in the throes of passage. We cross not only from place to place but also from time to time, and sometimes we are changed in the process. Niagara Falls honeymoons have been cited as a prime example of the liminal experience. The Falls, which are also a national boundary, offer a grand metaphor for taking the plunge, the same delirium courted by those who have attempted to cross them on a tightrope or descend in a barrel.

We travel both to forget and to remember where we stand. Our expectations shape what we find. Often we are compelled toward places by dissatisfaction, and we reject them by disappointment. All voluntary travel is characterized by longing for some elusive element that lies out of reach in daily life. The truly free-spirited nomad, leashed to nowhere, is rare. Most tourists are enjoying their yearly holiday, initially a "holy day," a time to savor the extraordinary and to celebrate the ineffable.

The luckiest among us can save up enough to take an occasional year off—off the treadmill, off the beaten track, off our head. Most of us have to content ourselves with two weeks to a month's

vacation, a "special" time that allows us to fill that void with new material, to depart from our own lives, even if we stay home, which is our "point of departure."

On a local level, tourism is both additive and subtractive. Although its parasitic role is often remarked, today it is widely perceived as a cure for regional economic woes. Tourism has become a kind of caulking that fits in the cracks of a supposedly un-sinkable economy. Across the United States, towns devas-tated by capital flight, techno-logical shifts, or union-busting make spectacles of themselves, desperately framing and rein-venting their histories to make the picture appealing to those who might buy a hamburger, T-shirt, suntan lotion, Indian jewelry, a plastic sea gull, a shell ashtray, or a boat ride. Historical sites are the straws that residents grab at in places lacking focal points. Regional centers and boondocks alike scramble to attract people from other parts of the country. Everybody has to go someplace else so they can come here, so we can all make a living. How much will the market bear? Where will it all end?

Corporate developers are invading the "unspoiled" with condos, Burger Kings, and golf courses that are more welcome to most tourists than the poverty thrown into relief by their construction and barely

Anonymous, *Shrine of the Unknown Tourist,* Bolinas, California, paint on carved wood (photo: Alethia Patton, 1998). This insignificant plaque is (intentionally, I suspect) small and hard to see—"down at the level a dog could pee on," notes the photographer. When she went back to get another shot, it had disappeared. The shrine, which features a big question mark, suggests that curiosity is the tourist's prime motive, or maybe it simply questions the entire touristic enterprise from the point of view of the embattled local.

affected by service-economy jobs. The bottom line of leisure travel, after all, is enjoyment, which for many means comfort. The ideal vacation site countenances no problems, local or imported. Painter Debra Drexler, wrestling with her move from St. Louis to Honolulu, notes: "Paradise is a place where all your needs are met effortlessly. Paradise is a place where you are not allowed to feel pain." Some talented souls actually know how to rest and relax on a tourist vacation, as advertised. For most, "doing the sights" is hard work.

Class and gender are salient components of travel's contra-dictions. How far away from home one can travel involves layers of touristic status, en-forcing profound class divi-sions that are now more blurred than they were in the past, when those who were able to travel at all or to have a "second home" were clearly divided from those who weren't. Classist distinc-tions are conventionally made between *travel* and *tourism*. Po-pular wisdom has it that edu-cated middle-class travelers, more aristocratic and superior, pursue the distant and unex-pected, gaining insights as they ply their graceful and god-given way across others' terrains; while common tourists, travel-ing in bulk on packaged tours, just gawk, go too fast to see, and are more interested in taking pictures than living the moment. Tourism is by expec-

tation constricted, while travel is by implication freer, partaken of by the well-heeled or by the down-at-the heel ("drifter tourism").

Everyone who travels is a traveler, even (I suppose, grudgingly) those who never raise their heads to look out the window, who never escape the airport and hotel conference rooms, who only "go to town" for an elaborate meal or a night of drinking and perhaps sex, for whom shopping is the only reason to be in another place. Tourism can be set apart as a specific activity within travel, if the trip has another focus. A better distinction might be between passive and active tourism, with artists falling in the second category. Passive or active, loud or courteous, affluent or working-class, tourists' behavior stems from a wide range of motives. They may be asserting their right to dominate, or rebelling against being dominated, or passing on the unwelcome experience of being dominated, or simply struggling with ambivalence about new roles in unexpected social situations. Vacations can serve as inversions of the everyday in which the affluent tourist can play peasant for a day and blue-collar workers can play king/queen for a day. When modest middle-class people first began to travel abroad they found themselves for the first time in a position to command and to be served, whereas at home, they might themselves be the servers. Such situations can bring out the best and the worst in people. Some identify with those serving them and are able to perceive tourism from both sides. Others switch roles with dexterity and become irrational dictators.

If you have pretensions to being a traveler rather than a mere tourist, it is intensely embarrassing to be perceived as a visitor at all. In the late 1950s, I spent my junior year of college in Paris. I had been told that I had *la mine Française*—that I looked French. Longing to pass, and fearing exposure as just another arrogant Yankee, I kept my mouth shut and left my Brownie at home. (Now of course I wish I had the pictures I'd have taken.) In those days, Americans, with Germans running a close second, were the quintessential and most disliked global tourists. Soon we would be joined by our fellow imperialists, Japanese. Today I am resigned to looking like a tourist wherever I go, even at home, because I'm *always* rubbernecking.

Tourists who perceive themselves as "sensitive," capable of appreciating the finer points while traveling, those who choose the "right places" to go and the "right things" to see, who say the right things about the things they saw, are still separated from those of us who lack the resources to know all those right things. Long trips obviously require more money and/or time than short ones, although the rat race of upward mobility has produced a new trend, even among the better off, toward many short holidays rather than one long one. These in turn encourage more regional travel, more tourists closer to home as well as more jet-setters headed for a weekend in Paris. The currently popular mini vacations defuse the anticipation and excitement of a full-scale holiday and make the borders between the quotidian and the "holy" more porous.

Yet this porousness is only one of many such developments that have eroded the structure of a grand holiday, leaving newer phenomena—at once more normal and more grotesque—in its wake. People now can abandon a single aspect of their lives for a few days, or the whole mess; or reproduce it elsewhere for weeks or months at a time, for example, by apartment swaps.

For those educated into a sense of social superiority, kitsch can generate a delicious sense of betraying one's class and educational expectations. Believing that nothing is real, some have trouble recognizing the real when they see it. Places that are beautiful or moving may be

considered dangerously sentiment-inducing, "essentializing" our relationships to landscape. But they continue to be enjoyed. Like sex, such experiences accelerate with pleasure and fade under analysis. Even the most critical travelers may helplessly suspend judgment in the face of an extraordinary sunset over snow-capped mountains, a stormy sea, or a friendly local bar, forgetting their scorn for Ansel Adams or redneck music. Despite a prevailing political indifference and the tendency of tourists to see no evil, lived experience comes first and theory later, once we realize what we *should* be thinking.

The underlying contradiction of tourism is the need to see beneath the surface when only a surface is available. However, peeps behind the stage set, or the wizard's curtain, offer just another layer of artifice. Destinations are chalked up

rather than savored. Some places are merely "famous for being famous," and some of them don't even exist. (The first two of the top ten questions asked of a Maine Tourist Information Center are directions to L. L. Bean and to Bar Harbor; sixth is how to get to Cabot Cove, a fictional television site that is filmed in Mendocino, California; how to get to the ocean is seventh.) Much tourism is not an "ad"venture. Passive tourists may not venture "out" any further than Disneyland—although, from another viewpoint, Disney's

Rigo, *One Tree,* 1995, next to a freeway ramp in San Francisco. A similar sign points toward "OCEAN." Part of the "Art in the Urban Landscape" program supported by the Capp Street Project and the Gerbode Foundation, these murals convey a deadpan message about the environmental and human repercussions of urban sprawl.

worlds are further away from daily life than anyplace else. Few would argue that much tourism is anything but frankly superficial, what Armand Mattelart has called the "shop window effect," in which visitors' consumption patterns are taken on by those visited.

Traveling only began to be called *tourism* around 1800. By then, European travelers were already curious about the United States, its size, its scenery, its new government and commerce. Of course, the growth of tourism was driven by the advent of modern transportation. From stage-coach to steamboat to railroad to automobile, bus, and plane, each offered its own style and affected its surroundings. Inns or boarding houses were replaced by hotels, then motels. Today bed and breakfasts try to return to an older model. The historical roles of pilgrimage and curiosity have been filled (though hardly fulfilled) by tourism and museums.

In the days when travel for pleasure was new to most Americans, everything away from home was worth seeing. Early tourism took in hospitals, prisons, businesses, schools; lumbering, saw-mills, and factories were not yet anathema to the well-bred tourist. People were more likely to be curious about all aspects of life in a place. Industry was eminently respectable and industrial sites were integral to nineteenth-century tourism; after all, it was the source of the tourist's money. In fact, historian Dona Brown, who calls her engrossing book on regional tourism in New England "a study in the spread of market relations," argues that

tourism played a key role in creating a con-sumer-oriented society and economy. The tourist experience was crucial to the transfor-mation of old-fashioned middling artisans, shopkeepers, and professionals into a new middle class, converting them from a tradition

of self-denying soberness and frugality to a consumer ethic that sought liberation and fulfillment in purchases....Nineteenth-century tourists turned away from the allure of the marketplace to travel straight into the arms of the marketplace.

So what else is new? Travel today is most often undertaken for business purposes. Business and pleasure are linked in a different equation. Busman's holidays have devolved into "perks" and "junkets." Competing with the notion of exploited natives is that of innocent tourists as victims of wily, greedy natives and extortion-bent local entrepreneurs, a still-popular view that ignores the underlying colonialism of any local or foreign touristic enterprise. Tourism remains a combination of big business and cottage indus-try. When cottage industry comes first, big busi-ness will simply build upon it and very often swamp it or swallow it up. Sometimes, though, big business will create a context in which cottage industry can thrive on its margins. The latter's small scale permits unthreatening variations of no interest to the larger enterprises.

Is the world smaller for those who have toured? Is it not only smaller but shrunken? This pulsating globe, netted and facsimiled and pixil-lated, seems immense one minute and tiny the next. The transformation of long-term travel into short-term travel is part and parcel of a broader evolution of American life, from the exploitation of natural resources to marriage. As time conflates and short-term thinking prevails, homogenization has pervaded all the senses. When I was a child driving with my parents from southeast to northeast for the summer, you could tell where you were geographically and culturally by listening to the radio. By the late 1960s, a bland generic mediaspeak was replacing local accents

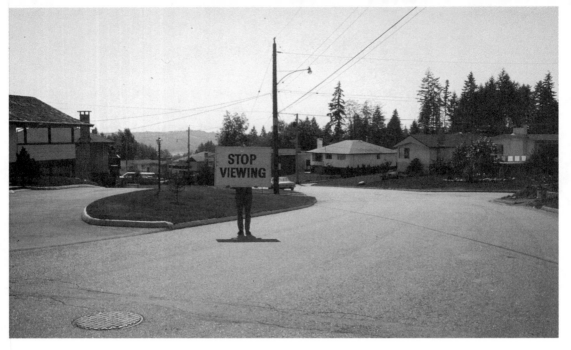

N. E. Thing Co., *Stop Viewing,* 1969, action or "social probe," Vancouver. Iain and Ingrid Baxter's N. E. Thing Co. pioneered any number of conceptual and now postmodern ideas, including this comment on how we see, and where. The suburb is out of bounds, although the "view" beyond is worth looking at.

in broadcasting, just as chain stores and national franchises have all but replaced local enterprises and their down-home names.

If the beaten track is created for the tourist, the tourist herself creates an "off the beaten track" to reassert her own autonomy and independence. Having discovered how attractive this toe dipped in freedom is to most people, the tourist industry has also gotten into the off-the-beaten-track business, usually more expensive and fundamentally more snobbish in its appeal for places where "the rest of them" won't be. In fact, we expect it to be a place where the rest of "us" or "you" will be—and we know who "we" are. We are unpleasantly surprised when we find we were wrong, and find ourselves lumped with "them." At this point we are involuntarily back on the beaten track.

Everyone wants to be the only or the first "there" in order to report back to our peers that we "discovered" something—an obvious throwback to the imperialism that gave birth to tourism in the first place. All tourists are afraid they are missing something. This anxiety is a basic condition of tourism, for there can never be as many minutes in a day as there are sights to be taken in. The turns not taken may haunt us to the point of casting a pall over the whole trip. We will probably never be back; there are no second chances. Been there but haven't done that? There's nothing so demoralizing as returning home to friends' sly comments: "Oh, you didn't see such and such? It was right near your hotel, or just past the place you stopped …" We have missed the one sight/event/revelation that might have brought the whole experience together—an unbearable counterpart for all the missed opportunities in ordinary life.

Perhaps it is necessary for me to try these places, perhaps it is my destiny to know the world.
It only excites the outside of me. The inside it leaves more isolated and stoic than ever. That's how it is.
It is all a form of running away from oneself and the great problems: all this wild west.
—D.H. LAWRENCE

It's useless and hypocritical, though not difficult, to be generally "against" tourism. In this book, I try occasionally to go against the grain of the dyspeptic and melancholy tone in which tourism is most often discussed, to acknowledge some of its pleasures. For all the scholarly breast-beating and finger-wagging that goes on, most of us who are financially able, *do* enjoy seeing the sights and "getting away." Some experience epiphanies in the process. Progressive people in regions that are economically dependent on "visitors" (sounds like they are from outer space, and they often seem to be) are struggling to imagine a progressive tourism that doesn't exploit local people or places and doesn't create rifts between personal lives and economic goals, history and spectacle, genders, races, and classes. A few artists are wondering what role progressive visual artists might play in facilitating, even creating, a responsible, critical, perhaps even satirical tourist industry—or alter-industry.

Must tourism be, by definition, as geographer Edward Relph sees it, an "inauthentic attitude to place?" Must it be, as Dean MacCannell suggests, "something insidious… the sucking of difference out of difference, a movement to the still higher round of the old arrogant Western Ego that wants to see it all, know it all, and take it all in?" Or will the consciously multicentered person-artist eventually be able to challenge her own pleasures and discomforts, to create a responsible tourist as well as a responsible inhabitant of unfamiliar places? I prefer David Harvey's contention that tourism is about *becoming* rather than *being*.

THE TOURIST AT HOME

This village loves this village because its river banks are full of iguanas sunning themselves and its fishes love to bite. —SANTIAGO CHUB

W"HAT'S HERE?" asked some friends from Maine as I walked them through the New Mexican village I live in. They had seen the place written up in a guidebook as "picturesque." "Nothing," I said with a certain mendacious pleasure, thinking how opaque the village's surface is.

"Is there anything over there?" asked a couple I met on the bridge; they were staying at the local inn. "Depends on what you're looking for," I replied, secure in the knowledge that there was nothing over there they would see.

Yet when I give my own walking tours through the rutted dirt streets (and few of my visitors escape them), it seems to me that everything is here: culture, nature, history, art, food, progress, and irony. There is the old village itself and its vestigial claims to "authenticity"; the church (relatively new as southwestern churches go, having replaced an older one in 1884); the 18-year-old upscale development to the west for contrast (and for an architectural tour of another nature; it's a good survey of imagined "Santa Fe style"); the movie set in the distance; the curan-

Manuel and Clara Anaya with replica of Nuestra Señora de los Remedios, Galisteo, New Mexico (photo: Lucy R. Lippard). The miniature church was made by Mr. Anaya; the actual adobe church, with the same distinctive double cross (which he helped to construct), is just below the hill on which this stands.

dero's "office" with its skull on a pole; what used to be here and there (scattered adobe ruins); the quite new community center and the brand new firehouse (partially built by community work parties); yard art; an extensive petroglyph site; the cloud shows and encompassing light on ranchlands and mountains; the (diminishing) biological diversity of the creek and bosque; the mouthwatering tamales at the Tienda Anaya; and, of course, the people. We have it all, but for an outsider, it's hard to find.

The next question is, should it be easier? What's in it for a town like this, with few local businesses? Who would profit from a higher profile? Will signs begin to proliferate along the highway? Will local artists lend themselves to making this place a "destination" rather than a fly-through? Will a proposed café/gallery and/or restaurant change our identity? We may soon have to answer these questions, as the state and county tourism bureaus look farther and farther afield for attractive "authenticity." Dean MacCannell has said that the concept of the authentic is a potential "stake driven into the heart of local cultures."

THE LOCAL IS DEFINED by its unfamiliar counterparts. A peculiar tension exists between *around here* and *out there*, regional and national, home and others' homes, present and past, outsiders and insiders. This tension is particularly familiar in a multicentered society like ours, where so many of us have arrived relatively recently in the places we call home, and have a different (though not lesser) responsibility to our places than those who have been living in the area for generations. Jody Burland has remarked on the "peculiar reciprocity of longing" at the heart of tourism which binds outsiders to insiders. Tourists may long for warmth, beauty, exoticism, whereas locals may long for escape, progress, and an improved econ-

omy: "Between us there can be a moment of strange, perhaps misleading comprehension." Local residents both possess and *become* a "natural resource which produces more pleasure, and tourists are necessary to its conversion to wealth." Smiles and solicitude are part of the negotiations. The exchange contains the contradictions that define a multicentered society.

Tourism is the apotheosis of looking around, which is the root of regional arts as well as how we know where we are. Travel is the only context in which some people *ever* look around. If we spent half the energy looking at our own neighborhoods, we'd probably learn twice as much. When we are tourists elsewhere seeing the sights, how often do we stop and wonder who chose the sights we are seeing and how they have been constructed for us? We do often wonder about the sights we're *not* seeing—houses and gardens glimpsed behind the walls, historic sites and natural wonders sequestered on private property or closed on Tuesdays.

The tourist experience is a kind of art form if it is, as Alexander Wilson says, its own way of organizing the landscape and our sense of it. "We tour the disparate surfaces of everyday life as a way of reintegrating a fragmented world." It is an art form best practiced domestically, challenging artists to work in the interstices between the art scene and local audiences. This can mean demythologizing local legends and constructing antimyths that will arm residents against those who would transform their places in ways that counter local meaning (which in itself is unstable). So the resident who accepts the role of tourist at home becomes responsible not only for the way the place is seen but for how it is *used*. Jim Kent, a sociologist based in the legendary Colorado ski town notes, "So many people complain about the people who bought Aspen.

What about the people who sold Aspen?"

Being here and being there, being home and being away, are more alike than we often think. Even as we learn them, our places change, because no place is static, and no resident remains the same as s/he lives and changes with the experiences life and place provide. People visit, they like

Louis Hock and Elizabeth Sisco, *Local Interpretations,* 1991 (photo: the artists) Book and supermarket coupon, in conjunction with the artists' project *Corral at Banff, 1991: Community Transactions,* Walter Phillips Gallery, Banff Center for the Arts. The exchange of cash register coupons at the Safeway checkout for a booklet of local comment which could be redeemed at the public library made a point about the role of local transactions in an international tourist town and the commodification of such transactions. The book came in a paper bag, like a tourist's purchase, with Walter Phillips' picture *Corral at Banff* on it. (The Canadian artist was a popularizer of the town.) The book ("an alternative souvenir") is drawn from interviews with thirty-nine long-term residents about their town, and thanks to the contributors "for allowing us into their homes as intimate tourists." The coupons included two quotes from the book: "If you live in a National Park you have a responsibility to work toward protecting it. That's the payment for the wonderful pleasure of living here"; and "The *ideal* tourist—he's a happy Texan who's been around the world, is broadminded, and can afford a vacation."

the place, they retreat or retire there, becoming what have been called "amenity migrants." Then, prey to the "drawbridge syndrome," they begin to complain about the tourists and other newcomers. In Aspen, they say "if you've been here a year, you remember the good old days." A former county commissioner observes, "What defines you as a local, in my mind, is whether you give more than you take." Yet locals can be takers too, from a littering habit that pervades the rural United States to more permanently destructive behavior. It was a local, mad at his girlfriend, who poisoned and brought down the great historic tree called the Austin Treaty Oak, in Texas. At Higgins Beach, near Portland, Maine, drunken party goers deliberately stomped on the nests and eggs of endangered terns. All over the West, local people target shoot at ancient rock art. Vandalism, not necessarily by "foreign" tourists, recently destroyed an arch in Canyonlands. The examples are chillingly ubiquitous.

Many towns are not so much potential destinations as service stops along the way to more desirable places. Considered negligible, they are unseen, recalling tourism in its innocence, when travelers were the strangers, providing entertainment for locals, when the passing tourists looked out upon views that were the same before they came and after they left. But all too soon came the deluge. Opposing tourism in the West, if only theoretically, has suddenly become "like being against ranching, or Christianity," writes Donald Snow in a bitter elegy for Montana titled "Selling Out the Last Best Place":

We're getting the endless strips of motels, junk food restaurants, and self-serve gas depots out along the interstates that make our towns look like every other greasy little burg everywhere else in Walt Disney's Amerika. We've

*got increasingly egregious pollution problems
now, here in the paradise of the northern
Plains, and we have seriously outstripped the
abilities of local government to handle even
modest levels of new home development.
Recent news in my hometown paper is that a
new hydrologic study of Missoula County
has found significant levels of septic
contamination in every single well...
including one well drilled 220 feet down to
bedrock.... If all that isn't stupid enough, we
spend what paltry money we raise from a
tourism tax right back on more tourism.*

Over a period of years, John Gregory Peck and
Alice Shear Lepie have studied three North
Carolina communities and charted the effects of
rapid growth, slow growth, and "transient devel-
opment" (weekend and special event tourist
trade) on three criteria of central importance to
local people: *power* (land ownership, sources of
financing, local input, and the relationship of
local traditions to development projects); *payoff*
(benefits and potential upward mobility for how
many residents); and *tradeoffs* (the social impact
on communities). Under the best of conditions,
balance seems achievable. Yet when tourism
becomes the only option for economic survival,
our labor force becomes a nation of service work-
ers, dolled up to look like our ancestors as we
rewrite the past to serve the present. Although
this situation might provide a chance for retro-
spection, the romantics, the generalizers, and the
simulators usually get there first. Towns can
wither on the vine as they preserve the obsolete
out of stubbornness or impotence, or they can
inform their residents' current lives. Past places
and events can be used to support what is happen-
ing in the present, or they can be separated from
the present in a hyped-up, idealized no-place, or

pseudo-utopia, that no longer belongs to the
people who belong there.

In recent years, a lot of cities around the coun-
try have come up with PR campaigns called Be a
Tourist in Your Own Town. It's an interesting
idea if it's taken way past the overtly commercial
motives that inspire it. Instead of discounted
trips to restaurants and museums offered in
order to stimulate local markets, this could be a
time to focus on latent questions about our own
places—areas we've never walked through,
people we've never met, history we don't know,
issues we aren't well-informed about, political
agendas written on the landscape. It is a task
taken seriously by the innovative Center for Land
Use Interpretation and its publications and tours.
(See pp. 20, 150.)

John Stilgoe's studies of "locally popular"
places such as the Blue Springs Cafe, just off the
interstate at Highland, Indiana, and the Ice House
Café in Sheridan, Arkansas, or even the ubiqui-
tous Wal-Marts, suggest that people are less inter-
ested in the visual impact, in the architectural
containers, than in "something different" from
the corporate style and, above all, in "high quality
product and service within the container." Thus
the tourist looking for the locally validated, the
truly "authentic," is unlikely to stumble into it
because *from the outside* it looks like nothing
special. Most locals, perhaps even some propri-
etors, would like to keep it that way. In tourist
towns, at least, residents feel displaced. They
need their own refuges, which are always endan-
gered—potential tourist spots, if the secret gets
out. MacCannell has pointed out that in San Fran-
cisco, "everything that eventually became an
attraction certainly did not start out as one. There
was a time when... Fisherman's Wharf was just a
fisherman's wharf, when Chinatown was just a
neighborhood settled by the Chinese."

Years ago, theater innovator Richard Schechner got a job as a tour guide to prepare for an article on tourist performances. Creative Time's 1995 *Manhattan Passport—7 Two Token Tours* encouraged New Yorkers to rediscover their borough by "re-contextualizing typical tourist attractions with areas of the island other than those in which you might live and work." The seven cleverly titled excursions included "Take the A Train" (Harlem), "More Than Harlem on My Mind" (Washington Heights and Inwood), the "Melting Pot Tour" (the U.N. and Roosevelt Island), and the "Cultural Cornucopia Tour" (Lower East Side and East Village). The latter stopped at the Henry Street Settlement, Gus's Pickle Stand, Liz Christie Gardens, the 6th Street Indian restaurant row, Nuyorican Poets Café, St. Marks on the Bowery, the Russian and Turkish Baths, and four yoga dens. This is cultural tourism

Kathy Vargas, *My Alamo,* 1995. From a series of altered photographs with handwritten texts. Vargas was raised and still lives in San Antonio, where the Daughters of the Republic of Texas ironically control the Alamo, the city's best-known tourist site. The text reads: "Then there's the Order of the Alamo, with their duchesses, princess and queen at Fiesta time. Beautiful dresses my mom would let me wave to until I finally said, 'When I grow up I want to be one of them.' My mother explained why I couldn't: expensive dresses and 'old' families. My mother never used the word 'racism,' only 'money' and 'lineage.' But it was the first time I looked at who I and my family were honestly."

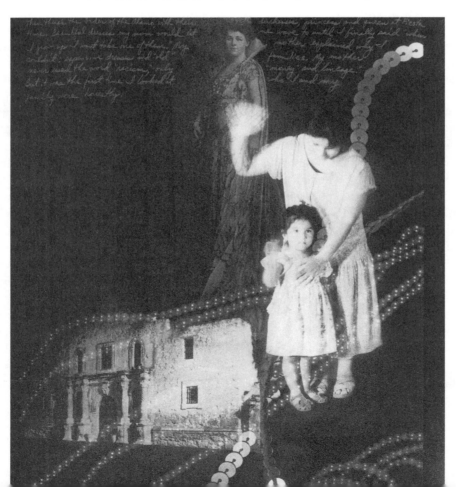

at its liveliest, though it is unclear how actively it addressed the problematics of gentrification, homelessness, redlining and other pressing social ills in relation to cultural issues.

A provocative community exercise in being a tourist in our own towns would be to ask people what local existing sites or buildings, artifacts, places they'd like to see preserved, and *why*. Times Square might not have been on my list during the forty years I lived in New York, but now that it's too late, it is suddenly on everyone's list. As early as 1914 the area was described as "a little bit of the underworld, a soupçon of the halfworld—there you have the modern synthesis of New York as revealed in the neighborhood of Forty-Second Street." First-run movies showed in the odorous and slightly dangerous theaters of my youth, now gone, as is Grant's, where New Yorkers could buy a hot dog and be goggle-eyed tourists on the seamier side of their home town—not to mention the squalid porn shops, hustlers of every stripe, adult movies billed as "XXXstasy," and the sometimes violent street life. All gone now, replaced by Disneyfication, to make Times Square a safe place for mallrats and anathema for locals.

What is at stake in Times Square, according to literary scholar Andreas Huyssen, is "the transformation of a fabled place of popular culture in an age in which global entertainment conglomerates are rediscovering the value of the city and its millions of tourists for its marketing strategies." And where will Times Square's marginalized population (which made the place what it was for better and for worse) go now? Wherever they turn up, it's unlikely that a new place will ever achieve the historical and populist grandeur of its predecessor. Or can Times Square be reincarnated elsewhere? Maybe Disney will take that on too, if we don't. As architect Michael Sorkin concludes sadly, "of course, it's terribly true that the demise

of Times Square, its conversion to another version of the recursion of Vegas (which has now built its own Times Square, even more pared down and distilled than the vanishing 'original'), must be blamed squarely not on the energetic advocates of sanitized fun but on our own failures to propose a better idea."

San Francisco has often been celebrated by its multifaceted artist and writer population. In 1984, a group of "activist punks" organized street theater action tours of corporations involved in nuclear energy and military intervention (modeled on the "Hall of Shame" tours of nuclear corporations in 1981 and preceding the "War Chest Tours" at the 1984 Democratic Convention). These enabled the anarchist Left, wrote David Solnit, to "collectively take their politics out of the underground shows and into public spaces." Fourteen years later, his sister Rebecca Solnit lauds San Francisco's scale and its street life, which "still embodies the powerful idea of the city as a place of unmediated encounters," unlike other western cities which are "merely enlarged suburbs, scrupulously controlled and segregated."

The city has been the site of several artists' tours, such as Jo Hanson's $5 tour of "Illegal Sights/Sites" in the early 1980s. Conceived as part of her "Art That's Sweeping the City," the environmental tours to ten sites were guided by community activists, exploring "the living city under the tourist attractions…focusing on the web of urban issues/relationships through litter and dumping." The selected sites included Chinatown ("where you will see more of the alleys and markets than the tourist shops"), "Bay View and Hunter's Point, the Shadow of Candlestick Park, the victimization of unique Black communities by illegal dumping from outside," "Ocean Beach and its devastation," and "Twin Peaks, the breathtaking grand view strewn with litter down its steep slopes."

In 1994, artist Bernie Lubell and writers/ professors/activists/artists Dean MacCannell and Juliet Flower MacCannell led a carefully considered bus tour of "unconventional sites" in San Francisco. Before they began they asked their passengers to make "metaphors of the city," handing out blank notebooks, a blank postcard, and a sheet of "suggestive words." They hoped to reconnect "the tourist quest to the fundamental human desire to see and know something else, resisting the conventional forms that have grown up around that desire, over-organizing and killing it." Aiming to produce "a common narrative of the city," the tour guides were convinced that

"only emptiness can fill a space with possibility."

The tour ended up at the Palace of the Legion of Honor, where a new wing was being hastily built over a century-old pauper's graveyard despite protests from archaeologists. By involving their tourists in a current, unresolved controversy, Lubell and the MacCannells forced an intimate relationship with the place—and with death, and perhaps with the imposed stasis, which is tourism itself.

A year later the three artists met again to discuss the tour, revealing some of their own motives. Lubell's "biggest surprise was the contribution of the tourists on the bus," the bits of information and insights garnered from them.

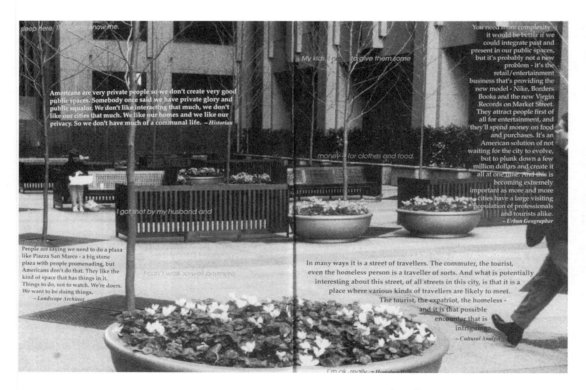

Susan Schwartzenberg (with Ali Sant and Amy Snyder) *The Plaza,* from
Cento: A Market Street Journal, 1996, offset book, 5-1/2" x 7"
(commissioned by the San Francisco Art Commission Market Street Art in Transit Program).

Dean MacCannell saw the "tour itself as the missing key: the buttonholing, imperious, insistent sharing of the overlooked." Juliet MacCannell wanted to end the tour by "getting lost" and calling attention to the fog, "so they wouldn't be able to 'see' in any usual sense," so that San Francisco would become for them "a conspicuously imaginary object." Imagined places are, after all, one result of conventional tourism.

In 1996, Capp Street Project sponsored the four members of the Chicago collective called Haha (Richard House, Wendy Jacob, Laurie Palmer, and John Ploof) who took turns living with four local residents and shadowing them as they went about their daily lives. In the gallery they exhibited the resulting audio tours of the city sites visited, providing a curious inversion in which a local viewer was made privy to an outsider's experiences of nearby familiar sites, literally "shadows" of real experience.

Susan Schwartzenberg's *Cento: A Market Street Journal* was commissioned by the San Francisco Art Commission as part of a series intended to animate and illuminate the Market Street area for those passing through it. This compact, densely illustrated 116-page artist's book is "a combination walking tour guide, personal journal, and map," which was offered free to visitors from June 1996 to January 1997. The artist has lived in the city for some twenty years and makes no attempt to oversimplify her experience for rapid consumption. She describes Market Street as "not a place, but a sequence of places strung together where all manner of life experiences are acted out." After researching a variety of tour guides and historical archives, Schwartzenberg took to the streets with camera and tape recorder and interviewed anyone who was ready to talk. "Sometimes we talked about San Francisco and Market Street, but more often we talked about work, success and failure—life and its uncertainties."

Beautifully designed, crammed with images, quotations, interviews, and pockets of unexpected history, the Market Street journal is more experimental art than visitors' guide, but what a rich compendium of the kind of miscellany that turns out to be significant when a place means enough to enough people. For example, the hotels that historically harbored merchant seamen and immigrants—they now cater to the elderly, the transient, the homeless, and to single (often Filipino) men—have been the first to fall to the wrecking ball. Development decrees that soon someone will build new hotels aimed at an entirely different clientele. Schwartzenberg's book also seems to be intended more for resident tourists than for those from elsewhere. As "a collage of voices and impressions," it replicates the random screen of daily encounters more accurately than the ordered view that is demanded, and needed, if the average tourist wants to make sense out of superficial experience. At the same time, the tourist's goal is supposedly to go backstage; if s/he succeeds, s/he is more likely to fall into the Market Street montage—"a confusing string of events and encounters we try endlessly to decipher." Schartzenberg quotes a private investigator: "It's a kind of psychological archeology. Everyone leaves traces—it's a matter of looking for them." Perhaps the ultimate in guidebooks is *The Visitor's Key* to Iceland, described by poet Eliot Weinberger as following "every road in the country step by step, as though one were walking with the Keeper of Memories. Iceland has few notable buildings, museums or monuments. What it has are hills and rivers and rocks, and each has a story the book recalls. Here was a stone bridge that collapsed behind an escaping convicted murderer, proving his innocence...."

Phil Young (Cherokee), *Genuine Indian Postcards 2,* 1991, mounted photo detail of *Genuine Indian Trading Post and Burial Site,* mixed media installation at John Michael Kohler Art Center, Sheboygan, Wisconsin, 1995 (photo: Kohler Art Center). The piece includes a number of antique and modern Indian souvenirs mixed with those created by Young, confusing and reframing the stereotypes. The burial site was a heap of dirt inside the gallery, trenched and marked as though undergoing an archaeological excavation.

Center for Land Use Interpretation, *Bus Tour of Giant Rock* from *Hinterland: A Voyage into Exurban Southern California,* 1997. Videos were shown on the Hinterland tour buses, as "the tour guide interprets the real world in a sort of land use theater, where the audience is brought to the ever-changing set." The caption in the guide book reads: "Several people are known to have lived in a cavity, hollowed out, in and under this giant rock. In 1942, one occupant, an alleged German spy, blew himself up with dynamite as deputies were questioning him (the deputies survived, miraculously). Five years later, a former test pilot and UFO abductee, George Van Tassel, moved his family into the rock, and the location became known as a site of major UFO activity (Van Tassel built the Integratron energy machine three miles south of the Rock). Located north of Landers, it has since become a popular rave location, attracting as many as 3,000 partiers."

This farm refused shelter to a pregnant woman, and was buried in a landslide that night.... Here lived a popular postman in the eighteenth century What other modern society so fully inhabits the landscape it lives in? Where else does the middle class still remember?"

TOURISM HAS LONG-TERM EFFECTS on our places, given its connection to development, traceable back to the 1820s when fashionable tours wended north from New York, transforming Saratoga Springs, the Erie Canal abuilding, and Niagara Falls. Now that tourism is the last economic straw to be grasped (as it often was in the mid-nineteenth century too) the damnedest places are deemed tour-worthy. If your town hasn't been naturally endowed, if it's too new or too flat or too modernized to be intriguing, then attractions must be created from scratch—a theme park, an amusement park, a marina, a spa, a museum, or just a vast shopping opportunity. (On the other hand, I have heard of one town that posted a sign on its outskirts reading: WE AIN'T QUAINT.)

Theme parks and proliferating bed and breakfasts are not isolated phenomena of individual entrepreneurship. Resource exploitation and tourist development often go hand in hand. Corporations whitewash clear-cutting and stripmining by masking their devastations with "parklands" as a "gift" to a gullible public, while government, too, is hardly above disguising its own agendas. In 1995, for instance, the New Mexico Department of Tourism ads featured Carlsbad Caverns, with no mention of the pending Waste Intensive Pilot Plant (WIPP), a national nuclear waste dump about to open at a nearby site that will imperil the same scenic routes through the "Land of Enchantment" that tourists traverse to get to the Caverns. For those aware of the federally funded WIPP, the glowing encrustations pictured in the ad bear an eerie subtext, predicting one effect of the nuclear waste to be dumped there.

From turn-of-the-century boosterism when the hoopla was aimed at attracting railroads, businesses, and permanent settlers to the age of rapid transience when money spent is what counts, any place can be marketed, developed, and drastically changed in the process. Whether all the residents will like the transformation is another story. Some may be reluctant to make their homes a zoo but can be persuaded by the promise of jobs. Some would rather run their own business or farm their own land than build roads, clean toilets, make beds, and provide valet parking for the more fortunate. Some are forced onto the highway not by choice but by the need to follow an elusive

David Avalos, *San Diego Donkey Cart,* 1986, wood, chainlink fencing, barbed wire, acrylic paint, hardware, 9' high, 6' wide, 10' long (without fencing) (photo: Dan Muñoz, Jr.). On January 5-6, 1986, this piece, sponsored by SUSHI, Inc., Performance and Visual Art Gallery, was in the courtyard at the San Diego Federal Courthouse, until it was ordered removed "for security reasons." (A judge thought it was a good place for "some kook" to plant a bomb.) See p. 48.

seasonal job market. In the process, the dangers of tourism have escalated from being cheated to being murdered.

Viewed from the perspective of the places "visited," even in those disaster areas that are victims of downsizing and deindustrialization exacerbated by NAFTA and GATT, tourism is a mixed blessing—sometimes economically positive, usually culturally negative, and always resource-depleting (as measured by the "demo-flush" figures in which toilet use becomes an indicator of success for summer and weekend resort towns). Tourism leads to summer people leads to year-round newcomers leads to dispossession and a kind of internal colonialism. As an increasing amount of the world's acreage is "opened up," the search for the "unspoiled" intensifies, exposing the most inaccessible places to commercial amenities and barbarities, from vandalism to jet-skis.

Tourists come to the American West, for instance, looking for places destroyed by shifting economies: Indian ruins, ghost towns, abandoned farms, deserted mines, and nineteenth-century spaces frozen in the governmentally managed wildernesses. For years now, Oregon, Colorado, and other states whose tourists have tended to come back and stay, have engendered a "bumper sticker jingoism": WELCOME TO OREGON, NOW GO HOME or, more brutally, GUT SHOOT 'EM AT THE BORDER. A popular Cape Cod T-shirt reads: I CHEAT DRUNKS AND TOURISTS. In Maine, some "natives" put out signs at the southern end of the turnpike: NEXT TIME JUST SEND THE MONEY, and the state has spent a good deal of money on campaigns begging the locals to be nice to tourists. One motive is plain old territorialism. Those same tourists at home may have similar attitudes about Mainers invading their own turf.

Sometimes we are tourists, sometimes we are toured. Even those who hate to travel, even those who live in out-of-the-way spots, have been exposed to tourists either in passing or as a sight to be seen. As we live what we perceive as ordinary lives, we are under surveillance—if not by the government then by the citizenry. I remember how startled I was when my picture was taken by some Japanese tourists leaning out of a bus as I schlepped my laundry through SoHo. Disheveled and purposeful in my black jeans, I was obviously a native. Turnabout is fair play, though as a tourist I'm more given to sidelong glances than stares and lenses. In Lower Manhattan, tourists are merely a nuisance. But in poorer "destinations," the divide is far greater, as Jamaica Kinkaid writes:

That the native does not like the tourist is not hard to explain.... Every native would like to find a way out, every native would like a rest, every native would like a tour. But some natives—most natives in the world—cannot go anywhere. They are too poor. They are too poor to go anywhere. They are too poor to escape the reality of their lives; and they are too poor to live properly in the place where they live, which is the very place you, the tourist, want to go—so when the natives see you, the tourist, they envy you, they envy your ability to leave your own banality and boredom, they envy your ability to turn their own banality and boredom into a source of pleasure for yourself.

If appalling disparities between classes are taken for granted, bypassed, and forgotten in metropolitan and international tourism ("It's none of my business; I can't do anything about it; it's their country"), they remain glaringly obvious when one is a tourist at home. Negotiating the contra-

dictions demands a sensibility finely tuned to local politics and the global forces that drive it. Places presented to tourists as false unities are then broken down into thousands of fragments, since no place is seen exactly the same way by several people—let alone by people from different backgrounds, temperaments, and needs. As novelist John Nichols has said of his hometown:

To make it palatable to visitors, our living culture in Taos is embalmed, sanitized, and presented much like a diorama in a museum: picturesque and safe. Tourists would rather not know that in many respects life here approximates the way four fifths of the globe survives…. When commerce and social interaction take place solely with transients, culture and responsibility die. The town itself develops a transient soul.

One of the obvious contradictions in tourism concerns what is being escaped from and to. Absence (sometimes) makes the heart grow fonder. If we live away from native ground and then go home to visit, we can see the place anew, with fresh eyes. Some return to their hometowns to find the mines and factories they escaped now glorified as museums. The sad tale of Flint Auto World, a theme park simulating the immediate past in the corporate-abandoned town of Flint, Michigan, was told with tragicomic wit in Michael Moore's film, *Roger and Me*. Long popular in socialist countries, industrial tourism is catching on again in the United States. An edifying example is the themification of the history of tumultuous labor relations in Lawrence, Massachusetts, and in Lowell, where the first national park devoted to industry has caught on. Are the visitors simply the curious, the history buffs? Are they those who worked in factories or remember their parents' and grandparents' experiences? Are they lefties looking for landmarks of rebellion? The ways in which places and their histories are hidden, veiled, preserved, displayed, and perceived provide acute measures of the social unconscious. Yet their relationships to broad economic issues seldom surface overtly in daily lives. We live in a state of denial officially fostered by State denial.

Such grand-scale abdication from the present does not bode well for the future. One can only wonder what our hometowns will look like when the fad passes. Will the ghosts of fake ghost towns haunt the twenty-first century? Or will our places be ghosts smothered in new bodies we would never recognize as home? Tourism is a greased pig, a slippery target, like its offspring—sprawl. The new populations that spring up around tourist sites become a necessary evil, as purported insurance in the event that the tourist boom falls slack. But "sustainable tourism" may be an oxymoron along the lines of "military intelligence." Those of us at home in towns, counties, and states soon to be converted for display value are unprepared for these changes. We wake up only when it's too late to channel or control them. Soon my private village walking tours may run into other, more public ones. There may even be "sights" to see. Two centuries ago, William Blake wrote, "You never know what is enough, unless you know what is more than enough."

TRESPASSING
ON COMMON GROUND

A Case Study

INTERNALLY POPULAR PLACES and externally popular places suffer different fates. Those that are both inevitably become sites of clash and contradiction. Then someone has to decide between integrity of place, local quality of life, and imposed popularity that brings "progress" and change that may or may not support local interests. At this point, complex emotional and political conflicts erupt between people and place or people within a place. No single view prevails. Most of us pray for the status of the status quo.

They think a campground would spoil their vacation houses. I guess this is a change in use, and nobody likes change.—Eric K

This is the story of potential change in a small part of a larger and very popular place—mid-coast Maine, in summer. Early in 1997, the K family, longtime owners of some fifty acres at the little community of Sagadahoc Bay on George-town Island, pleading high taxes on their water-front property, announced plans to open a commercial RV and tent campground with eight, then sixteen, and finally a total of seventy-two sites. Descendants of the island's earliest Euro-pean settlers, they live in four houses on a historic saltwater farm at the center of a small group of summer homes, all clustered around a beach between a wooded point and a salt marsh. Over the millennia, this plot of land has been an aboriginal campground, a colonial homestead, and a summer colony. Now it is a battleground.

Every popular place that has been "discovered" is a vortex of different needs and desires. We could argue long and hard about when or even if the boundary between "unspoiled" and "popular" (read "spoiled") has been breached on George-town Island. In any case, Sagadahoc Bay, on the Southern, oceanside tip, is now on the endan-gered list. Tucked away on a narrow, curving, wooded road off a secondary route from George-town Center, it lies at the back of the bay itself, looking out to the distant sea and the hump of

Seguin Island with its historic lighthouse. The tide goes out almost a mile, leaving a vast mud and sandflat articulated by meandering silvery channels, a haven for an incredible array of bird life, for shellfish harvesters, and for walkers. Deer, fox, and an occasional moose are seen on the periphery. At high tide, seals, striped bass and even sturgeon are frequent visitors, although the fish, like the birds (several kinds of gulls, some endangered terns, snowy egrets, cormorants, plovers, sandpipers among them) have diminished in number and variety over the last fifty years.

Georgetown has been settled for over 350 years, and the proposed campground overlaps the site of one of the oldest habitations marked on early maps. There are several Indian shell middens along the bay's western shore, and one on Molly Point, where part of the RV park was plotted, that could be either Native or Colonial, or both. It is a quiet and pretty place. Not dramatic, but soul-soothing.

It is also very like many other popular places along the Maine coast, within reach of the ever-longer tentacles of the Route 1 tourist strip. Such a large campground will bring traffic, noise, and lights. In the years to come there could be a historical marker, some information about indigenous peoples' use of the area, perhaps a house tour of the K's eighteenth-century farmhouse (Ruth K, who was raised there, is an antique dealer), perhaps a display of the artifacts that have been found eroded out around the site,

Peter Woodruff, *Viewing Fog, Reid State Park,* Georgetown, Maine, 1983, color slide.

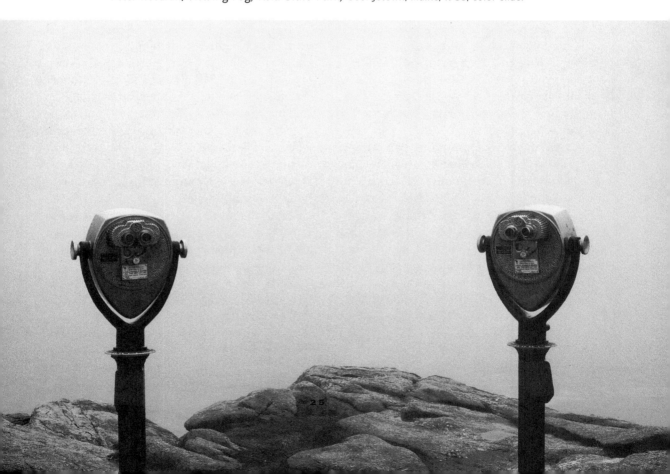

or even weekend clambakes. (Eric K, Ruth's son, with his wife Pat, proprietors of the proposed campground, is an aging clam-digger—a notoriously hard and unlucrative profession—though he has tried other work, including farming the place.) Would any of these seriously alter the place? Is this just a tempest in a teapot? Or is it a case of give 'em an inch and they'll take a mile? Depends on who you listen to, and how you interpret the place's history of popularity.

It's not as though Georgetown is isolated and pristine. The mid-Maine coast became popular about 150 years ago when the urbanites arrived. The initial farm and coastal boarding houses gave way to fancy resort hotels, which gave way in turn to second homes, then to motels and the dreaded horde of "tourists" on whom the state's economy is pitifully dependent. Georgetown has had its share of summer homes since the 1880s, as well as at least three hotels on the northern part of the island; only one, now called Grey Havens, still stands. Originally the Seguinland Hotel, it was built in 1904 by Walter Reid (1869–1955), a self-made shipping tycoon raised in Georgetown who was also a land speculator on his home turf and donor of the state park.

In the later 1800s, Georgetown's modest popularity was a boon for landowners whose farmlands were abandoned to encroaching woodlands. Ever since, old families have been forced to move inland when farming, sheepraising, and fishing declined, and jobs became available mostly in urban areas. The summer houses edging the beach at Sagadahoc Bay and the small fields behind it have sprung up on the land surrounding the old farm, sold off over the last century. Soon "the public" (including local residents) had virtually no access to the island's beautiful beaches, all of which were privately owned, primarily by summer residents. Some

"natives" moved only a few miles inland, and still enjoy the island's eighty-odd miles of wooded coastline as soon as its "owners" leave on Labor Day. Yet it was only with the inauguration of Reid State Park in 1947 that disinherited Georgetown residents could once again take pleasure in their own shoreline during the summer months.

Since then, steady summer traffic has rushed through Georgetown Center, two miles from Sagadahoc Bay, to Reid State Park and the Seguin Campground (consisting of only twenty-two tent sites and eight RV sites, far smaller than the Sagadahoc Bay proposal), which has existed for decades to service those headed for the park. The couple who run it now (he is a maintenance mechanic at the Bath Iron Works) bought it ten years ago and claim a summer income of about one thousand dollars per site. They have had no trouble with their neighbors, but the previous owners did. Camp Seguin is self-contained, set on the rocky shore. It infringes directly on no common ground or private purview, and its visitors are there to take advantage of the park rather than to prowl around the immediate environs.

This cannot be said of the Sagadahoc Bay proposal, where all but thirty-odd feet of the small white sand beach are owned by the Ks, who allow no one else to use it. One other family uses the remaining portion, but most of the dozen or so houses in the community have no legal beach rights at all, though they overlook the field where the RVs will be parked. The extensive tent ground will be in the woods across the road, just behind a small, mosquito-breeding beaver pond.

When the K family planned their assault on the Georgetown Planning Board, they unwisely failed to warn any of their longtime summer neighbors in this tiny colony, despite the fact that many of them had been there all their lives. This did not forestall or divide opposition, but exacerbated it.

The summer families (some of whom are the children of a much-loved full-time member of the Georgetown community, recently deceased) are in a difficult position, but feel they had no choice except litigation. At the hearings, they have fought the campground proposal with passionate arguments about resource protection, road safety, the welfare of wild-

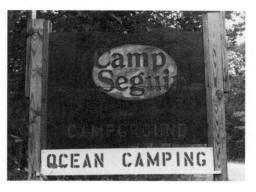

Peter Woodruff, *Seguin Campground,*
Georgetown, Maine, 1997, color photograph.

life habitat and historical and archaeological sites. Their own "quality of life" is rarely mentioned, but it is clearly the bottom line. Those attending an August (1997) site visit for the planning board, looked miserable, not only (I surmise) because it seemed they might lose, but also because they felt betrayed by their neighbors, whom they had perceived as friends, and by the unacknowledged American class system that rears its ugly head in such situations.

The Ks rather confusingly (and strategically) broke up the campground proposal into three sections, thus sidestepping the impact of the whole. A condition for "Campground Two" involved the use of taxpayers' money to widen the road to accommodate 30'-long RVs. (For some reason, this was not a condition for Campground Three, just up the same narrow winding road.) This might have run into some obstacles, since not even all the year-rounders—few of whom will profit from the additional traffic—want the campground, and most of the area's summer people, also taxpayers, are decidedly opposed.

Although the RVs will park directly in front of her house, blocking her view to the water, the only Sagadahoc Bay resident who is sanguine

about the situation is Ruth K's forthright widowed sister, Marge, who says she will welcome the company. Both elderly sisters are angry at their summer friends for opposing Eric's hopeful plans. This is the general tone of local response, that the "rich" summer people are begrudging "the natives" a better life and their piece of the popularity pie.

Summer people, on the other hand, rather naively assume that with their annual returns to Georgetown, nothing will ever change, although everything does, and they are the agents of much change. Conveniences—like the Georgetown Country Store that replaced the old general store, which closed in the mid-1960s, and a lobster restaurant on the town wharf—are welcomed and rapidly become part of "tradition." But a line is drawn when it comes to sharing our popular place with other outsiders whose desires differ from ours. Class alliances are outed. A few years ago, a Texas couple built a large and unnecessarily high-profile house on the end of a nearby point across from our peninsula, thereby "ruining the view" and causing much grumbling but no overt protest. Yet another big summer house, however ugly and obtrusive, does not pose the same threat as the "invasion" of a less wealthy clientele—those who will use the campground, which I've heard referred to as "that trailer park."

Residents of Indian Point, adjacent to Sagadahoc Bay—summer people for the most part—are in view of the campground, and most of them vehemently oppose it. Kennebec Point, on my side of the bay, has few direct views of the site, but will

have to share the bay itself, at high and especially low tide, with the camp's clientele. Ironically, when Indian Point was subdivided in the late 1950s, an aging man living next door to my family, who had been summering (and sometimes wintering) in the area since the turn of the century, declared he could never return; the sight of all those little houses was too much for him. But he came back. Just as I will return for the rest of my life even if the tranquil flats are overrun with campers.

LINES BETWEEN ENVIRONMENTALISTS and locals are blurring all over the country, although the spotted owl remains the Willy Horton of rural areas. Lurking beneath my own dilemmas along these lines, and my empathy for those who resent the apparently easy lives of summer residents, is the fear that a careless camper will drop a match in the unguarded woods that border our point. (My house almost burned to the ground when I was a child, thanks to similar carelessness.) The Ks promise their campground will adhere to strict rules, but they concede that there is no way to enforce them when people wander off the campground.

And wander they will. Shoreline access is a crucial issue. People in the campground's RVs may rarely budge from under their awnings, but tent campers will. I have to admit that I dread finding more people and perhaps litter on the flats, and jet-skiers and more "cowboy" powerboats on waters where rowboats and small sailboats have prevailed. Those living closer to the campground are worried about the loss of privacy, as well as the noise and lights at night.

All of these things have already happened to some extent in Georgetown. I am often irritated by a brilliant all-night beacon on an Indian Point house. Nocturnal noise is amplified by the amphitheatrical geography. The whine of mowers,

chainsaws, and power boats has been accepted as a necessary, and unregulated, evil. Yet these amenities have drastically changed the place since my childhood, when only foghorns and occasional ship whistles broke the warm summer silences.

Concern about the wildlife and ecology is genuine, but most fear the ugly more than anything else. The vague legal concept of preserving "natural beauty" has become the last hope of the campground's opposition, but neither side is equipped to argue aesthetics with any specificity. The Ks boast that from November 1 to April 30, the land will be in its "natural" state except for the RV hookups in the field. But there, of course, lies the rub: those who will be most disturbed by the campground are only there when it is open. A tremendous discrepancy divides the ways this place is seen, experienced, and remembered by those who live there only in summers, albeit for generations, and those who live there through all seasons—the cold stormy winter and chilly, muddy spring as well as the foggy, sunny summer and crisp, blue fall.

As in most seasonally popular places, zoning is controlled by full-time residents. Little communities around Maine's inland lakes are forming associations to protect themselves from outsiders looking to exploit their home turf. The village of Popham Beach, across the Kennebec River from Georgetown—with a long history of tourism, two popular public beaches, two restaurants, and a bed and breakfast in the former Coast Guard Station—has closed down a trailer park near the village center because it detracts from its stunning beaches and impressive Civil War fort.

Conflicting views on land use and taxation are at the heart of this story, as is the cherished self-image of Georgetown as a working landscape rather than a bedroom/summer community. Local rural families that have managed to

hang on to their land are often "land rich" and cash poor. They may not be tempted by the alleviating conservation easements offered up as tax panaceas. While some might approve of limits on tourism, limits on land use and development are unpopular. Every local landowner seems to be either contemplating commerce of their own or worrying about how to protect themselves from their neighbors' commerce. Each commercial application is seen as an individual case, usually upholding the right of "natives" to make a living off their land. The Ks have played this both ways, by claiming for the purposes of the RV park that the land was already developed when they farmed it, but also claiming it was undeveloped for tax purposes.

Sooner or later, however, development simply fills in all the gaps, at which point the Maine coast stands to lose the rugged beauty and peaceful (sometimes "quaint") isolation for which it is popular. Toothless local zoning ordinances have been powerless to stop the flow of development. Campgrounds, motels, fast-food joints, miniature golf courses, souvenir stands, and bars are developed randomly, and short-term thinking still prevails among those who claim to care more about their hometowns than summer visitors do. The selectmen and planning boards are usually sympathetic to their year-round neighbors; summer people, in residence annually for two to three months, are supposed to pay up and mind their own business. Taxes on shorefront property are high to support schools and roads. (Georgetown publishes an annual report that lists how much everyone pays.)

Five generations of my family have come to Georgetown for the summer and this has always seemed a fair tradeoff. Those of us who can afford a second home (though economic status can vary hugely between generations) can damn

well afford the fairly high taxes which go to support an environment we love but for which we take little communal responsibility. (The perception that all of these homes are luxurious and all the owners rich is decidedly inaccurate; on all sides of Sagadahoc Bay, most of the houses are modest.) We do not consider ourselves outsiders, though we must concede that we are "from away." But why should people who only live in a place two or three months a year, people who can afford two homes, dictate the terms of life for those who live there all year, some of whom are struggling to make ends meet in order to remain in a place they too love?

However, the class card, once played, can be terribly destructive, as currently demonstrated in other Maine communities on issues ranging from schools to tourism, development, and fishing rights. At one planning board hearing on the Sagadahoc Bay campground, a town selectman suggested that summer people are simply afraid of change, which is inevitable. True enough, but there is change and there is change, change for the better and change for the worse. The conflicts arise from very different views of which is which, and for whom.

Rural Mainiacs, notoriously independent and conservative, are adamant about their property rights. Equally conservative summer residents are pretty clear on theirs too, and on the power of money and privilege. ("How dare they infringe on our well-earned pleasures? They gave up their land; they just don't work hard enough....") But a good many of Georgetown's longtime summer residents are "liberals," uncomfortable with their privileges vis-a-vis less fortunate natives. They can be guilty of stereotyping local people as they were decades ago, when the economic gulf was much wider and animosity toward summer folk was probably as deep as it is today but was veiled

by a pragmatic and characteristic courtesy. They want to see both sides of the issue, to sympathize with the locals even as their own nostalgia for this childhood place resists change that does not consider "natural beauty" and environmental consciousness. (This is a lot easier for progressives like myself who do not live directly in the line of fire; I live three months a year next door to, but out of sight of the Sagadahoc Bay community. It is also complicated by the fact that an increasing number of retirees from the summer colonies are living in Georgetown year round.)

Since the campground proposals saw the light, tempers have risen. The Ks perceive themselves as the underdogs, made to jump through one hoop after another, each of which costs them money; but they have wagered too much to stop. (A town official even suggested, unofficially, to a wealthy summer couple that they should buy the Ks out.) The friendly Eric K and his canny developer/advisor—who appears at hearings in a sports shirt, looking and sounding down-to-earth in contrast to the opposition's bright young attorney in coat and tie—have done their homework and offer an effectively populist image. Maine Historical Preservation, a state body that is supposed to keep an eye on historical or archaeological resources, did not seem to have been paying attention until a local historian/student archaeologist re-alerted the authorities; in the process, the Ks had him banned from the site by the sheriff's office. And certain townspeople who are usually vociferous on ecological issues were conspicuously absent from the debates when wildlife and habitat needed defending. Non-participation was presumed to be support for the Ks.

More nefariously, while the planning board was deliberating the K's applications, a member of the board whose Indian Point home is in view of the campground was asked to recuse himself because his property values were at risk. However, another board member, who runs the sole local store with his wife (the legal owner), who figures to profit mightily from a campground, was allowed to remain. This was a clear case of bias. And I haven't even touched on the involved history of the town's Comprehensive Plan, controversies around the long-unfinished process of trying to introduce zoning within that plan, and the town's relationship to the state in regard to shoreline zoning ordinances and resource protection zones.

WHEN A PLACE BECOMES too popular, and too populous, when the intimacy is vanishing because its pleasures are shared by too many, its popularity wanes. Also vulnerable are the various ways in which places bind people together. Familiarity is one of them. Every summer we arrive and excitedly greet the people on our common ground. With some of them we have little else in common, and out of this context the bonds might prove fragile. The place itself is paramount. The people belong to the place. I know that in these now-aging people with whom I grew up, I see the beaches, bays, boats, parties, weathers we have shared; I respond to an aura of escapades, confidences, rumors, romances, spats, and resentments. They all bear the scent of pine, salt, and sandy mud, of fog and sun and goldenrod. A Native American friend says that community is something you can't walk away from.

The debate around the Sagadahoc Bay Campground finally comes down to the question: Is there a way to protect the place, its wildlife, its natural beauty, *and* its native humans as well? Georgetown, already prosperous on summer property taxes and good will donations, is currently balancing on a brink, as are so many small towns in mid-coastal Maine. So far, while there are a

Peter Woodruff, *Popham Beach, Phippsburg, Maine,* 1996, black and white photograph. This popular local beach in a small fishing and tourist village is across the Kennebec River from Sagadahoc Bay. It is more populous and more intimate than the big state park adjacent to it.

couple of upscale restaurants, the island has no motel, no gas station, no bars, no movies. In the parade of settlement, summer colonization, and tourism, a second RV campground is perceived by some as the next step to perdition.

It was late September 1997, with the summer houses boarded up and the noisiest opposition out of the way, when the Georgetown Planning Board approved one of the K's three campground applications. Now the Ks are suing the town for not permitting RVs close to the water and their opponents (most of the other Sagadahoc Bay residents) are "interveners" on the town's side. Should the litigation be settled, and the road

financed, then it remains to be seen if the Ks can make a go of such an ambitious enterprise. Georgetown will live with it, but the lives of the summer residents of the Sagadahoc Bay colony—and perhaps those of all of us who live on the bay—will be changed forever. The Sagadahoc Bay campground is not an isolated story. The next battle is already on the horizon. Pending are propositions to straighten the main road and rebuild the bridges to ease (or grease) the tourist's way to Reid State Park, perhaps destroying the historic nature of quiet Georgetown Center in the process. The pendulum of popularity is swinging toward us. We can duck, but we can't run.

POSTSCRIPT (NOVEMBER 1998)

Since this essay was written in fall 1997, the campground case has been batted around in committees and courts, and I have accordingly revised the text. As of this writing, Campground Three—the largest number of RV sites plus fifty tent sites, located in the woods away from the shore and therefore needing no permission from the planning board—opened eight RV hookups with no fanfare at the end of August 1998. Campground Two appears to be dead. After lengthy hearings and deliberations, the Georgetown Planning Board approved Campground One (on Molly Point, bordering the bay) with eight RV sites, but it was appealed, sent to the Sagadahoc County Superior Court, and landed back in the lap of the Georgetown Board of Appeals. At the end of April 1998, the board voted down Campground One (with the one male "environmentalist" board member voting for approval and the four female members voting against it) because the appellants had been unable to prove that this RV camp would not affect the area's natural beauty. The Ks then sued the town, determined to beat the "natural beauty" conditions. They lost on all counts but could still go to the Supreme Court.

In the meantime, this essay as printed in the *Harvard Design Magazine* found its way to Georgetown and copies were made for the Board of Appeals. I was probably naive to have been so surprised by this turn of events. It underlined the fact, which I know well from editing my local newsletter, that in this field the boundaries are blurred between professional, personal, and political.

At the same time, Georgetown was unpleasantly divided over an independent Land Use Ordinance—the product of years of work—which lost by four votes in the spring Town Meeting, perhaps because of bad weather and low attendance, perhaps because it was seen as relating to the campground controversy. After several hearings, the road straightening was fended off, but the new bridges in Georgetown Center will be wider than the old ones, and construction will involve some destruction as well as a lot of inconvenience in the spring, summer, and fall of 1999. The son of the local store owners has opened a successful kayak and bicycle rental store. This is enjoyed by residents and tourists alike, but an increase of litter and toilet paper in woods and behind beaches is a disquieting symptom of what the future may hold. Behavior has regressed; Erik K and his wife regularly flip the finger at anyone perceived to oppose their plans. Throughout the summer, they distributed a pictorial brochure for the still-under-construction Sagadahoc Bay Campground, ironically touting its natural beauty. By advertising boating on the bay, "Bird Watching on the Marsh," "Beachcombing," and "Lobsters on the Beach" the Ks may be guilty of false advertising, since the beach use and water access do not seem to be included in the commercial use permit. This story is not over yet.

Thanks to Peter Woodruff for help in the research and Susan Lemp for legal details.

SURPRISE PACKAGES

If you believe your world is formed by what you look at, and you just don't look at the usual things, then your world will change. —JOHN BALDESSARI

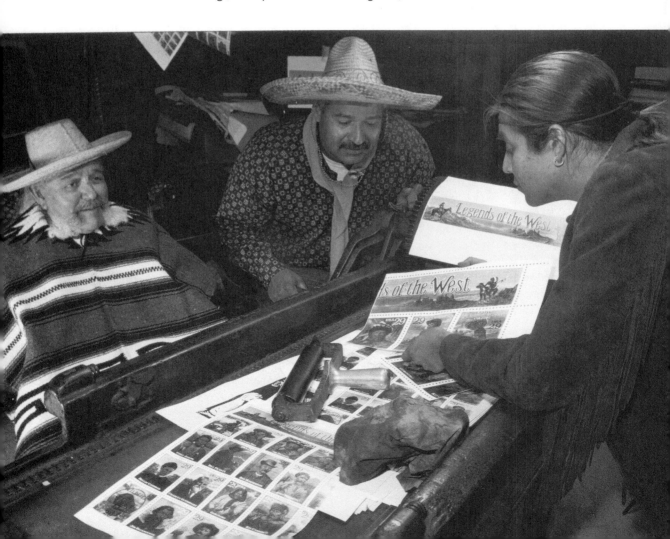

NOTHING IS MORE SURREALIST than tourism. Tourist and toured meet in unlikely combinations, and they surprise (overtake) each other. The Dada tours of Paris in the 1920s first used art to demonstrate the ironies and absurdities of travel. As they pioneered the collage or montage aesthetic, the Dadas epitomized the shock of known meeting unknown, or one unknown meeting another. Dreams, exotica, and the jolt of unexpected encounters comprised Dada and Surrealism's central strategies. Tourism similarly juxtaposes and superimposes people coming both literally and figuratively "from different places" to create a reality that is real to neither one. Great distances are perceived as short durations— the *temporal* counterpart of the Surrealist collage— and apparently new relationships are created by dispensing with the median space or time.

One cruel result of the twentieth century's mobility is the transformation of poor regions into stage sets on which their citizens act like their forebears for the benefit of those who feel superior because they have lost touch with their own backgrounds. Painful material contrasts are exacerbated as the mobile rich travel—staring— through the lives of the indigenous poor. If you are too poor to go anywhere, and your state or nation is also poor, you will know where you came from, for better or worse. But you will also begin to see your place through the camera lens you don't own. Even as you may be stuck there, you can find yourself an everyday tourist in your own homeland—involuntarily touring the tourists and catching capitalism in the process. As the buying power of the visitors is envied by the visited, and imitated where possible, hard-earned internal money begins to be spent in different ways and social change is accelerated. "Tourism injects the behavior of a wasteful society in the midst of a society of want," one Tunisian onlooker has noted. "The rift between rich and poor societies at this point is no longer an academic issue but an everyday reality."

Virtually all travel and/or tourism is "disorienting." Like most middle-class Americans, I have enjoyed my share of these out-of-sync experiences. Ultimately surrealist was a trip to China in January 1980 as a feminist-socialist cultural tourist with a small group of art types, just after the Gang of Four had been deposed, at a moment when many Chinese were entering the current period of enchantment with capitalism. We saw as many factories as art displays (the factories were often more interesting), but despite consistent goodwill on both sides, the lack of communication and common ground was staggering. On my return I wrote an article titled "The Ten Frustrations, or, Waving and Smiling across the Great Cultural Abyss." I described it as "an attempt to make some sense of a baffling experience," and began: "In retrospect, I'm not sure *what* I saw in the two and a half weeks I was in the People's Republic of China." Among the bewilderments was the role of tradition in Chinese painting and

previous page: **Robert Buitrón,** *Missing Legends of the West,* from *El Corrido de Happy Trails (starring Pancho y Tonto),* 1995, chromogenic print included in mixed-media installation (photo: copyright Robert Buitrón). The title of this staged photo (one of the actors is the well-known Chicano artist Carlos Cortez) derives from the U.S. Post Office's stamp series in which, "following the multiculti/diversity line, they included Indians and blacks in the American West myth, and once again excluded, ignored, neglected, and dismissed the role (not that of *bandidos*) Mexicans played in the development not only of the myth but also of the United States" (Robert Buitrón, letter to the author, March 31, 1998).

its relationship to the forms of Western painting Chinese artists were avidly appropriating (mostly neo-Impressionist at the time). I mention this because, since then, I have often found myself in places where tradition and homage by repetition and imitation hold places of great respect—a situation hard to grasp for North Americans raised with the notion of an avant garde and planned aesthetic obsolescence. It is one of those jolts inherent in cultural tourism and can happen in domestic as well as in foreign circumstances (in the "tricultural" southwest, for instance).

At the same time, although I did not yet know of him, an immigrant from Hong Kong (via Vancouver, Paris, and Montreal) was finding a way to make sense of his ex-oriented experience and was producing the first major body of recent work about tourism in the United States. In the late 1970s, when Tseng Kwong Chi moved to New York, he was unexpectedly drawn to observing Asian tourists. According to Asian American artist and scholar Margo Machida, he was "perturbed to discover that not only were there few Chinese sightseers at the time, but the majority appeared to be so "completely westernized that you cannot really tell if they are Chinese, or Korean, or Japanese." He began to photograph himself (neatly dressed in a Mao jacket, a plastic ID badge, and mirrored shades that cast the "reflection" back on the viewer) with prototypically "North American" tourist monuments. Throwing their familiarity off balance by his very presence, Tseng ironically called himself an "unofficial" or "ambiguous" ambassador, but the subtext was clearly intervention.

Tseng began his "East Meets West" project by posing as a Chinese dignitary, crashing the opening of the Costume Institute at the Metropolitan Museum. His Mao suit and mirrored gaze provided keys to the "intrusive" and "reflective" char-

acter of the entire enterprise, as well as to the symbolism of his own "costume"—a comment on authoritarianism and extinguished individualism, and perhaps on the tourist "uniform" worn by others. In the early photos of this series, he always held the cable shutter release as visible proof that these were self-constructed images of identity. Having started out as a tourist in the art world, photographing himself with local "celebrities" at clubs, studios, and galleries, Tseng then launched into his touristic parody of the Long March. At first he visited urban, human-made sites, then branched out into nature, especially the grand vistas favored by nineteenth-century American landscape painters and photographers.

Noting that monuments especially appeal to tourists "because they represent past or present glories and power," Tseng seems to have been announcing his own subversive intent. He described himself not as a tourist but as "an inquisitive traveler" and a "witness of my time"; by calling his work the "Expedition Series," he recalled other such political forays fueled by Manifest Destiny. From Disneyland to Cape Canaveral, from the Canadian north to Mount Rushmore, Tseng inserted himself into landscapes where his presence was unexpected and perhaps unwanted (especially since he was gay, though this is only a hermetic pulse below the surface of the work). In many of these real-life montages he is only a tiny figure, barely discernable in the vast landscapes, referring perhaps to traditional Chinese landscape painting, or to the powerlessness of Asian Americans. Yet his power lay in the fact that he was not the expected figure; he has been transported rather than deported. Tseng's photographs can be seen as documents of a fragmented performance piece or as a series of self-portraits in which the self changes according to the place it is set down. Or is it the identity

of the emblematic place that changes? And is it changed by the gaze of the tourist, like the tree in the forest? Can we differentiate between the gazes of this tourist and that one? Asian tourist, North American tourist, and Asian-North American tourist?

The very self-consciousness of the tourist experience, so intelligently highlighted by Tseng Kwong Chi, allies tourism to art. Both are the offspring of modern industrialism and a conception of "leisure" that separates both work and leisure from the rest of life (though today leisure time is as likely to be spent on the couch or on the Web as on the road). One myth about artists is that they are immune to the separation of work and life; in fact, they are as bound by the illusion of freedom as others are to particular employers. Cultural assumptions and marketplace demands can be as constricting as any overseer. In the post-modernist art world and in post-structuralist academic anthropology, for instance, it is taken for granted that nothing is authentic. But cultural tourism depends on the implication that authenticity is just over the hill, around the corner, within our reach so long as we're holding hands with those in the know.

Tseng Kwong Chi, *Mount Rushmore, South Dakota,* 1986, silver print (photo: copyright Muna Tseng Dance Projects, New York City; courtesy Julie Saul Gallery, New York).

Art about tourism must of necessity be based on the modern and postmodern montage of fragmentation, disjunction, and alienation. Anne Turyn's constructions of an apocalyptic future paradoxically reflected back to us by staged tourist "snapshots" in large scale Cibachrome are dizzying in their implications. Tim Maul says he photographs "the things between the things we see" as a way of forgetting rather than remembering. Yet his close-up of the bedspread in a Paris hotel becomes an aerial landscape of surprising mystery and ironically sticks in the viewer's memory. When he's abroad, he says, "I always feel that I'm 're-photographing' everything; that is, removing some small portion of it." (And he quotes Iggy Pop: "I am the Passenger, I stay under glass.") Since 1988, Andrei Roiter, a Russian living in Amsterdam and New York has cryptically annotated his travel snapshots. ("My Tourist Self" is one of them, offering a possible oxymoron. Is anyone himself when a tourist? Which persona, which place?)

Nomadism as an international form has become an intriguing subject for cultural critics and artists in the last decade. The seminal figure here is the Japanese conceptual artist On Kawara, who bombarded his friends in the 1960s and '70s with rubber-stamped postcards documenting when I Got Up and who I Met as he traveled all over the world in what appeared to be a relatively random fashion. Conceptual art was virtually invented to slip across borders and avoid the high-art immigration authorities in the New York monopolies. North American Lawrence Weiner, Latin Americans Eugenio Dittborn and Gabriel Orozco, Stanley Brouwn (from Surinam/Holland), and most recently, Dominican Marcos Lora Read have made works about shipment, communication, career, and travel in the international art world.

WHAT PRICE AUTHENTICITY?

MacCannell compares the contemporary tourist's search for authenticity to the traditional quest for the sacred, arguing that tourists, or pilgrims, used to come from the peripheries to the centers, whereas today many of us go from the centers to the margins to find what is missing. What we miss, or have missed, is often the illusion or remnants of so-called primitivism. The notion of authenticity is largely applied to others' lives, not to our own. Yet we ourselves, in North America, are increasingly the subject of study by tourists and newer immigrants. I've been told of a Nigerian anthropologist who turned the tables and went to Middle America to study the culture there; he was practically lynched in the process. A black man taking photographs of everyday life and asking the kind of intimate questions white people assume they have permission to ask of people of color was clearly unacceptable.

In April 1998, Rirkrit Tiravanija traveled in a motor home across the country from Los Angeles with five art students from Chiang Mai University in his native Thailand, who recorded their daily responses to the United States on a website, their final destination the Philadelphia Museum of Art, where an installation was set up concerning the trip and the participants discussed their journey. Tiravanija had in mind the road odysseys of Beat generation heroes like Jack Kerouac and Ken Kesey. (Swiss photographer Robert Frank's great tour that resulted in his classic book The Americans might be a better comparison with such an international eye.) Tiravanija, whose medium is interaction, describes the project as "a typical family

vacation." But his previous work suggests that he is introducing America to means of communication with "foreigners" as much as the other way around. (One piece involved serving Thai curry in a New York gallery; in others he has traveled and cooked for people along the way, reversing the notion of the tourist as a hungry consumer.)

Much of the significant art about travel and tourism is by members of those cultural groups that are stereotypically stared at. They tend to be

Rirkrit Tiravanija, *Untitled 1998 (On the Road with Jiew Jeaw Jieb Sri and Moo)*, 1998, road trip, documented daily on the Web, April 1-May 3, followed by two-week residence at the Philadelphia Museum of Art (photo: from the website courtesy Philadelphia Museum of Art). The handwritten picture postcard of Canyonlands accompanying this image describes a typical tourist experience: "Dear Marcel Duchamp. On 5 April 1998 we planned to see Michael Heizer's work [*Double Negative*]. We drove up hill that is rather steep. I saw beautiful nature that was different from others. It is a broad, broad mountain intersect with blue sky. Then the van stopped because it didn't like high mountain. We had to walk up quite far and looked up Michael Heizer's work but we couldn't find it. Finally we decided to walk down and turned back. I think it is a new experience in my life. I hope you will follow our trips."

artists of color, women, and political dissidents, or all three, critical thinkers who feel directly affected—even threatened—by the social mechanisms of the tourist industry. Their strategies tend to outraged cool, the rage sometimes so heavily blanketed in irony that the message is muffled for general perception. Whatever the style employed, any art about tourism must almost by necessity be based on the modern and postmodern montage of fragmentation, disjunction, and alienation.

In 1992, some Native Americans went to Europe announcing their intention to "discover" European culture. The same year, in order to review Christopher Columbus's "discovery" of the Americas, Guillermo Gómez-Peña and Coco Fusco presented *Two Undiscovered Amerindians Visit the West*, a.k.a *The Year of the White Bear*, a real-time performance in which they appeared in a golden cage disguised as aborigines from an island in the Gulf of Mexico that had somehow been overlooked by Europeans for five centuries. The piece was presented in various public spaces (including several museums here and abroad, but most notably in Columbus Plaza in Madrid and at the Smithsonian). "We called our homeland Guatinau, and ourselves Guatinauis," writes Fusco. "We performed our 'traditional tasks,' which ranged from sewing voodoo dolls and lifting weights to watching television and working on a laptop computer. A donation box in front of the cage indicated that for a small fee I would dance (to rap music), Guillermo would tell authentic American stories (in a nonsensical language), and we would pose for Polaroids with visitors. Two 'zoo guards' would be on hand to speak to visitors (since we could not understand them), take us to the bathroom on leashes, and feed us sandwiches and fruit. At the Whitney Museum in New York we added sex to our spectacle, offering a peek at authentic Guatinaui male genitals for $5." (The

display of the male rather than the female of course breaks conventions of international sexual tourism, or at least its most publicized aspects.)

The staggering repercussion of this deeply humorous and humiliating (for the audience) performance was the fact that a substantial part of the public swallowed it whole, without the intended grain of salt. The artists were actually accused of misleading gullible onlookers, most of whom were unaware of the historical precedents for the display of people like objects, "orchestrated by impresarios but endorsed by anthropologists." Fusco attributes this to the element of surprise, when "people's defense mechanisms are less likely to operate with their normal efficiency; caught off guard, their beliefs are more likely to rise to the surface."

The temporal and visual montage consists, then, of two extremely sophisticated contemporary artists playing the role of "primitives" from the "wilderness" in urban settings for an audience that is sometimes so trapped in its own temporal cage of ignorance that it cannot see the ironies or the art. Like Maximo and Bartola, microcephalic Salvadorans billed by Barnum and Bailey as "the last Aztec survivors of a mysterious jungle city called Ixinaya," White Bear and consort are wholly fictional characters. But unlike the unlucky Central Americans, Fusco and Gómez-Peña were fully in control of their destinies and were able to make fools not of themselves but of their audiences, wreaking some small but no doubt satisfying vengeance for a long list of ignominious "intercultural performances" from the fifteenth to the twentieth century, one of the most recent being when a black woman midget was billed as "Tiny Teesha, the Island Princess" at the Minnesota State Fair in 1992.

Among Teesha's predecessors were Christopher Columbus's own display of captured

Coco Fusco and Guillermo Gómez-Peña, *Two Undiscovered Amerindians Visit the West,* 1992-94
(photo: Glenn Halvorsen; courtesy the Walker Art Center, Minneapolis).
This stop was in Minneapolis. Coco Fusco and Paula Heredia produced a video
of the work, *The Couple in the Cage: A Guatinaui Odyssey* (1993).

Arawaks in 1493 and the much-mythologized Pocohantas, who was brought to England to advertise tobacco in 1617 and died soon afterward. In the mid-eighteenth century, tourists paid tuppence to visit London's Bedlam, and were "suffered unattended to run rioting up and down the wards, making sport of the miserable inhabitants." Indigenous survivors of genocide from Tasmania and Uruguay and various "red Indians" at expositions here and abroad can be added to this hall of shame, as can the Mexican prisoners publicly displayed in Texas during the U.S.–Mexico war, in cages where they slowly starved to death. In 1896, Robert E. Peary brought back six "eskimos" from his polar expedition, exhibiting them in ports from his ship on the way to the American Museum of Natural History. When most of them died, their bones were kept by the museum. The only survivor was a small boy named Minik, who spent his lifetime futilely trying to retrieve his father's corpse. In 1993, the remains were finally returned to the Arctic for traditional burial. Then there is the scurrilous case of Ota Benga, a pygmy displayed in the primate cage of the Bronx Zoo in 1906, and a few years later the "benign" five-year imprisonment of Ishi, the "last Yahi," who died in the U.C. Berkeley Museum of Anthropology. Ishi has since become an anthropological talisman, like Saartje Benjamin (Sarah Bartmann), the "Hottentot Venus," who was exhibited all over Europe from 1810 to 1815; her genitals remain today in the Musée de l'homme in Paris. In the early 1990s, African American artists Renée Green and Renée Cox have made art about Benjamin, and native artists have commemorated Ishi. As John McAloon remarks, "One man's life is another man's spectacle."

Slumming is the most domestic of tourisms, offering opportunities for social voyeurism or what Dean MacCannell calls "the museum effect"—where people become anthropological specimens or "signs of themselves." The Mandan/Hidatsa/Arikara photographer, Zig Jackson, has called attention to this kind of reification in his series *Indian Photographing Tourist Photographing Indian*, typical of the barbed humor that characterizes the work of many Native artists. He says it "deals with the invasion of space, privacy, and cultural boundaries of native peoples... the casual disregard for the sanctity of our customs and ceremonies displayed in these images reveals itself as just another means of exploitation of a culture originally marked for extinction." Jackson's series on *Sacred Sites* with tourists crawling all over them, and *Degradation*, about similar disrespect for objects, are witty too, but more overtly angry. One of the most powerful shows a white "trader" in a safari hat (at the Tesuque Pueblo flea market in 1993) threatening the photographer as he shoots a stuffed buffalo head. (This provides a counterpoint to the century-long history of Native people resisting violation by photography with what one anthropologist called "avoidance behavior.") Jackson, whose Indian name is Rising Buffalo, was particularly distressed by the lack of reverence with which the bison, sacred to Plains tribes, was being treated. The "trader" yelled that he had to pay five dollars for the photograph he had taken—another inversion. Jackson "went over and petted the buffalo, and walked away without paying him." He recalls that "in light of historical circumstances, paying for that photograph would have constituted the height of irony." (The presence of an *End of the Trail* statuette in the foreground augments that irony.)

In another play on this syndrome, Diegueño/Luiseño James Luna did a museum piece in 1991 in which he offered viewers the opportunity to

Take a Picture with a Real Indian (p. 42). Luna was there in person at the opening, but for most of the exhibition, the artist was represented by three cut-out versions of the "real Indian," which challenged the stereotypes; the artist appeared in street clothes, in traditional California Native garb, and in the Plains Indian regalia tourists expect all Indians to wear all the time.

The playful juxtapositions of ancient and modern in Gómez-Peña's and Fusco's *Two Undiscovered Amerindians* (and its attack on the notion of barbarians captive in the legendary past) was preceded by Robert Buitrón's 1989 photographic calendar *The Legend Continues,* in which the ancient Mexican myth of Popocatepetl and Ixtacihuatl was updated into modern life with asides on tourism. Buitrón's 1995 work *El Corrido de Happy Trails (Starring Pancho y Tonto)*(p. 33) consists of tableaux in which postmodern versions of the famous sidekicks declare their independence. (Malinche and Pocohantas also appear, *"chismeando con Power-*books" in a yuppie "western" bar patronized by various Mexican stereotypes.) Among Buitrón's targets are the Disney-Hollywood preference for

Zig Jackson (Rising Buffalo, Mandan/Hidatsa/Arikara), *Indian Photographing Tourist Photographing Indian,* 1992, black and white photograph.

Zig Jackson, from *Degradation Series,* 1993, black and white photograph.

James Luna, *Take a Picture with a Real Indian,* performance/installation, 1991.

cowboys and Indians as well as the conspicuous absence of the Mexicans who shared the historical western stage with them. A Chicano of Mescalero Apache ancestry, Buitrón found himself as a child playing cowboy (not *vaquero*) and asks today, "Whom should I emulate? The dirty, untrustworthy *mestizo*, or the lazy, docile Mexican?"

He has been joined in this hybridizing enterprise for historic truths by several other Chicano photographers included in Chon Noriega's important 1995 show *From the West.* Christina Fernandez's *Maria's Great Expedition* follows the history of women's diasporas between the United States and Mexico from 1910 to 1950 in a chronological series of costumed tableaus. Harry Gamboa Jr.'s *Social Unwest* documents a gunfight/tug of war performance in which the modern Chicanos kill off the

fake historical "Mexicans." Miguel Gandert's series on Los Comanches dances in *hispano* communities in New Mexico focus on extraordinary events that are *not* tourist events because, like Buitrón's characters, the dancers fall between two spectacles, the Native and the Anglo, or cowboy and Indian. In certain images, Gandert also interrogates, without parodying, the Edward Curtis portrait type.

Delilah Montoya's *Shooting the Tourist* is a set of seven artist's books in the form of accordion-fold postcards, titled "Looking," "Imaging," "Staging," "Collecting," "Going Native," "Preserving," and "Syncretizing." They serve a triple function, scrutinizing Montoya's own identity as "a Chicana in occupied America," exploring "the topography of my conceptual homeland, Aztlan," and examining

the occupiers as they peer at the natives. The installation work included a photomural of tourists standing in line to ride on Thunder Mountain at Frontier Land in Disneyland. Montoya intended to "redirect documentary photography from the 'objective' vision of modernity by documenting its search for 'the West' through tourist attractions." She mixes local and invented objects, events, and celebrations, presenting a fusion of views from inside and outside. The last image in "Syncretizing" is a cut-out ship bearing a load of cartoon children of all nationalities over the seas and into the melting pot.

Kathy Vargas directly addresses tourist sites and activities in her poignant series *My Alamo* (1995)(p.16), from the viewpoint of an insider/outsider—a Chicano/mestiza looking at the focal point of tourism in her hometown, San Antonio. It is a history promulgated by Anglo mythology and the Daughters of the Republic of Texas, which administers the site, a history from which local Mexican-Americans have been excluded. Vargas says of the "bite" inherent in her outwardly lyrical hand-colored photo-montages, "It's a bite that I did not invent. It's a bite that recurs in the inherent aggression and often in the racism that is part and parcel of standing before war monuments and thinking oneself to be on one side or another, either by choice or because history gives us no choice."

These artists have taken into their own hands and cameras the task of challenging Hollywood's and Disney's views of their West—the views that inform most touristic expectations. They do so within a storytelling format not necessarily to recall or wax nostalgic about oral tradition, but in order to sustain their arguments in a neo-cinematic form. And they are also aware that by targeting stereotypes (and, by implication, the tourisms that thrive on them), they are engaging

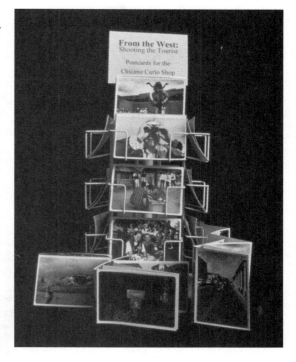

Delilah Montoya, *From the West: Shooting the Tourist (Postcards for the Chicana Curio Shop),* 1996, toned black and white photo postcard. The accordion-folded postcards form an artist's book that documents various touristic activities. The installation commissioned for the traveling exhibition *From the West: Chicano Narrative Photography* also included a documentary photomural. The one-line captions on the cards underline each theme and provide a running theoretical text on tourism: the "Syncretizing" section, drawn from Disneyland, Albuquerque, Los Angeles, and Santa Fe, for instance, reads: *"Syncretizing* 'civilized' cultures to convey a message of humanism. *Syncretizing* the 'East' with the 'West'—a convergence of the Occidental. *Syncretizing* to glimpse the authenticity of the noble 'other.' *Syncretizing* to incorporate the cultural activities of the other. *Syncretizing* cultural heritages to form an identity. *Syncretizing* non-western people with modernity."

in a guerrilla war of quotation and voyeurism, a war waged from within the frame.

Renée Green's work is more dense, but touristic themes have played a major role in her examinations of exploration and colonialism since her early New York shows. Her 1991 installation *Peak* used an Ansel Adams photograph to stand for the "because it's there" ethos, a ladder and climbers' ropes with which to attain the goal, binoculars and a telescope with which to scrutinize the goal, and a conquering flag inscribed "Mt. Olympus."

In another section, Green awarded prizes to quotations from explorers; "Kima ja Kegnia, Mount of Whiteness... It has only been seen by myself" took second place. Green's work often comments on the absurdity of the Western habit of superimposing Latin names on places and species long since named by indigenous peoples in Africa and the Americas. She incorporates language and literature (ranging from slave narratives, Conrad, Poe, and Melville to W. E. B. DuBois, Richard Wright, Harriet Jacobs, Stuart

Renée Green, *Partially Buried Continued,* 1998, made for catalogue, Kunsthalle Krems (Austria) (photo: courtesy Pat Hearn Gallery, New York). This follows up on a piece that "excavated the 1970s." Brian Wallis has said of it that Green's version of history "focuses on the overlooked memento, the outmoded object, and the miscellaneous" (*Art in America,* Sept. 1997).

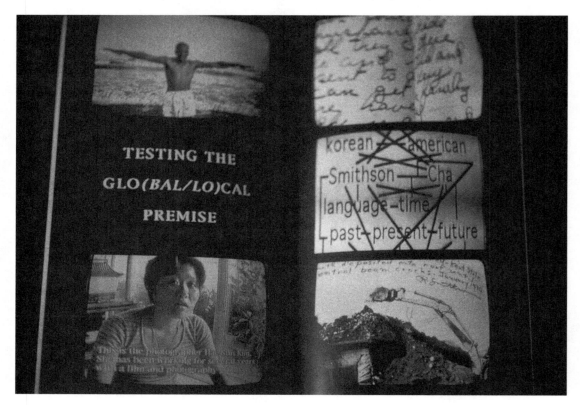

Hall, Angela Davis, Theodor Adorno, and Kobena Mercer) into all of her work.

In 1992, Green began *World Tour*, a large project with several parts, including installations in Venezuelan, French, and American museums. Having done extensive historical and literary research on the ideology of travel, she has included an idiosyncratic and broad-ranging collection of "souvenirs" in her various interrelated installations, many of which treat the themes of slave trade, "blackness" and "whiteness," loss and retreat, art and (obliquely) politics, as well as contemporary African-American culture, hiphop and funk. *World Tour*'s components are adapted to the places where they are created and shown. In *Mise en scène* in Clisson, France, for instance, she constructed a museum of decorative arts, a "cultural fiction" for today's tourists. (Included were references to a local restaurant called "L'Esclave," a natural history museum's Africana collection, the botanical gardens with the "black-eyed Susan" among its exotica, and an "antique" textile featuring master

and slave on a bed of flowers.)

"Who owns history?" asks Green. "Who can represent its complexity? Who cares?" In *Partially Buried*, she has explored student radicalism (and her father's Korean War experience) through a trip to Seoul and Kwangju, and the Vietnam War era by visiting Kent State. In both journeys she seeks out the "confusion of foreign encounters," the "spiraling" of ideas and images that takes place when one is out of place. She writes, "I think of my work as an exploration of Western history and the way in which African diasporic subjects have been configured into this history." She works with fragments because a diasporic subject can "have no linear history." Elsewhere, she has spoken of "taking a normal situation and retranslating it into overlapping and multiple readings of conditions past and present," which might serve as an intellectual's ambivalent definition of tourism. Appropriately for work about time and space, Green's installations take a good long time to take in. The passing tourist has little chance of getting it.

FOUR EYES ARE BETTER THAN TWO: THE DUAL RETURN OF THE GAZE

Contemporary art on the gaze returned is often done in collaboration, often between cross-cultural couples. Fusco and Gómez-Peña (respectively Afro-Cuban-American and Mexican), Yong Soon Min and Allan deSouza (Korean American and East Indian-Kenyan-British American), Andrea Robbins and Max Becher (Jewish-American and German-born American) have collaborated across their personal cultural differences while negotiating the broader cultural gaps between them and their audiences. Working as couples permits the artists to play off each other the way tourists play on the looker and the seen,

and avoids an overemphasis on the individual. And it probably allows them—paradoxically, since they all favor uneasy fragmentation over easy totalities—to round out the pictures, to better represent the facets of their subject.

In 1994, deSouza and Min extended the reversal of ethnographic inquiry in a photographically documented performance piece called *alter idem/ performing personae*. Wearing T-shirts (one white on black, the other black on white) identifying them as "native' and "informant," they explore the space between the anthropologist and her subject, mediated by a "second self" which might

be the informant or simply a metaphor for the unwanted transformation that takes place during academic scrutiny. Min and deSouza were photographed in "ethnically coded tourist attractions" around their home base of Los Angeles, and in punning sites such as a car rental agency labeled "domestics & exotics." In an act of comradely homage, they are shown with Fusco, and in another they pore over anthropology books (with James Clifford's influential *The Predicament of Culture* prominently displayed).

The installation component of *alter idem* (at Camerawork in London) was centered on a tent in a dark room (a camera oscura), which the viewer explores with a flashlight that might represent the searching beam of "education" or "discovery" or

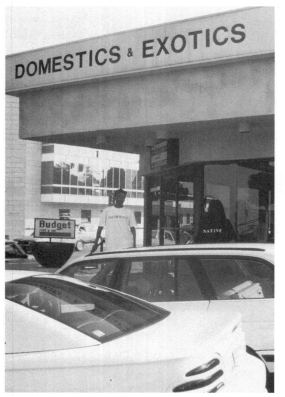

a glaring destruction of privacy. The tent was a collage of images of artists and anthropologists at work in cross-cultural contexts. The gallery's walls were lined with double "negative" photos (content and form) of native subjects, a comment on the location of power: "Ownership of the image and therefore of the subject lies with ownership and control of the negative." The viewer was made to feel the fragmentation of identities that results from such invasions, and to consider them from the positions of both guide and object of curiosity. Handwritten field notes in which ethnographers expose their own biases are contrasted with more formal texts, just as texts are contrasted to images as sources of information. The "performing personae" of the title are not merely the artists, but the "natives," the informants, the anthropologists, and the exhibition viewers as well. No one escaped their turn on the world as a stage.

A younger pair of collaborators, photographers Andrea Robbins and Max Becher, (see pp. 89, 121), have specialized in cultural and geographic anomaly, reflecting their own senses, since childhood, of a temperamental dislocation in America. Their focus is what might be called montage places— sites where extreme dislocation may be obvious or may be nearly invisible. Their finished product is often a series of postcards; early work dealt with the incongruously classical bank buildings built by foreign interests in precommunist Havana, as

Yong Soon Min and Allan deSouza, *alter idem/ performing personae* (detail), 1994, slide projection/chromogenic print. This was one of fifty different images projected in an installation at Robert B. Menschel Photography Gallery, Syracuse University, Syracuse, New York, in 1997, each depicting the artists enacting roles of "native" and/or "informant," and sometimes wearing safari hats.

markers of the history of capitalism and of architecture as a structural reminder of the past, even when its contents have been transformed. In 1991, Robbins and Becher traveled in Namibia and Zimbabwe, looking for similar artifacts of the colonial past during a moment of independence. They included, for instance, the Great Zimbabwe ruins (ca. 1400), with a text noting historic attempts by Europeans to endow these impressive and clearly "advanced" remains with a more "civilized" pedigree—Phoenicians, for example, or "mysterious" others rather than the local Shona people. Another reverse tourist site was the decidedly surrealist town of Luderitz, Namibia, built when the area was German Southwest Africa. European-style buildings perch in barren desert on the edge of the Atlantic, hundreds of miles from any other town, apparently dropped from the sky in the vast reaches of sand. A nearby contemporary colonial diamond mine, they note slyly, "is being preserved in a state of 'controlled decay' as a national historic site."

In the United States, Becher and Robbins have photographed the town of Holland, Michigan (a classic example of tourist entrepreneurship and transculturation in its clean, graceless appropriation of the cultural impedimenta). In their 1993 series on a fifty-four-year old western theme park in Arizona that was originally a movie set, they remark that "Old Tucson is neither 'old' nor 'Tucson,' but it is a kind of historic landmark generated by cowboy/western movies. Thousands of tourists visit Old Tucson each year and its filmic spaces have been visited by millions worldwide. It exists as a familiar location for the mythification of the nineteenth-century settler and, by extension, the twentieth-century entrepreneur free of ethical burdens." (In 1995, Old Tucson burned down, and insurers were still trying to "put a price on the losses" of John Wayne's movie wardrobe

and the other "historic" props and costumes; while the "attractions" were closed, the gift shop remained open and the tourists kept coming.)

Robbins and Becher concentrated on the irritatingly "new antiquity" of the set, making clear by their straightforward depictions exactly how fake this reality is, through contrasting patches of "worn" adobe with shiny new tile roofs and flagstone walks or pointing out an unashamedly "aged" trunk. Their pictures of Old Tucson are studies in illusion (what works in a movie doesn't work in the flesh) and in what tourists are willing to believe. Their most bizarre subject is visitors at the Oregon Vortex—"a circular area of about 163 feet diameter in which strange phenomena occur," where compasses and light meters behave erratically and people seem to tilt at an angle, sway back and forth, or appear measurably smaller on the left side than on the right. "We are drawn," write the artists, "to places where there is a shift between location and convention. What comes through in this disorientation is that things, places, and people not only change according to context but reveal parts of themselves as well." Two recent series of their work deal with the New York, New York casino in Las Vegas and the devotedly "authentic" German "Indians"—fanatical imitators of Native American cultures.

The tourism touted in travel agencies and trade magazines escapes the glancing blows inflicted by critical art, which remains caged for the most part in academic and art world arenas, despite the fact that tourism is a prime issue in local politics and well-reported in local papers all over the United States. However, a loose group of San Diego artists have for a decade now brought the artist's skills to bear on combatting the image of their city as "America's Finest," and they have done so within the public domain. Urban tourists may notice public art more than local residents, but when it

gets a barrage of media attention, everybody notices it. Controversy has been the strategy, beginning with David Avalos's 1985 public art work *San Diego Donkey Cart* (p. 21). When it was installed at a Federal courthouse, it was censored, purportedly for reasons of public safety, but pretty obviously because the cart—a takeoff on a standard Tijuana tourist photo set—shows a Mexican immigrant being frisked by the U.S. Border Patrol, and is exhibited in a pen of chain link and barbed wire. In 1988, Avalos, Louis Hock, and Liz Sisco raised a new furor with their back-of-the-bus poster project: a photo-montage of a pair of handcuffed hands next to a gun (an "illegal" being nabbed by *la migra* at the border), and next to it hands scraping a dirty dish and reaching for a doorknob over a *Maid Service Please* tag. The text demands boldly whether "America's Finest Tourist Plantation" wouldn't be a better way of describing San Diego than its official slogan, given the

David Avalos, Louis Hock, and Elizabeth Sisco, *Welcome to America's Finest Tourist Plantation,* **bus poster, 1988.** In the press release the artists sent out to announce this public art piece, they explained their motives: "Assume that there is no such thing as public space in San Diego. The few plazas that lie dormant before their corporate towers await an 'art' at the service of public relations campaigns. The city fills its space with work that buffs its image as a fitting housekeeper for tourist attractions...." Given the city's hostility to public art, public artists "will increase their chances of survival by making that target a moving one."

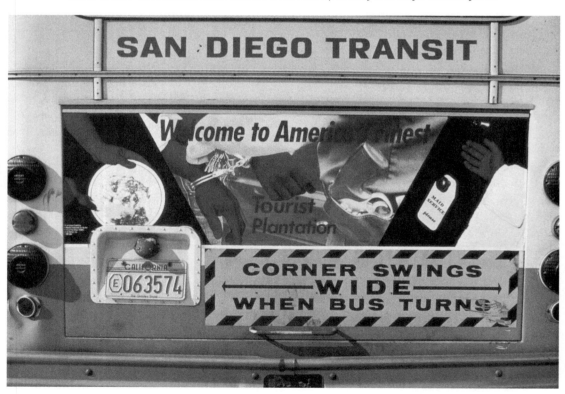

exploitation of undocumented workers in the hotel and other industries on which the tourism industry depends. The issue the artists raised was debated far past the already-considerable number of people who saw the hundred bus posters, since opponents and the media took up the battle and gave them more publicity than is received by most multimillion-dollar blockbuster museum shows.

In 1990, Hock and Sisco, this time with Deborah Small and Scott Kessler, struck again, receiving more press for renting space on twenty-five bus benches to ask "America's Finest?" The words were accompanied by seven silhouetted figures modeling bulletproof vests to join the campaign against San Diego's killer cops. Tourism again was the artists' target because it represents a vulnerable point in the city's PR anatomy. The artists have stated their intention to "connect local history and the mythological tourist landscape," to "create collaborative events within the context of San Diego's ongoing civic narrative," exposing it as a "site for both recreation and conflict, for transnational industrial development just south of the border and cardboard villages in the city's canyons, for multicultural rhetoric and English-only laws, for amnesty provisions and vigilante violence against immigrants, for promotion of culture as a tourist attraction and censorship of public art and expression."

Finally, a recent collaborative public project by Kristy Krivitsky and Brant Schuller called Site-Seeing took the form of a "tourist brochure" distributed free at thirteen Ohio Travel Information Centers during the summer of 1998, which could reach over a million travelers. The straightforward text about tourism is offset by two ambiguous color images (a flower? a traffic signal?). The five basic questions are "Where are you going? How do you get there? What are you looking for? Who lives there? and Why did you take this?" After an ingenuous opener ("Welcome... are you new here?") the text gets down to brass tacks, asking the visitor to consider "the implications of pollution or loss in social contact generated by automobile travel compared to other modes of transportation. Or, consider the economic and material differences between you and the population you are navigating through and the impact your visit has to those individuals. Or even, consider what has been exploited in a particular region to draw you there in the first place." There is a happy ending: "So sit back and enjoy the ride. Just remember to keep your eyes wide open..."

IT MAY BE THE THINGS we don't see, the surprises we expect but never receive that make tourism such a poignant affair and prime fodder for artists in particular. Or the fact that despite the socially provided frames we all see different pictures. A former student once told me that when his family traveled, no cameras were allowed. His mother, an artist, insisted that each night the whole family draw what they had seen, over and over. "Did it look like this? Or this?" The result was sharpened eyes and a collection of drawings of a trip from different personal viewpoints, like a *cadavre exquis* of landscapes. The jolts in the tourist experience, the glue and edges of the collaged cuttings, can be smoothed over into illusion, but discontinuity and incongruity remain at the core of all tourism. If, as Dean MacCannell contends, "all cultures are composed of the same elements in different combinations," and "sightseeing is a ritual performed to the differentiations of society," the possible combinations could go on forever. Given the limitations of tourism as we know it, that would be a real surprise.

SEDUCTION AND HYPERBOLE

MOST OF US LIKE to be seduced. Few of us like to be fooled. Seduction is by definition a relatively slow and sensuous process. Hyperbole is hit and run. The two are as different as sun and moon, or sunset and moonrise in the cosmology of tourist literature.

Sunsets, ubiquitous in the visual commerce of travel, do not connote an end (unless it's the end of "a perfect day") but, rather, a beginning. The golden glow holds out prospects of luxury and nocturnal romance, candlelit meals and bed, preferably not enjoyed alone. Dismiss that

nagging reminder that some dramatic sunsets come courtesy of melodramatic radiation and industrial pollution.

Tourism is about desire—desire for change, but also a more sensuous desire to become intimate with the unfamiliar. The full moon represents fulfillment of desire, but also its unattainability. Although popular in photography competitions, the moon is not found in tourist ads as often as the sun; perhaps because its distant chill implies possible failure. Sunset and moonrise combine seduction and hyperbole. The sunset

amazes with blazing color, the moon awes with the enormity of its distance, its absence of warmth. Both represent transitional moments before illusions crumble and things "don't work out," before the vacation ends and reality pounces—moments as emblematic of tourism itself as its dependence on desire for the different, the exotic, the other.

The exotic other is most often female. Gender joins race on the manipulated bottom line of tourism. Seduction is horizontal, hyperbole vertical. Lands to be conquered (or just "toured") are described as women's bodies, a convention introduced to this hemisphere by Columbus. In pure imperialist prose, blessed by long frontier traditions of "subduing" "virgin" lands, historian Samuel Eliot Morrison once celebrated the moment when "the New World gracefully yielded her virginity to the conquering Castillians," ignoring those native women who resisted rather than sinking gratefully to their knees.

The identification of women and earth as the objects of "sightseeing" is rampant in tourist advertising, where, thirty years after the women's movement made a case of the insults, women (or their bodies) are still consistently used to portray "desirable" destinations. Conventional sightsee-

Barbara Jo Revelle, from *Consuming Mexico* series, 1995-98, C Print. "I'm interested in the tourist because I have so often been one," writes Revelle. "Can't do it innocently any more... What is it? What we think we desire, what we call 'fun,' the spectacle and all that stuff and also *how* one culture consumes another's. I am particularly interested in the relationship between tourists and the people making their living from the tourist industry" (letter to the author, March 1998). Revelle's pictures, like this shocking image of an affluent white woman imitating the hairstyles of those who serve her, are often matter-offactly, even joyfully, terrifying.

ing resembles (and often includes) girl-watching. Lazy, sensuous experience (seduction, the mermaid) and hard-nosed adventurous experience (hyperbole, the fish tale) are both embodied as male goals in female flesh. Rebecca Solnit has written with acerbic wit of the parallels between photographic pinup calendars featuring women and those featuring nature. Both wallow in an uneventful status quo, "a stale vision of delight," undisturbed by rape, death, violence, or change.

Such approaches are especially but not exclusively true of tourism in the tropics, where the models can be photographed almost naked. The hotter the climate, the hotter the image. However big their smiles and red their cheeks, snow bunnies can't compete with mermaids. Nor can "civilized" elegance compete with "primitive" complaisance. Risk and danger are also seductive. A man trapped by a wily woman may "go native."

Seduction in tourist literature is not the robust variety. It is coy and prurient, dependent in its politest forms on charm, the sugar (and salt) in the come-hither recipe. Charm for the tourist is the "good wife"—restful, undemanding, inviting you in for tea and scones or a chintzy daydream. I'm as ambivalent about these offerings as I am about tropical hedonism. It's a rare bed and breakfast, for instance, that doesn't drown its beloved clients in syrup. When you're staying one night it's too much trouble to sweep all the porcelain figures off the mantle, stuff all the little baskets of dried flowers under the bed, fill the closet with the twenty extra pillows and two layers of curtains, and finally fling open the windows to enjoy the garden. (There isn't time to topple the leprachauns out there either.) You can lie back with a good novel and escape from your escape. When you're tired enough, the tarted-up surroundings and aura of social control and con-

formism can be disregarded, and the clean down comforter, matching pillowcases, fuzzy towels and hot shower are downright pleasurable (though I personally like my charm a little under-done and rough around the edges).

I have plowed through piles of travel maga-zines with kind of a dead eye. The manipulations and givens are so obvious they barely lend them-selves to satire or analysis. There is little visual or even textual differentiation between advertise-ments, or between advertisements and feature articles. Now and then I find myself with a toe in the trap. There are places I'd like to go if… If I had endless time and money. If I weren't so fascinated with my home turf. If a compatible traveling companion were free and solvent at a time when I was too. If I could be seduced by the hyperbole.

We don't often look closely at advertisements. They are a familiar part of our culture and we think we know how to read them at a glance, how to push back and untangle their tentacles. But when we do scrutinize them, we find an art form as surrealist as travel itself, even when the effect is unintended. An ordinary tourist ad for Tobago, for instance: captioned *sunshine with scattered showers*, it shows a white couple sitting next to a jungly waterfall with an anachronistic wooden steamer trunk at their feet. (Pandora? abun-dance? hidden treasure? hidden pleasures? the advent of colonists?) If the trunk implies vagina or virginity, it is the man who is dressed in white, sheltered under a white beach umbrella as he inexpressively fondles the calf of the woman perched at his side. Her pose is simultaneously prim and abandoned. She sits on a red towel in a skimpy blue bathing suit, head back in exagger-ated laughter, balanced on a rock just above him, her legs placed neatly on either side of his torso. The ad copy reads: *In Tobago, Nature is in balance, as well as in abundance.*

The surrealist or montage-like effect of this tableau is augmented by the way the woman's scale is curiously smaller than her partner's, as though she had been digitally inserted into the picture. The collage aesthetic is reinforced by the fact that they are opposites juxtaposed: he is stiff, she is loose. He, like the waterfall, is bridally white and pure; she is sinfully colorful and exuberant. In addition, it is the "beach-like" interior of the island that is being promoted. Inside/outside is a favorite binary of the tourist ads, with all innuendoes intact.

In an amusing analysis of America's token female monument and tourist goal, the Statue of Liberty, Dean MacCannell reflects on the per-haps subliminally gendered implications of "getting inside" Lady Liberty—mother or whore, a "libertine who takes on all comers." In this case, of course, getting in has special implica-tions for the immigrant enduring the rites of passage at Ellis Island. MacCannell points out that Liberty is a European immigrant herself. Neither her image nor her inscribed words make sense to those who were brought to this country by force or came by sinking boat or were forced to enter in the false bottom of a truck only to be deported.

Even in the sun, sand, and sex category of tourism, not everyone is looking for the same thing. A feminist nature lover might enjoy Puerto Rico but never get there because she is turned off by excessively gendered ads focusing on minus-cule bikinis—designed, as the name implies, to blow men away (but perhaps unintentionally blowing many women off). An experienced trav-eler's eye may be caught by a luscious photo of rolling hills and an old stone inn, but s/he will do some homework before falling for it. Finally, after the initial pictorial seduction, people flock to places not because of their beauty but because

of their promise. Expectations are high, but they often have less to do with what the place itself will offer in terms of new insights into one's own or others' lives than with what is lacking in the potential consumers' lives—something advertisers all too skillfully exploit. For some it's solitude, for others company.

As tourists we are susceptible to promotional hyperbole because we share the fantasies, and good copywriters know this. It's like a new romance: unwilling to admit our own manipulation or exploitation by larger and more powerful concerns, we go headlong down the beaten path to disappointment. Like sex, tourism is based in experience, juxtaposition, and contrast. Beauty rather than truth is the key word, and the eye of the beholder is the unpredictable key. Truth would instill too many doubts. Travel magazine writers can be witty and self-deprecating about minor failures and humorous encounters, but the trip from hell to hell is generally reserved for "literature," where irony is permitted to deflate both the seduction and the hype for a far smaller and less impressionable audience.

We think we know what is being sold. But as Judith Williamson pointed out in her classic 1978 book *Decoding Advertisements*, "they are selling us ourselves.... instead of being identified with what they produce, people are made to identify themselves with what they consume." Williamson dissects an ad for Thompson Winter Sun tours that is headed *When Were You Last Yourself?* If you "break out" with a Thompson Holiday, you'll "hardly recognize yourself." She interprets it through the lens of the French psychologist Jacques Lacan, "in terms of traversing the distance between you and the 'real you'— actually going off, spatially, to find the 'lost' Self." But this ad can also be seen as yet another example of the inside/outside syndrome.

Williamson points out that in most advertisements, the source is invisible, undefinable. There is no face or voice, but "a space, a gap left where the speaker should be... we are drawn to fill that gap, so that we become both listener and speaker, subject and object." (Artist Barbara Kruger has captured that Big Brother voice, with her questions and declarations that come down on contemporary media hypocrisy like the hand of God.) Our ambivalence toward these ads, our vulnerability to targeted fantasies, may stem from the ease with which we slip or fall into that gap (or even into The Gap).

Sexual tourism from the United States to other countries is a growth industry. Men are encouraged to join up in order to make their spouses angry, or because they don't care for American women, or "to encounter different types of women." Sex tours advertise "girls" who are "available," "affordable," and "an amazing variety of female bodies, faces and personalities." The industry considers its services "nothing more than mom and pop stores," just another kind of cultural tourism. Artists Coco Fusco and Nao Bustamante have created a performance piece called STUFF that combines the fast beat of a musical show with an investigation of the cultural myths linking "Latin women and food to the erotic in the Western popular imagination." The two artists/performers—one from Cuba, one from a Chicano immigrant family—weave their ways through multilingual sex guides, revolutionary references to Chiapas, fast-food menus, hip-gyrating dances, and bawdy border humor. While mingling with and drawing in the audience they subvert notions of cannibalism "as the European colonial's fear of the indigenous other... as a trope for Europe and America's ravaging of Latin America's resources, and, finally, as the symbolic revenge of the colonized who feed off the colonial."

Nao Bustamante and Coco Fusco, *Stuff,*
performance, 1996-1998 (photo: Hugo Glendinning).
Bustamante is Cuxtamali, "Precolumbian goddess
who invented the recipe."

THERE ARE TWO MESSAGES conveyed by
the female images in tourist ads. The first pro-
mises a place to "forget oneself," to rev up or
solidify a relationship by isolating it, by becoming
"foreign." The second depicts the woman alone,
waiting, like the place itself, to be "discovered."
Women in ads are often seen not only *on* islands
but also *as* islands—lonely, alluring curvilinear
skylines waiting for invasion. The island is itself a
symbol of escape, isolation, distance from reality.
Artist Karen Atkinson and writer Andrea Liss, in a

deceptively pretty little artist's "guidebook" called
Remapping Tales of Desire: writing across the abyss,
cites the texts of two 1991 tourist brochures. "An
intimate hideaway on an island for your every
need and desire.... Discover virgin beaches and
breathtaking tropical scenery," reads the first. (Is
breathtaking a euphemism for orgasm?) The
second says: "Refined. Laid back. Waiting just for
you. Impeccably beautiful." Atkinson's multi-
faceted project began in 1989, when she was
researching the concepts of discovery and tourism
and "kept running across the same language used
in both areas." In order to call attention to the
"occupation of feminized territory" throughout
history, she premiered the first version in 1992, as
part of the counter-quincentenary of Columbus's
arrival in the Americas.

Male and female tourists have inevitably
dissimilar experiences no matter where they travel.
Men are afraid of being "taken in," of waking up
with their wallets gone. Women feel more physi-
cally vulnerable. The protective padding provided
by a male escort or group tour is removed, and
resistance to stereotype is exposed. The woman
tourist is not insulated from what she tours. Even
as we are watching "the natives," we ourselves are
being watched. Voyeurism is tourism's modus
vivendi. The two-way gaze provides an ambivalent
bottom line. Such travel is adventurous indeed.

I've traveled solo a fair amount, with a modest
situational adventurousness (camping alone,
setting out on foot to see the Inca monuments
around Cusco, flying with a bush pilot to Cape
Laura's painted caves in Australia, or braving a
local downtown hotel in San Salvador's worst
days). I've always been an avid admirer of those
truly adventurous Victorian women travelers for
whom the wilder, lonelier, and harsher the land-
scape, the fewer, stranger, and more hostile the
populace, the better. They tended to be middle-

and upper-class Brits, driven to mad and incredible feats by sheer confinement, by a major compulsion to escape humdrum lives, and by their own society's disrespect for women's potential. Daisy Bates, cooking mealie cakes and carrying an ancient aboriginal man on her back across the outback; Isabella Bird riding alone through the winter rockies with only a light coat and defending a romantic desperado; Alexandra David-Neel, disguised as a Tibetan pilgrim crossing the Himalayas; Marianne North, blithely sketching botanical wonders on several continents. Their stories remain riveting models for modern traveling women.

Photography has seldom captured the exhilaration of such experiences, but one great protofeminist photograph—Ruth Orkin's 1951 *American Girl in Italy*—captures their ambiguity. Head up, eyes down, both proud and distressed, a young woman runs the gauntlet of ogling, cajoling, hooting men, one grabbing his crotch. (This detail was airbrushed out when the picture appeared in *Cosmopolitan* in September 1952 to illustrate a silly article on women traveling alone.) Six years later, when I was twenty, a tourist in Rome fed up with the endless pinching and whistling that distracted me from seeing what I'd come to see, I finally lost it and pushed away an old man who was pestering me in the catacombs. He fell down, and the Italians present turned on me as a batterer of the elderly. On the other hand, when I was in Naples around the same time (having been warned that if I thought the *northern* Italian men were bad…), I had a wonderful time sketching on the waterfront, talking to the fishermen, going out on a sailboat, and (yes) watching the sunset from the crest of Vesuvius with a courteous pickup who was as interested in speaking bad English as in my body language. Such nonconforming experiences are inherent in active tourism, but unfamiliar to those who travel

Karen Atkinson, *Remapping Tales of Desire,* detail of installation, 1991-97 (photo: Karen Atkinson). This work has found several different formats: a large installation work, a slide audio piece, a performative lecture with slides, and a "guidebook" with texts by writer Andrea Liss.

passively, as impervious to opportunity as if they were always looking out of the windows of a bus.

At the same time, it is difficult to travel without disturbing reminders of the power relations that become starkly evident when different groups of people intersect in one space. Feminist geographers have begun to explore women's mobility in space, issues of exclusion and intimi-dation, private and public space. Women moving freely in the world today confront a whole new set of cautionary tales. Spatial structures, behavior patterns, and most relationships are inevitably changed and charged. Women traveling alone or with other women in unfamiliar places had better be aware of cultural codes and customs. (I recall accepting an invitation to dance a *bolero* in

Ruth Orkin, *American Girl in Italy*, 1951, black and white photograph (photo: copyright 1952, 1980 Ruth Orkin; courtesy Mary Engel, Ruth Orkin Photo Archive, New York). When this famous photo of a young American woman braving a gauntlet of harassing men in Florence was published, the caption read in part: "Ogling the ladies is a popular, harmless, and flattering pastime you'll run into in many foreign countries...." The photographer was only twenty-nine years old herself when she took this picture, and knew the experience well. The model, Ninalee Craig, then an art student, has since explained to feminists that she was not afraid of the men but was pretending she was Dante's Beatrice "with great dignity to uphold. There was no danger because it was a far different time." It was not, as is sometimes said, a setup, although Orkin did ask the men not to look at the camera while she took two rapid candid shots.

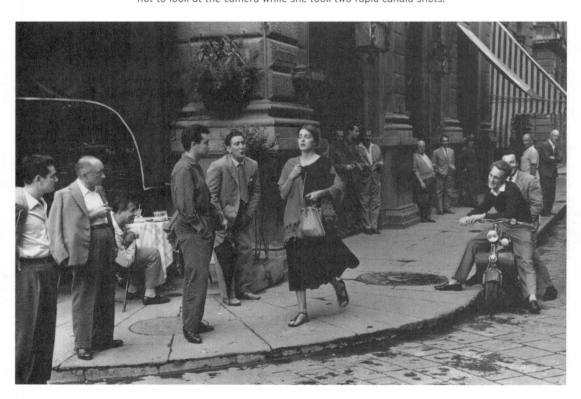

Nicaragua and finding it an uncomfortably intimate experience. I was belatedly informed that acceptance to partner someone in this particular "slow dance" often implies acceptance of a lot more than dancing.)

Historically (in most written histories, anyway), men have traveled for conquest, for war, for adventure, at times for penance, "penetrating" new spaces. Wives and lovers have stayed home and waited to "receive" their men (today they may accompany their spouses on business trips or go off on vacations of their own). The salutary exceptions were those extraordinary British traveling women and New England ship captains' wives, whom fate sometimes transformed into captains or navigators. (Their counterparts today might be the all-women groups climbing Everest, and sometimes dying there, or venturing into the wilderness, down wild rivers, or, more modestly, Outward Bound on solo searches for independence.) How-

Ellen Zweig, *She Traveled for the Landscape,* a performance at the Giant Camera, San Francisco, 1986 (photo: Michael Shay). Marianne North (British, 1830-1890), who inspired this piece, traveled around the world painting flowers and landscapes, then wrote about her travels in *Recollections of a Happy Life.* This group of nineteenth-century travelers could be seen on the screen of the Giant Camera, where an audiotape played. Zweig was inside moving the lens system to frame and follow the performers.

ever, most nineteenth-century women—unsung, often unlettered—did not travel for adventure, but adventured for survival. Their tales have just begun to surface in the last few decades, from the native women who traveled the continent before the advent of Europeans, to the women who arrived in New England in the seventeenth century, to the westering women of the eighteenth and nineteenth centuries, to the "Okies" of the Depression, to the immigrants and farm workers of today.

One of performance artist Ellen Zweig's works from the mid-1980s on Victorian women adventurers juxtaposed a nineteenth-century woman with a steamer trunk against a modern traveler with her suitcase and Walkman (the latest in painless escorts). In *She Travelled for the Landscape*, Zweig's performers in Victorian dress posed in tableaux near San Francisco's seaside Cliff House, where two audiences perceived them very differently: those who came for the performance saw them framed and projected from inside the Giant Camera (a room-sized camera obscura); the "outsiders"—generally uninformed and uncurious tourists—took this peripheral and unframed spectacle in stride.

The piece's central focus was a recreated Marianne North, who had sketched on the same site in 1876. An earlier version, with Zweig's own mobile camera obscura inside a stagecoach in Houston, took the audiences into a kind of "time machine." (Two small children understood immediately that "something was happening with time, that time was being stretched.") In another work, *In a Barrel of Her Own Design*, Zweig commemorated Annie Edson Taylor, the first woman daredevil to go over Niagara Falls in a barrel, in 1901. Zweig described a related piece—*The Lady and the Camel* (inspired by a nineteenth-century photo of a wasp-waisted woman standing at a haughtily detached distance from a camel, but holding its reins)—as being "about the dark side of the Victorian lady traveler, her invasiveness, her alliance with imperialism and colonialism, her blindness to the cultures through which she travels, and her obsession with her own power when looking at the Other." Within the timewarp provided by this series of performances and their disjunctive, poetic scripts, women venturing out, taking off, taking the plunge, taking control, could meet. Zweig's series also offered ways of thinking about photography, posing, setting up, creating backdrops, and inventing places—the mechanics of tourism.

There was a tremendous amount of advertising analysis in the fields of feminism and media studies in the 1970s. Though these criticisms were groundbreaking at the time, contemporary theory has become much more nuanced and sophisticated. Yet the tourist industry has not been listening to any of us. By subverting both seduction and hyperbole, and by replacing them with models of no-nonsense independence, Zweig, Atkinson, Fusco/Bustamante, and other women artists who have dissected the subject of travel from their own viewpoints are offering valuable alternatives to the golden glow of sun and moonshine.

SANTA FE'S TRICULTURAL TRIP

*This constellation of arts and architectural revivals, public ceremony, romantic literature
and historic preservation together have created what I call the myth of Santa Fe.
It is a myth in the pejorative sense of the word—a half truth, something made up.
But... it is also a myth in the honorific sense of the word—something that
provides a unifying vision of the city, its people, and their history.....—CHRIS WILSON*

"**W**hy are you moving to New Mexico? Santa Fe is *over*," I was told six years ago, when I moved to a tiny village twenty-five miles away from the legendary capitol of the southwest. Actually, I resisted New Mexico for two decades, even as it tugged at me, even as I spent more and more time visiting friends there, because I didn't want to be "one of those people who move to Santa Fe." I didn't want to live in a subdivision behind an adobe gate. (Whatever made me think I could afford one?) Like the movie stars and the new-agers, if for different reasons, I was attracted by the notion of three cultures coexisting. But I was not so naive as to think that Natives, *hispanos* and Anglos coexisted "in harmony," as the tourist literature would have it.

My first visit to Santa Fe was in December of 1972. The dirt roads near the center of town made a strong impression; no eastern city had looked like this for a century. Armed with minimal funds, sleeping bags, and a book of Pueblo Indian poetry to read out loud when we weren't gawking at the scenery, I was traveling with an artist boyfriend and my eight-year-old son. We had come for Shalako at Zuni and the Rio Grande Pueblo Christmas dances. We were into the outdoors (very cold camping in Chaco Canyon) and indigenous cultures. Ruins were on top of the list. I knew close to nothing about *hispano* history or modernist Indian arts and there was little in sight to offset my ignorance.

We came back whenever we could. On a later trip, trying to find a field for camping on the outskirts of Santa Fe, we noticed a lot of new houses that made such an enterprise impossible. The process that cultural and environmental historian William deBuys has called "the metastasis of Santa Fe" had begun.

By 1998, everybody—natives, old-timers and newcomers, outsiders and insiders—seems to agree that Santa Fe has changed for the worse in the last twenty-five years. The "City Different" is now too crowded, too expensive, and either vulgarly cliché-ridden or so tasteful as to be tasteless. (The howling pink coyote is endangered, but the humpbacked flute-player and seed-carrier Kokopelli thrives). In May/June 1997, the cover of the *Utne Reader* read: THE 10 MOST ENLIGHTENED TOWNS IN AMERICA (AND WE DON'T MEAN SANTA FE). Art critic Dave Hickey writes that he prefers his hometown of Las Vegas—the "real fake"—to Santa Fe's "fake real." Those who prefer any kind of traditional beauty to flash have been made to look like snobs, retros, and even reactionaries.

"Fanta Se" or "Santa Fake" is easy prey. King Philip II of Spain set the tone as early as 1573 when he laid down the law for new world settlements, mandating plazas, grids, portales, and architectural homogeneity "for the sake of the beauty of the town." The "Americans" arriving in the 1840s were often horrified at the crouching mud houses and "crude" culture. They introduced the righteously vertical building until 1912, when

previous page: **Robert Haozous (Chiricahua Apache),** *Cultural Crossroads of the Americas,* 1997, corten steel and concertina wire, 29' x 25'. This sculpture stands (but may not remain) on the campus of the University of New Mexico at Albuquerque, subject of a major public art controversy because the wire at the top was not included in the original design (although the contract gave the artist what appears to be plenty of leeway for such an addition). Its cultural content is not overtly at issue, but the razor wire highlighted the artist's intentions: a critique of the Anglo technoworld and homage to indigenous wisdom. As of this writing (September 1998) it looks as though the parties will settle and the sculpture will be removed.

The billboard-like work now stands along the old Route 66, and was therefore destined to be something of a tourist attraction. At the left are three figures with Aztec references (two standing on the plumed serpent Quetzalcoatl); the center is a pillar of smoke rising from a pyramidal form; at the right are a dollar sign, a pair of spotlights, McDonald's arches, the letters U.S., a cross, and the Statue of Liberty. In the foreground slumps a cowboy version of *The End of the Trail.* In the sky, jets hum and on the lower border, traffic roars.

The artist says the wire addition improved the work both in form (breaking the rectangle) and in content (emphasis on border crossing in several senses). "It's really about the border in our minds between responsibility and convenience," Haozous said of another piece on the subject. "We tolerate horrible things so as not to sacrifice convenience" (interview with Joy Waldron, *Southwest Art,* August 1992).

New Mexico became a state. Then, for tourism's sake, the forward-looking began to look backwards. They arrived at the Pueblo Spanish Revival style, and the slogan "City Different" was coined.

Santa Fe's homogenized architecture (eventually legislated in the "historical styles ordinance" of 1957, updated in 1983) has been the target of much ridicule. But it worked, if not flawlessly. In many areas, Santa Fe's charm remains intact, at least for those who did not know it well before the balance of the tourist tide was broken. What might have been worse is all too obvious in the sprawl on the edges of town where the architectural rules do not apply, where huge and/or tall houses with bright-colored roofs stand out like sore thumbs rather than melding into the landscape as even the ugliest of the "traditional" ground-hugging Santa Fe Style neo-Pueblos and territorials will do ("Surprise— it's really just painted stucco"). And for all its obsession with tourism, Santa Fe continues to resist expansion of its tiny airport and has no railroad (except for a tourist spur from Lamy, fifteen miles to the southeast).

I loved New Mexico in the 1970s, and I love it now, for all its shortcomings—such as the fact that it is home to 2,450 nuclear warheads, the most in the nation, a fact not mentioned in the promos. The "real Santa Fe" (subject of the latest tourism campaign) is changing as fast as the Santa Fake. While I "go to town" at least once a week and am still helplessly struck by its beauty in all weathers and seasons, I am also unpleasantly struck by the sprawl, the strips, the tourists, the traffic, the assembly line condos, the trophy houses perched hideously on ridge-tops, and the increasingly unavoidable presence of the arrogant wealthy (as well as the humbly worshipful) newcomer. Many native New Mexicans can no longer afford the rents, the prices of houses and land, or the property taxes. Everyone bemoans this fact and nothing is ever done about it. It is not a pretty picture, but it is placed in an awfully pretty frame.

Santa Fe hovers between the devil and the deep brown desert. An ironic local bumpersticker reads LESS TOURISM, MORE STRIP MINING; for some, anything would be better than tourism. But for others, tourism looks better than sprawl and the military/nuclear industry to a state that is forty-eighth nationally in per capita income, one of the highest in poverty, way down there for education and healthcare, and way up there for crime and highway homicides. Tourism doesn't demand an expensive infrastructure of schools, water, roads, etc. It brings jobs but not permanent population—except for those love-struck tourists who return to live here.

Historian Chris Wilson, worried about the bloodsucking impact of tourism and Anglo immigration on the vitality of the local culture, has called for ideas on how to combat "the trivialization of local cultures into tourist clichés and their denigration as second-rate by cosmopolitan intellectuals"; how to "harness tourism for community needs....to create a separate space, both psychologically and physically, where local communities can nourish their own myths and social lives." He wryly suggests public art as an antidote to the current adobe Disneyland, "challenging romantic history and tourist stereotypes," with, perhaps, "a gigantic bleached steer's skull [at Ghost Ranch], placed high in the air, in front of the red-brown landscape made famous by Georgia O'Keeffe." And along the lines of the pink flamingo or the black jockey—a lawn ornament that is a "cast concrete three-foot-tall tourist."

TRIPLE WHAMMY

Santa Fe is best known for cultural tourism, as an arts and archaeology center. Its biggest boast is that it is a delightful "tricultural" mix, unlike the rest of the union. The Museum of New Mexico embraced this term around 1912 as a keystone in a "fusion of tourism, civic identity, and romantic aesthetics [that] brought New Mexico regionalism to a mature form." The trivialized triculture remains paramount in every tourist promotion: for instance, a cute recent *Travel Holiday* article on shopping in Santa Fe recommends "One Saint, To Go" (tin-framed retablos for only $8.35), "Cuff It" (an antique Indian silver and turquoise bracelet, neither identity nor nation of the maker mentioned), and "Georgia On My Mind" (the O'Keeffe Museum shop). Yet the visitor's experience in Santa Fe tends to be monoculturally framed, while purveying the artifacts rather than the people, places, and lives of the two "other" cultures.

Adobe and Indians are the main attractions, but it is Anglo "civilization" and cultural efficiency that make them attractively familiar to the mostly white tourists. Within the rhetoric of the tricultural construct, however, Anglos are supposedly just another ethnic group, though admittedly not as interesting as the others, even to themselves. It's fun, but not high on the local recreational agenda, to watch the tourists in the plaza: the hippies just hanging and trying to look like they've been here all along; the middle class in their jeans, shorts, sweatshirts and sneakers; the wealthy bedecked in or in search of silver and turquoise, promenading to expensive restaurants in their new tight jeans and new tight cowboy boots and new cowboy hats and new velvet

Peter Woodruff, *Tourists paying homage to Indian artists,* Santa Fe, 1998.

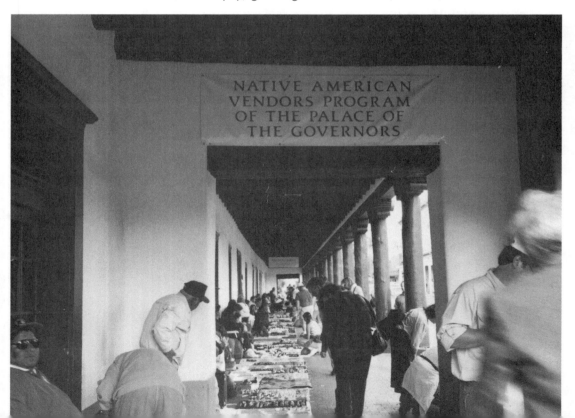

skirts—all looking for Indians to shoot (with the cameras hung around their necks), most toting a purchase or two. (This roster is truism rather than merely a cliché.) The strangest sight of all is when they line up under the portal of the Palace of the Governors, facing the seated Indian artists with wares spread on blankets before them. The tourists are shoulder to shoulder, heads bowed in homage, as though performing some strange ritual contra dance.

Hispanic culture is curiously both dominant and subordinate, despite the fact that the *real* "real Santa Fe" is better reflected by Latino than Anglo or Indian culture. The conflict is often internal. The general *hispano* population is for the most part poor, proud, underrated, undereducated, and underemployed. The "traditional" upper-class promotes a history based on pre-Enlightenment Spanish caste systems, a relic of the not-so-distant times in which the conquistadors and their descendants lived off the backs of the peasantry. "Aristocratic" content is emphasized; history is oversimplified, stereotyped, and fragmented. Chicano/a descendants of those exploited for centuries are now rewriting that history, but Santa Fe remains primarily "colonial" in viewpoint.

Only in the 1990s has there been any support for El Museo Cultural de la Santa Fe, which acquired an unremodeled space only in 1998 and may possibly present a broader picture. At the same time a grander New Mexico Hispanic Cultural Center in Albuquerque is being federally funded and southern New Mexico is weighing in with the proposed El Camino Real International Heritage Center—a drastically modern building cantilevered over the desert near Socorro as a "linchpin in creation of a 'cultural corridor' stretching from Las Cruces to Los Lunas, perhaps prompting more tourism in the southern half of the state along I-25—and a concomitant economic boom." All of this activity is belatedly taking place at a time when the balance of Santa Fe's population has tipped; the traditional *hispano* majority dropped to forty-eight percent and Santa Fe became for the first time in its history predominantly Anglo. (As then-City Councillor Debbie Jaramillo said in 1991, "We painted our downtown brown and moved the brown people out.")

Indians are unquestionably the prime drawing card for tourists. Few Native people live in the city proper. The outlying northern pueblos are places in themselves, totally unrelated to the city except for the institutions full of their artifacts and their chroniclers. (There are two museums and an anthropology laboratory-archive devoted to Indian arts, not to mention the expensive stores and Native vendors on the plaza.) But it has been a long time (over three centuries) since Santa Fe was a Pueblo town in anything but mystique and veneer.

The three cultures are supported and separated by two consecutive tiers of colonialism. The Native peoples find it hard to forget the Spanish invasion; the Spanish-speaking people find it hard to forget the American invasion; both appear powerless in the face of the ongoing Anglo invasion by tourists and newcomers. Although Anglos have moved here because of the area's history (a real estate booklet offers facts about history along with a glossary on "how to speak Santa Fe Style," how to toss off words like *banco, canale, farolito, portal,* or *viga*), many of them dismiss or blithely ignore it. Others actively study the history (or wallow in it as live-in tourists). Much is made (and marketed) of an indigenous "spirituality" in Santa Fe, but all three of its cultures are secularized. Virgin visitors (especially foreigners, especially Germans) perceive the Pueblo dances as performances "in

costume" rather than a legitimate religion and an integral part of contemporary life. The Loretto Chapel—built for nuns and featuring a "miraculous staircase" built against the laws of engineering by "a mysterious carpenter"—is now owned by a hotel and is a tourist attraction. Even art museums are de-spiritualized when they become tourist destinations rather than inner sanctums of high culture.

The armload of brochures found in the rack at the Santa Fe Convention and Visitor Bureau, for all their superficiality, hold out quite a range of local destinations—from prehistory (Bandelier National Monument), to early cross-cultural history (Pecos National Historical Park), to Spanish-influenced history (the Santuario de Guadalupe—"200 years of history in adobe"), to the eight northern Pueblos and their dances and casinos, to Canyon Road (garbed in pure Santa Fe Style commercialism as "the art and soul of Santa Fe") and its upscale counterpart, the new Georgia O'Keeffe Museum.

In the late 1990s, Mayor Debbie Jaramillo, elected on a "take back our town" platform, appointed a new tourism director and doubled expenditures for tourist advertising with award-winning ads that purported to "celebrate our culture instead of selling our town." The new promotion (still in place, though there is a new mayor) was as sappy as its predecessors, touting an "enchanting land of ancient cultures… where traditions live on." In a photographic style straight out of the 1950s, it features a little girl with a rag doll and a similarly costumed *hispana* awkwardly clutching a bowl of chiles. (The less romanticized hispanic man stands in the shadows, dressed humbly and holding a horse—perhaps a telling reflection of changing gender relations, or perhaps standard dependence on female as sales device.) The same picture in color,

framed differently, appeared on the cover of the official 1998 *Santa Fe Visitors Guide*.

From 1912 on, the most popular *hispano* component of tricultural tourism in New Mexico has been the September Fiesta's *conquistadors* and anything to do with the Spanish Colonial period (witness the new American Girl doll "Josefina," whose accompanying narrative tells of her life on a New Mexican *rancho* in 1824). The "Spanish" elite in New Mexico have traditionally provided folkloric reminiscences, distancing themselves, as Chris Wilson notes, from *mestizos*, *genizaros*, and *coyotes*, while a once younger, once radical generation of Chicanos emphasizes its mixed Indian and Spanish heritages. The quintessentially *hispano* villages of Northern New Mexico (Truchas, Trampas, Cordova and Chimayó in particular) are visited on the way up to Taos but hardly "entered." The beloved Sanctuario at Chimayó, with its beautiful reredos and ancient well of healing dirt, is a "destination" for both religious *hispanos* and cultural tourists. (I go there often but am painfully aware of the distinction between those praying and those prying.) Nowhere are visitors directed to the histories of the Mexican working class, the *mestizo campesino* or the impressive Chicano murals sprinkled around Santa Fe. Both the famed Indian Market (now run by the Southwest Association for Indian Artists, or SWAIA) and the somewhat overshadowed Spanish Market (both founded by Anglos) now have out-of-season counterparts. The more the Anglo population grows the more it is necessary to beef up the other two thirds of the touted triculture.

THREE DISTINCTLY "cultural" staples of Santa Fe tourism—Pueblo dances, El Rancho de las Golondrinas, and the Georgia O'Keeffe industry—offer three separate views and demonstrate the fallacy of tricultural conflation. My response

to all three is ambivalence. Their disparate characters reflect commercial manipulation as much as each culture's approach to its own "heritage" in New Mexico. It is rare to see *hispano* people (aside from relatives) at the Pueblo dances. The only Indian presence at Las Golondrinas is a "Navajo lady" occupying a weaving room which was actually the slave quarters for Indian captives. O'Keeffe was attracted to the *place* not to the people. Native and *hispano* people are unlikely to see themselves as outsiders see them, unless they have fallen prey to external propaganda. Anglos are unlikely to identify with Kit Carson or Georgia O'Keeffe. It's *all* foreign.

Of these three attractions, the Pueblo dances are probably the best-known, most sought-after, and least understood. As tourist events, the dances represent an uneasy and often tense compromise with the Anglo majority and with economic necessity. Except for open dances, or specific invitations and appointments, I personally avoid the Pueblos. It is simply too embarrassing and depressing for all concerned when outsiders wander through insiders' lives staring, although this is accepted tourist behavior. The Pueblo people who still live in their village centers rather than in outlying homes or HUD subdivisions are, heaven knows, used to it. Which doesn't mean they like it. The Pueblos are often closed without notice for ceremonial privacy or in retaliation for visitors' insulting behavior. Major dances can be closed for years (Zuni Shalako) or forever (Hopi Snake Dance).

Tourists cannot possibly comprehend what it is like to live in a place perceived as existing solely for scrutiny. "What happens to these people you are trying to grasp something from?" asks an exasperated Rina Swentzell, a member of Santa Clara Pueblo. "How can they live a normal life when twenty people a day come into their communities asking them why they dress like that, why they build their houses like that, why they live the way they do?... You say you want diversity, but the more you want diversity, the more you are destroying it." In the Taos Pueblo plaza (where, to provide an aura of the past, electricity isn't allowed), summer inhabitants leave doors open to the breezes. Some of the 300,000 annual visitors read this as an invitation to barge right in. Other Pueblos have similar experiences of "culture surfing."

Jemez tribal administrator Roger Fragua has said:

I've had people stop while my three boys are playing ball in the front yard and take my sons' picture. My question is what would happen if I went to Iowa in a van and stopped and took pictures of their kids playing out in their front yards? I'd be accused of being a pedophile or a kidnapper or whatever, because of the color of my skin.

The Pueblo peoples have responded in various ways. Jemez Pueblo, for instance, has adopted a closed village policy "due to lack of tourist facilities and out of respect for the privacy of those who live there." Nambé Pueblo runs the only native-owned and operated tour company in New Mexico. Picuris is part owner of Hotel Santa Fe. In 1990, the Indian tribes in New Mexico formed their own Tourist Association. Despite their acknowledged primacy as the state's major tourist attraction, Native people feel overlooked and underpaid by the State Tourist Association. Pueblos with no visitor center and no infrastructure are at a disadvantage. Tourists may buy inexpensive crafts and a fry bread taco on Indian land, but the real money is spent in the cities. Indian people are tired of tourists complaining because there are no restrooms, and they are tired of cars blocking the pueblos' narrow roads because there is no parking. In 1995, Taos, Sandia, Jemez, Acoma,

Juan de La Cruz, age 12, *Pueblo Plaza,* pen and ink, ca. 1995, from the book
Where There Is No Name for Art: The Art of Tewa Pueblo Children, by Bruce Hucko
(Santa Fe: School of American Research (SAR), 1996). This drawing is the product of a collaborative project
between the Pueblo communities of Northern New Mexico, SAR, and Hucko, in which students were
interviewed about their lives and perceptions of being Pueblo, making art, and the world around them.
Over seventy-two children participated. Hucko commissioned a drawing from Juan de la Cruz,
who was known for his sketching skills. Having been told it was ready, Hucko went to Juan's home
in Santa Clara Pueblo to pick it up. "When I arrived, his mother informed me that he was in his room finishing
the drawing. I was puzzled. 'I thought it was done!' If he was finishing it now it would probably be a rush job
and not look that good. I was beginning to feel disappointed. Juan came out and showed me the drawing
and explained that one of the neighbors (whose house is in the drawing) had just had a TV satellite dish
installed on their roof that morning and he wanted to include it. We had a good laugh. It's in there.
See if you can find it!" (Bruce Hucko, letter to the author, April 3, 1998). Sixty-five percent of the author's
royalties go to a Tewa Children's Art Fund to continue such work.

Tesuque, and Zuni Pueblos asked for money to build tourism services, preferably away from the village center so visitors could park and be shuttled in, as they are now at Acoma. The bill didn't pass the state legislature. Unemployment can reach 45 percent at the pueblos, but casino gambling has blurred the picture, especially for the few resolutely nongaming tribes. Some have considered boycotting tourism altogether until they are afforded a fairer cut of the state tourism budget. "We're happy to see other people share what we have," says Taos Lieutenant Governor Valentino Cordova. "But we would just for once like to see the non-Indian say 'we need them' instead of just 'you need us' and let's stop hassling each other."

It is not broadly understood by tourists that when the ceremonial dances are open to the public, these are not spectacles performed for the spectators' pleasure but religious activities they are allowed to attend respectfully. Although Indians are all too often imaged and imagined into "the past," these dances are integral parts of contemporary Natives' lives. (Tourists tend to be disturbed by "anachronisms"; dancers in sneakers and with cool teenage haircuts destroy the illusion of being in a different time as well as a different place.) There are now rules galore for visitors at Pueblo feast days and ceremonial dances. Photography is either forbidden or requires a permit (which is not cheap), but this is small recompense for the century in which tourists rudely interrupted ceremonies to get a good picture. Today visitors can be told in no uncertain terms where they may and may not wander, sit, stand. Strictness varies from pueblo to pueblo, event to event. Etiquette requires little talking, no shouting, no clapping, and no interference with the residents on any level. Experienced dance-goers cringe when tourists cheerfully plunk themselves down on lawn chairs belonging

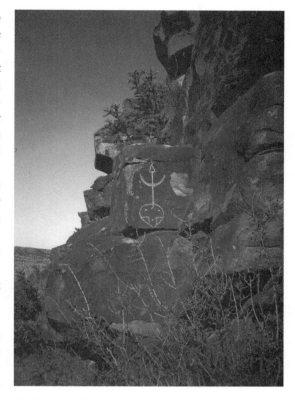

Galisteo Basin petroglyph, 1995 (photo: Lucy R. Lippard). Petroglyphs like this one in New Mexico, which is perhaps five or six hundred years old, have only recently been deemed tour worthy, although this site has been popular with Santa Fe residents for many years. (A tourist at Petrified Forest National Park in Arizona asked a ranger, "How come some people are allowed to graffiti on the rocks?") Most rock art is on inaccessible private land and is subject to theft and vandalism. The huge collection (some seventeen thousand individual images) at the Petroglyph National Monument on Albuquerque's western escarpment are under siege by a Congressionally sanctioned violation of national monument rules in order to let a highway run through the middle of the place, sacred to nearby Pueblo peoples. Such actions reflect the total lack of understanding of Native religion, which values the site as an integral whole.

to Pueblo elders, elbow their way through a local crowd to get a better view, shout across the plaza at each other, point at cute children and "quaint" sights, or barge into homes expecting to be fed. Ostentatious displays of "southwest" couture and old jewelry (pawn)—de rigueur in the early days of the Anglo invasion—now seem in bad taste. Yet Native courtesy is such that the respectful tourist usually feels tolerated, sometimes even welcome.

For many long- and short-time New Mexico residents, the Pueblo ceremonial dances have become a kind of addiction. We attend in a space that is neither that of the participants nor that of the tourists. The spiritual space surrounding the dancers therefore doubles as a performance space for some outsiders and as something in-between for those who are well informed about its content, who admire, empathize, or hold related beliefs. Attention to the pounding drums and intricate steps, invitations to the midday meal in Pueblo homes, allow for some personal entrance, fending off the depersonalization that comes when those participating by watching become merely an "audience." Visitors are drawn in, but not too far in. No matter how many dances one attends, one is always aware of hidden layers of meaning, which is, no doubt, one of the attractions. Dean MacCannell says "the best way to keep a cultural form alive is to pretend to be revealing its secrets while keeping its secrets."

MODEST MEMORIES

At El Rancho de las Golondrinas—"a living history museum"—there is no pretense of relationship to contemporary life. For the most part, this spacious two-hundred-acre semi-working farm represents an adamantly embraced if humble past. It represents the lives of the majority of *hispano* settlers, an experience still within memory for the elders. Upscale *hidalgo* culture is left to Santa Fe, to the handsome displays of artifacts, paintings, and silver at the Palace of the Governors. Las Golondrinas features instead an ancient *acequia*, *milpas* and farm animals. It was the site of the last *paraje* (stop) before Santa Fe on the long Camino Real from Mexico. The remains of early eighteenth- and nineteenth-century buildings have been restored, replicated, and augmented by additional more or less antique structures brought in from around the state (one building came from a movie set). The sixty-nine points of interest on the self-guided tour include a tiny schoolhouse, a *morada*, a grinding mill, corrals, churro sheep, a little church, a threshing ground, a weaving room, a store, a *campo santo*, a defensive *torreon*, many sheds, and some homes. The land and buildings are unpretentiously charming. Signage and amenities are kept to a minimum. Although the grasses are cut and the paths are smooth, some buildings are comfortably dilapidated and the surroundings are simple and unmanicured—a pleasant blend of "authenticity" and concoction. Alone beneath the giant cottonwoods, it is possible to pretend the past.

The three-hour tour I took of las Golondrinas was geared to a group of fourth graders from a small town in the western part of the state— mostly Anglo and Native American. Their attention spans held up well thanks to Francisco Apodaca, the engaging sixtyish guide in a poncho and leather hat. He based his spiel on personal memories of working on his grandfather's farm in Chilili. Culture didn't interest the kids much, but the animals did, and the place itself did. I'd expected to be bored and wander off on my own but I stuck with the guide because I was learning

all kinds of odds and ends about farming and local custom. A harsh way of life was casually referred to, but never elaborated. A cultural studies course the place is not, but should it be? It was a lot better than the theme park I expected—though at the height of the tourist season, the place is probably a madhouse. There are a great variety of demonstrations and events, music and games, weaving, shearing, cooking, and a newly introduced "gunfight"—an ominous intimation of serious Disneyfication.

Geared to education, las Golondrinas does its job of explaining how things worked back then, though a subtext—the creation of Hispanic class culture—is more disturbing. To judge from my tour (admittedly geared to grade school level) and the posted signs and brochures, the administration is less forthcoming about anything not entirely upbeat on "Spanish" culture, perhaps to placate Spanish speakers who feel left out of much of Santa Fe's lucrative tourist industry. Not all of the docents are *hispano*, but all of the workmen seemed to be. Past curators have been *hispano*, but none are at present. The supporting group, Amigos del Museo, is mostly Anglo, as is the board of directors. Despite the emphasis on humble living, intersection with other indigenous cultures is ignored. Anglos also take a

Miguel Gandert, *Musicians, El Rancho de las Golondrinas,* 1996, color slide. Gandert, a native New Mexican, is a well-known chronicler of cross-cultural phenomena in his home state; he has made an important body of work documenting the Comanche dances as they appear in both Native and *hispano* contexts.

narrative back seat, presumably because the historical period is more or less pre-1848. Yet it is Anglos who founded and for the most part are running las Golondrinas, and this is definitely an issue within the Chicano scholarly community. One can't help but wonder if the place would have a different character with more progressive *hispano* input and control.

POSTER GIRL

"God told me if I painted it often enough I could have it," said Georgia O'Keeffe of her "private" mountain, the Pedernal, or flint hill, west of Abiquiu. This often-quoted statement might have come from a nineteenth-century imperialist and is designed to dismay both the Native people who settled the slopes of the Pedernal and the Mexican-Americans who named it. O'Keeffe, who came to New Mexico to live in 1940 and stayed for forty-six years to embody the southwestern landscape, represents to the world New Mexico's Anglo "art scene" from the turn of the century to the present, although she spent little time in that milieu. People, especially women, still flock to the art colonies to have the O'Keeffe experience. The Georgia O'Keeffe Museum opened to much

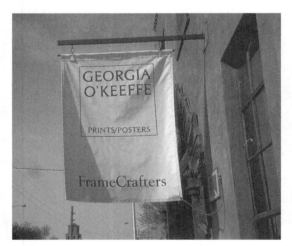

The O'Keeffe Industry, Guadalupe Street, Santa Fe, 1998 (photo: Lucy R. Lippard).

fanfare in the summer of 1997 (directed, briefly, by an expert on another Western icon—the former director of the Buffalo Bill Historical Center). A year later the O'Keeffe Café opened next door, featuring a photo of the artist stirring a stew. The museum joined the artist's house in Abiquiu as a tourist mecca and visibly boosted Santa Fe's appeal. O'Keeffe's seven acres at Ghost Ranch is newly open to the public. Signs in the nearby nature museum announce upon entry that this place has nothing to do with O'Keeffe (though you are shown how to peer at her former summer home through a telescope as part of a local geology display). Real estate ads for the area, however, never fail to mention that "Georgia O'Keeffe Country" is up for sale. She would have hated it.

There are three Georgia O'Keeffes: the artist, the woman (or the biography), and the industry. Although her predominant image in New Mexico tourist literature is that of a (not necessarily sweet) old lady dressed in black, art queen of the region, token powerful woman artist of the entire country and century, she is rarely discussed in relationship to any cultural group except her own. (Unlike Mabel Dodge Luhan, she did not marry into New Mexico.) A recluse much of the time, she was good at being a celebrity when duty called. An uneven artist whose glorious early work at times seemed curbed and literally desiccated in New Mexico, she has provided a cultural icon for the Anglo southwest, joining Kit Carson, Billy the Kid, Lew Wallace, Mabel Dodge Luhan and D. H. Lawrence. (At one point she said, "I should have

kept a diary because they are going to get my life all wrong.") Her works, which were juicily reproduced on annual posters for the Santa Fe Chamber Music Festival for twenty years, are perennial best-sellers. Although she adopted New Mexico relatively late in life (she was forty-two when she spent her first summer there and fifty-three when she moved here), she is more identified with the southwest than any other artist, male or female—and certainly more than any Native or *hispano* artist. The southwestern landscape is represented to the rest of the world by relative newcomers.

According to art critic MaLin Wilson, a long-time New Mexico resident who has written without blinders about the O'Keeffe myth, this canon-ization came about in part because of Alfred Stieglitz, "a passionate patron, famous lover, and demanding companion who was also a wily agent and promoter." She points out that O'Keeffe was a "great image maker," many of whose works are improved by reproduction, and that she is most popular in the United States because she is "primarily an American phenomenon—a symbol of boldness, individuality, success and passion." As well as being a reluctant hero to feminists from 1970 on, O'Keeffe is also heir to our esteemed "pioneer" image—a single woman, raised in the west, having taught in Texas and conquered the New York avant garde before moving to mysterious New Mexico.

NEAR MYTH

These three cultural phenomena—the "primitive" dances, the nostalgic farm, and the famous artist—span the ages for Santa Fe's touristic enterprise. Indian people, especially at ceremonies, and despite their efforts to free themselves from this detrimental stereotype, are forced to represent prehistory, the deep past, the ancient presence, art before art. At las Golondrinas, *hispano* people represent "history" and craft, or vernacular art—the middle past; they are rural people, land-based, honorable tillers of the soil, a vanishing breed as farm and ranchland succumbs to suburbs. And O'Keeffe represents modernity, female independence, high art, affluence, and Anglo "cultural authority by virtue of connoisseurship."

Buttressed by this unbalanced triculturalism, the Fanta Se mystique holds, while the place's beauty diminishes, tarnished by the commerce that has always been its sustenance. (There are a few exceptions, such as Recursos de Santa Fe, founded and run by native New Mexican Ellen Bradbury, which encourages an intensively active, educated cultural tourism incorporating not only university-level courses but also teen tours and other inclusive activities.) If, in the past, the economic necessity of tourism functioned in a broader social and symbolic context, "in the 1980s," writes Chris Wilson in his definitive book *The Myth of Santa Fe*, "its balance tilted almost completely toward the manipulation of the myth as a tourism marketing image." As elsewhere in the country during the Reagan-Bush decade, the abyss between rich and poor became larger and more noticeable. In Santa Fe the myth at best provides coherence and continuity amidst change. It's still a small city (around 60,000 not counting the sprawling county). Secure in an aura that even the condos, subdivisions, trailer courts, neon strips, and changing attitudes within cannot destroy, the place remains artificially beautiful and even meaningful—like art. Santa Fe is a city in waiting. As William deBuys observes, those who reinvented this place around 1912 might wonder "not that their vision was so successful, but that it went unrenewed for so long."

CROSSROADS EVERYWHERE: CULTURAL TOURISM

CULTURAL TOURISM is what the bureaucrats prefer to call "arts and heritage tourism," since the very term *culture* is considered elitist. For some bold souls, however, it has become a buzzword in the late 1990s. Cultural tourism operates within the United States on three fronts: arts tourism, history tourism, and the less acknowledged but ubiquitous ethnotourism. The first includes art galleries, museums, ballets, theater, symphonies—"red carpet arts," virtually all created and patronized by white people (everywhere). The second emphasizes historical sites, remains, replicas, and reenactments where The Past is still being lived in and/or set off as a commercial entity (Charleston, South Carolina, the various "Old Towns") or has pretty obviously succumbed but is still labeled "living history" (replica villages such as Williamsburg and Old Sturbridge). Ethnotourism uses the arts as well as the lives and mores of non-Anglo cultures to add spice and collectibles to golf courses, restaurants, and upscale resorts (Harlem, the Gullah tours in the Carolinas' Outer Banks, the Rio Grande Pueblos in the Southwest, and a twelve-day, $1,600 journey to retrace American Indian trails in Lakota, Crow, Arapaho, and Shoshone country).

Diego Romero (Cochiti Pueblo), *Time Machine,* from the *American Highways Series,* 1994. Paint on ceramic, part commercial clay, part Cochiti clay (revised coil method), 14 1/2 h x 14 1/2" w (photo: Robert Nichols; courtesy Robert Nichols Gallery, Santa Fe). Romero combines traditional medium and unorthodox images (stylistically derived from Mimbres pots) to create a disjunctive humor.

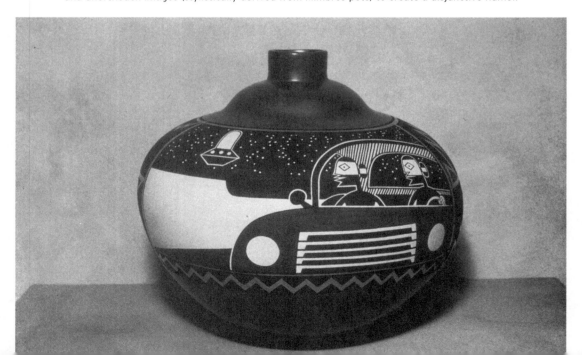

A fusion of heritage and ethnotourisms has spawned what can be called "nationalist" or "special interest" tourism—sites of particular (and potentially exclusive) interest to specific cultural groups, like the Black Panther Tour of Oakland, California, including the site of the attack on Huey Newton, or the Feminist Institute's walking tour in Washington, D.C., which examines government buildings from a feminist perspective. Such anomalies have until recently been marginalized, but now that tourism is seen as a panacea for all economic ills, anything goes. Kramer's Reality Tour visits Seinfeld sites in the Big Apple. A Mennonite settlement in Chihuahua, Mexico, founded in 1922, is commercially willing, if conversationally reticent, about its out-of-contextual attraction for tourists. The Japanese have theme tours of America based on their favorite books, such as *Anne of Green Gables* and *Gone With the Wind*. In another curious (inverted) scenario, there are now highway tours of highways. As far as I know, there are no tours of farmworkers' camps, sweatshops, or chain gangs yet, but they are probably on the horizon—only slightly farther down the line than longstanding "labor as spectacle" sights such as the catwalk at Corning Glass, which allows tourists to watch the workers as involuntary actors on a readymade stage.

Some artists may enjoy performing their crafts for the public (the "fire arts" are particularly popular; famous glass sculptor Dale Chiluly has billboards in Seattle to announce his presence there). Others definitely do not. As metalworker Jan Brooks points out, "the romantic notion of craft eludes the reality that making things is real bodily labor as opposed to a nationalist ideology of the self-made, self-sufficient yeoman type, moral improvement, or just plain 'fun.'" The folk-life and crafts sectors have launched energetic campaigns, using the Cultural Corridor concept as a kind of artsy interstate, heading for the hills. Western North Carolina calls itself the Crafts Center of the World. Unofficial tours of "outsider" artists around the country are undertaken by artists looking to escape art world pretension and to recharge their imaginations by absorbing the sparkling visions of their vernacular colleagues. There are also state-funded websites and official tours by folk art societies in which large groups of collectors descend like locusts on small towns in the Southeast looking for "deals" (just as they descend with similar motives on Indian pueblos in the southwest). There are even "public-sector folklorists" who are agents of this process. "These earnest, so-called preservers of culture," writes Brooks, "stand on the hyphen between the isolated cultural producer and larger audiences, playing the role of self-appointed baby-sitters to protect the 'authentic,'" while in reality these "experts" are based neither in academia nor in local economies, but in tourism agencies.

Although I'd hesitate to sic tourists on anyone, and some self-taught artists assiduously reject and even repel visitors, few small towns yearning for business have any idea of the attractions hidden in their back streets. Rather than the exploitation of vernacular artists by urban dealers and collectors, there must be a way (like getting rid of the middlepeople) to make these tours respectful, self-determined, and independently lucrative, giving the artists more control over their own lives and the distribution of their creations. The same goes for local utilitarian arts, from metalwork to baskets, furniture, stitchery, and food.

A more specialized brand of art tourism involves visits to the monumental earthworks located inaccessibly in the rural west. This has never caught on outside the cognoscenti, except for Walter de Maria's *Lightning Field* in New Mexico, with its reserved cabin accommodations adminis-

tered by the Dia Center for the Arts. Robert Smithson's *Spiral Jetty*, the best-known if least-seen earthwork of the late 1960s, has only recently risen again from beneath the Great Salt Lake, where it spent a decade enriching its geological coloration. Both James Turrell's massive *Roden Crater*, and Charles Ross's *Star Axis*, in the works for over twenty years, include plans for visitor centers when completed.

In the process of making my living as a freelance art writer, I have seen a monstrous amount of art, so my idea of cultural tourism does not include galleries and often bypasses art museums as well. Like most tourists, I am looking for things I see less often. I prefer new landscapes to walk into, or tucked-away historical societies, roadside kitsch, and the even more suspect process of trying to "get into" a place simply by walking the residential streets. At the same time, of course, I'm aware that's impossible, that the place I'll get into is not the place where people live.

Cultural tourism is all of the above, and more.

THE GREAT WHITE HOPE

When all else fails, current touristic wisdom has it, fall back on the arts. This is the most common alternative for areas lacking desirable options in exotica, carrying with it an aura of upward mobility. The trouble is, the arts are in economic trouble just like the industry-abandoned regions that need

Suzanne Lacy, *Mona Paints at Tikal, Atop the Splendors of a Past Guatemalan Civilization, Monumental and Anonymous,* from *Travels with Mona,* 1978, postcard in accordion fold, edition of 2,000 (photo: Rob Blalack). Performance artist Suzanne Lacy (as Mona) is Woman Artist recreating the world's most famous painting of a woman through a follow-the-dots kit in new contexts, at various tourist sites around the world, from the Louvre to the Swiss Alps. "Musing at her train window, as unfamiliar landmarks and Major Monuments of Art rush by," wrote Arlene Raven in the foldout, "Mona also contemplates her own image. She is a universal hallmark of Woman—mysterious, self-enclosed, silent. She is European artistic tradition at its highest level of aspiration. At the start she is unfinished.... How will Mona make her mark?"

a boost, what with the withering away of the NEA and predictable deflation of philanthropic mammary glands. In a nation devoid of cultural policy, getting funded is a chaotic and highly competitive vocation. Is any old art a tourist draw? Just famous art? Just good art? Just bad art? (And who's to say which is which?) One positive outcome of the spotlight on arts tourism and art defunding is a growing organizational awareness that the bottom line is the local base—and that more attention had better be paid to what and who's right here.

The title of a 1998 article by Doug Hubley, surveying this trend in mid-Coast Maine, asks, CULTURAL TOURISM: IS THERE STEAK IN THE SIZZLE? Ashland, Oregon—population 17,000, a college town, home since 1935 of the Oregon Shakespeare Festival—is held up as an example for Brunswick, Maine, where the Bowdoin Summer Music Festival aspires to the "350,000 culture-hungry visitors" annually attracted to Ashland. The steak is exemplified by Ashland's sixty-three-year-old festival, the sizzle by the "much ballyhooed Downtown Arts District" in Portland, Maine.

Maine is one of many states scrabbling to keep up with the national mania for touristic development as industry runs away to sites of cheaper labor. (At the same time it has just endangered its tourist quota by repealing a gay rights act, triggering rumors of a gay tourist boycott like that in Colorado in the early 1990s.) As in so many poor states, the newspapers are full of suggested tourist strategies (which are then shot down in letters to the editor). One of the more cynical ventures, given a longstanding bias against French Canadian millworkers in Maine since the mid-nineteenth century, is promotion of a "roots" tourism and historic corridor from Quebec, to tap into the European market and "pick off" some of Quebec's visitors, as Governor Angus King so delicately put it.

A cultural resources guide and arts inventory for the scenic Bath-Brunswick area is being created in order to build "awareness of the importance of the arts to the region's identity and economy," and even to assess the needs of local artists and organizations. An arts and crafts map and synchronized open studios (which in turn encourage the restaurant business) are suggested as alternatives to the mall. None of this will do any harm. The worst that can happen is what's happened already: the cultural seed money still circulating goes to the safe art, the big institutions, and the encouragement of more banal tourist art that has received a high-art stamp of approval because it is perceived as "an economic development resource." The fatalists say, hey, if that's what people want, let 'em have it. Resisters stubbornly hold out for an art of provocation rather than panaceas.

A region's local identity is more likely to be further falsified or diluted than researched and amplified by such campaigns. For instance, another recent article bemoaned the fate of La Conner, Washington, a nice little fishing and farming town in the Skagit Valley colonized by artists and writers, which enjoyed a brief bloom as "a pretty cool place" attractive to tourists, and as a result was corrupted into "an exceedingly tacky fudge." The artists, of course, have moved on, and are busy involuntarily creating another commercial opportunity nearby, in a place less quaint, more industrial, and therefore perhaps better protected from invasion.

This trajectory is all too familiar. In cities too, artists "pioneer" rundown areas with cheap space and become the flying wedge of tourism and gentrification, only to join in dispersion the communities they themselves have displaced. I lived in New York's SoHo and environs for thirty-five years of tremendous change. First came the artists, ousting the few remaining small manufac-

turers. Then a variety of New Yorkers came for the "cutting edge" scene. Then tourists came to see real artists in their native habitat. Now what my son (born on the Bowery, raised in SoHo) uncharitably calls the "idiot parade" comes for the shopping. Even the art dealers have fled to Chelsea. The convergence of arts and shopping, the rise of the mall as public (but not communal) space, and the introduction of immigrant cultures with new expectations have shifted the ground where the American imagination goes to play. The tourist spectacle is now callous and virtual. Theme parks, Disneyland, and Las Vegas have replaced mere artworks and stable places, although blockbuster museum shows still appeal to large numbers of the upwardly mobile.

These scenarios raise all kinds of questions for land management, as well as dilemmas for artists who are being chased around the country by avid but not necessarily supportive or lucrative

"appreciators." When towns start lusting after tourists, individual artists whose work doesn't fit the pleasantness niche are edged out, as they are by the NEA in its downswing. It's all very well for artists and local tourist agencies to work together, but for my money the best art is made in studios and communities, free of pressure (admittedly a true luxury for most American artists). Although it is trendy to observe that "the arts industrial cluster" contributes to "the quality of life," sellers also worry about "oversupply." It goes without

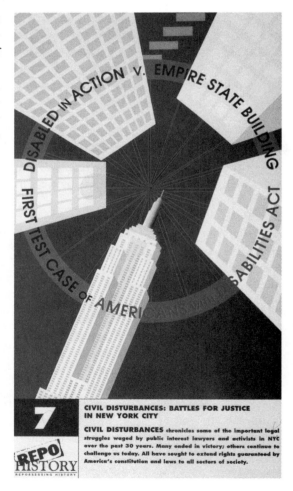

Janet Koenig, with REPOhistory, *Securing Equal Access to Public Spaces, Disabled in Action v. Empire State Building,* 1998, metal image and text sign in street (photo: Tom Klem). This sign was one of twenty image-and-text works by members of the radical artists', writers', and historians' collective in New York City. Koenig is a founding member. The sign commemorates the first test case of the American Disabilities Act and was decided in 1994. REPOhistory specializes in urban public sign projects that call attention to neglected and forgotten events and sites. Two sets of these signs were mounted—one in Manhattan, one throughout the boroughs—as part of REPO's *Civil Disturbances* project, which documented pivotal legal battles in defense of the rights of the city's politically and economically disenfranchised. The image of looking up at a powerful structure can be seen as a symbol of a triumph for the disabled and it can double as a tourist glance up at what was once "the tallest building."

saying that in the arts, production always exceeds consumption, when artists are given a chance to produce in the first place.

If the Metropolitan Museum of Art is New York City's top tourist draw, why has cultural tourism so often been left out of the overall equation? Why is New York's artist population defunded and neglected when they contribute so much to the economy? Why is art merely folded into the recipe for recreation and entertainment? I suspect it goes back to the notion that art is above it all (the province of the rich and highly educated who can take care of themselves) or below it all (byproduct of "real work," and low on the list of necessities). There is also an element of disconnection. Officialdom does not make the connection between the grungy Lower East Side or sleek SoHo artist producing today and all that old stuff in gold frames at the Met. Internally there are additional problems, including elitist self-importance, croneyism, and faddism.

More insidious, funds for communities, for artists working in schools or retirement homes, with the disabled, prisoners, or the homeless, are being siphoned off to promote tourism, which in turn pushes the arts in directions they shouldn't

be going. Local arts organizations are being pressured to be more tourist friendly or have their funds cut. "What about the people who live here?" asks one angry administrator. The definition of art becomes, yet again, recreation, decoration, and entertainment. Worse still, even these last straws may be ineffective, because the ideal cultural tourist, with time and money to spare, is graying. The younger generation, deprived of arts programs during their schooling (despite research that proves children exposed to the arts do better in all subjects) resorts to new and less healthy kinds of recreation and entertainment.

In the last thirty years a large number of artists have moved to places like Maine and New Mexico, most of them resigned to never making a full-time living from their art. When the buses start arriving, however, temptation and necessity can override ethics and aesthetics. Who can blame the poor artist, caught like a prostitute between a rock and a hard place? Few outside the self-funded high art world (where thinking artists are still encouraged now and then) have the luxury or the courage to resist. And for that matter, who can blame the tourists? We are all complicit in what our culture has become.

IMPORT-EXPORT CENTERS

Museums epitomize cultural tourism. They are the ambulatory counterpart of armchair tours through the exotic, and they come with the added value of an encyclopedic factor. It's all there, and all sorted out for you. No need to worry about good and bad. It must be good, or it wouldn't be in here, right? Meanwhile, the big international exhibitions—the Venice and Sao Paulo Biennales, Documenta, and increasingly far-flung bids for similar attention at biennials in Havana, Istanbul, Cairo—have become integral destinations for cultural tourism at

its flashiest (when it becomes "socialite tourism," not to be confused with social or socialist tourism). It doesn't hurt that the sites of these shows are usually "destinations" in their own right.

In their dry and contained manner, conventional museums look out as well as gather in. They offer views into many other places. The photographic or dioramic or muralized sight, while not as picturesque as the place itself, is easier to take in, another brand of virtual or "armchair" tourism, though harder on the feet and brain than televi-

sion and popular magazines. Unlike actual tourism—overtly driven by commerce and the state—museums are covertly ideological. These institutions, often private, play a role in the formation of national (ethnic) identity—not just those of the United States, but throughout the world. Historically, American museums have provided one-sided and unabashed colonial views of the world from the dominant white Euro-culture. (The richly tendered Peabody Essex Museum in Salem, Massachusetts, with its array of international spoils handed down from the great nineteenth-century seagoing families, is a classic example. The elegant museum shop is an indicator. And just beyond its walls are the witches.)

"What is really important is not just promoting cultural tourism, but using the cultural resources of a community and region to build a 'sustainable destination area,'" writes the Director of Development for the American Association of Museums. He goes on to define such an area as combining "recreation, natural areas, cultural resources, hospitality and retail," and contends that only those with all of these assets will be likely to survive. In other words, place, environment (one might even say decor) is part of the draw.

In the inevitably intertwined nostalgia and heritage industry, I've come across two slick, ad-crammed publications: Reminisce: The Magazine That Brings Back the Good Times (published in Greendale, Wisconsin) is unashamedly sentimental, "a walk down memory lane," and Historical Traveler ("brand new" in 1995 from Cowles History Group in Leesburg, Virginia) concentrates on "culture." Art figures prominently in its offerings, ranging from framed pictures of Washington's Prayer at Valley Forge (complete with brass plaque), to a bronze replica of Cyrus Dallin's Appeal to the Great

Joan Myers, *Hannibal, Missouri,* 1993, black and white photograph (photo: copyright Joan Myers). Hannibal was Mark Twain's birthplace. The picture was taken during the devastating floods of the Mississippi River.

Spirit, to a complete framed set of Civil War generals' cards, to an "Americas Southwest Watch" from Native USA in Albuquerque, to a collector's plate of the United States Marine Corps.

Everything is grist to heritage's greedy mill. Mass-produced table mats in diners and restaurants feature "Old Mills of America" or the occasional local historical tidbits. (I like these.) Plastic miniatures of old fishing dories are sold as planters; retired wagon wheels and millstones have long been popular yard ornaments, lending a melancholy touch to a velvety lawn as well as suggesting that hard labor is a thing of the past for the inhabitants of this elegantly renovated home.

In more sophisticated terms, and couched in better writing, local magazines such as *New Mexico Magazine* or *Down East* (Maine) promote tourism state by state, while the Mississippi-based *Reckon* offers scholarly depth on southern culture and Florida's *Forum* is smart, lively journalism. But the states' advertisements, concocted by the official tourism departments, are blatant one-shot bids for attention, and are particularly revealing in their sappiness. Rhode Island—"America's First Resort"—is illustrated by a pretty little red barn-like house with the headline THE MAN WHO PAINTED GEORGE WASHINGTON SLEPT HERE (it's Gilbert Stuart's birthplace; talk about secondary celebrities). The father of our country is apparently a big draw; several states invoke him. Others resort to puns: Iowa announces YOUR TWO LIPS ARE SMILING in front of people in Dutch costume and a field of tulips, promising to "put the bloom in life and paint a smile on your face." Pennsylvania puts its money on Valley Forge (FIFE AND DRUM ALWAYS, HUMDRUM NEVER). Vermont presents itself as an oddly pristine and sunlit attic complete with three neatly placed rocking horses and some antique furniture, claiming "it will change the way you look at things." Cali-

fornia simply urges PUSH FOR BETTER NATURE OUTINGS, while Nevada slyly flashes its casino card (an ace of hearts) as it piously urges a visit to a historic opera house. Louisiana is casually cross-class, featuring a fried shrimp po' boy and a huge gleaming white plantation house (COME HANG AROUND OUR HOUSE). New Jersey, butt of many modern jokes, reinstates itself with antiquated dignity, a classic autumn photo of Washington's headquarters, also promising revelation: COME SEE WHAT A DIFFERENCE A STATE MAKES. Difference is clearly the key word here. Copywriters have caught up to the tourists.

In a full-page double spread, Oregon (THINGS LOOK DIFFERENT HERE) pulls out the stops with a golden-tinted western landscape foregrounding a Plains Indian dancer, incongruously alone in the vast landscape. This is a cultural tourist's vision of what has been called "the mild west," where tourists can participate in long cattle drives, short roundups, or spend weeks in covered wagons. Or they can stay at dude ranches ("guest ranches") which herd people instead of cattle. Or they can just drive through the landscape conjuring up scenes from the movies. The surrounding landscape is more of a factor than is usually admitted. Small, ordinary towns tucked at the foot of a mountain are more attractive than those dropped "in the middle of nowhere." (All of this is important because so many tourists are picking up and moving to the west.) Yet for me, sleaziness *becomes* some of those desolate western towns, perhaps because of the sheer bravery or bravado of their harsh existence.

In the east and south, where spaces are not so vast, walking is more likely. As detail takes on more importance at a slower pace, places must be more carefully edited. Quaint New England villages with predominantly white houses are easily spoiled by a salmon-pink intruder (though

bright-colored buildings might be more histori-
cally accurate) or a McDonald's on the corner.
Rundown eastern factory towns are less appealing
than their western counterparts. Grain elevators in
the rural midwest are more picturesque to the trav-
eler than fish canneries in the northeast. But ruins
are another story. The huge abandoned brick mills
of New England, looming over polluted rivers, can
be given a facelift and become assets to the region.

A superb example of the geographical interde-
pendence of changing museum practices is the
"Connecticut Impressionist Art Trail," directed by
a veteran of the marketing and advertising fields.
The trail incorporates not only the small muse-
ums that collected American Impressionism but

the bucolic landscape depicted in it, still relatively
intact. It is a classy road show, but a road show
nonetheless. The brainchild of both museum
directors and the state's Tourism Division (under
the Department of Economic and Community
Development), the trail was inaugurated in 1995.
Marketing in *The Connecticut Vacation Guide* and
Yankee Magazine was "pulling well." The Art Trail
increased attendance at the participating muse-
ums some 40 percent, but to no avail. In a move
consonant with national lack of support for the
arts, the state cut the trail's funding and two of
the twelve museums have dropped out.

One result of the established museums' repu-
tations for cultural bias and elitism is a move-

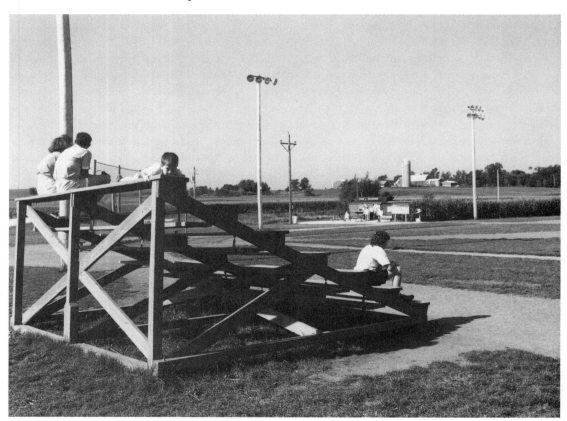

ment, since the 1960s, for culturally specific (or "separatist") institutions designed and run by the erstwhile subjects of scrutiny. More recently, under pressure, some major institutions have hired "minority" curators, shown artists not hitherto welcomed, and organized nontraditional shows that often run counter to or criticize outright the host institution. Some even extend the museums' purview to include public art components around town, occasionally in unexpected neighborhoods. (Some New York museums in the 1980s got into "slum tourism," shuttling their clientele to cultural hot spots in the South Bronx and Lower East Side where they gazed briefly upon the products of angry, scruffy, and/or radical youth.)

While such feeble antidotes may have opened up the field, they have not brought (or bought) wholesale trust. Despite a scholarly trend toward downplaying nationalism and denigrating "multiculti" or "identity" politics, most ethnic groups who perceive themselves as groups (usually oppressed groups) would still prefer to represent themselves. Los Angeles has the handsome new Japanese American National Museum. The George Washington Carver Community Center in San Antonio is the first African-American history and culture neighborhood museum in Texas, and Hispanic cultural centers have been proposed belatedly for both Santa Fe and Albuquerque. So it goes all over the country, leading to a number of

Joan Myers, *Waiting for Ball Game to Start, "Field of Dreams," Dyersville, Iowa,* 1992, black and white photograph. For the film *Field of Dreams* (1989), a Midwestern cornfield was cleared to create a baseball diamond on a working farm. After the movie was made, the owners left the bleachers up, printed some T-shirts, and created a modest tourist attraction advertised as "a little piece of heaven... Welcome to the place where reality mixes with fantasy and dreams can come true."

new and proposed museums under the gigantic Smithsonian umbrella in Washington, D.C., and elsewhere. A National African-American Museum was approved by the Smithsonian Board of Regents in May of 1991; despite promises to open by 1995, it has dropped from sight, although an impressive new Museum of African-American History has opened independently in Detroit. A branch of the National Museum of the American Indian, based on the former Gustave Heye Collection, took over the old Customs House in New York, while its monumental new space on the Washington Mall is wending its rocky way toward construction. Yet the loss of local context can neutralize and/or homogenize a culture for national consumption, with the effect of all but censoring complex issues and severing ties with the regional audiences who need most to learn.

Some claim that this flurry of ethnic and historical museums testifies to increasing national balkanization, while others argue that it is a positive result of multicultural literacy and ethnic self-determination. It remains to be seen whether separate enterprises are the best or the only way in which to support whatever is passing at the moment for multicultural authenticity, cultural democracy, or nationalism. One thing is certain—these "special interest" museums, when they don't charge high admission fees, can bring in a whole new public. Audiences ill at ease in classic museums feel more welcome in "our own place" (which is not to say such museums can't also be pretentious in their own sweet ways, as they aspire to the "professionalism" of larger institutions).

Many of these culturally specific museums merge the techniques of art and ethnographic museums in the ways they tend to frame the collected objects with context and information that may seem esoteric to an outside audience. In art museums, Native American arts, for instance,

are offered room as objects, but decontextualized; in the ethnographic museum, the presentation is more "old fashioned." Context is provided, but the orientation is more educational, sometimes to the detriment of aesthetics. Updated installations often borrow stylistically from commercial Indian arts galleries, featuring subdued pinkish plasters with pastel turquoise accents and neo-adobe banquettes. In the Denver Art Museum, faceless gray mannequins (and horses, also faceless) model the beadwork and buckskins, a reflection (probably unconscious) of the anonymity of the Indian artists themselves. Erika Doss has noted the persistence of this anonymity even when the curatorial staff knows the artists' names, and pointedly compares the Native collections to the elegant display of the Euro-collections on another floor. For the average viewer, the art museums tell too little about objects and ethnographic museums tell too much. The culturally specific museums often achieve an intimacy that is foreign to both conventions. It remains to be seen whether this accessibility will be wrung out of them by the monotonous criteria of funding sources or whether they will continue to develop their own innovative methodologies.

Another aspect of museumized domestic cultural tourism is the modernization of exhibition and display styles in ways suggesting that the old colonial framework remains intact. The audience is led away from home, to foreign parts, and the local touristic aura is enhanced in the process. Advertisements for the Metropolitan Museum of Art's 1990 *Mystery and Wonder of Mexico* (the title alone gives it away) boasted MANHATTAN WILL BE MORE EXOTIC THIS FALL! Cultural critics made hay of this blatant exploitation of otherness. Yet there is no question that exoticism is a major appeal in ethno-related exhibitions—and perhaps in all art, so long as artists

themselves remain marginalized as "weird" members of society. The exhibition's accompanying "festival" (supported by global corporations often dependent on sweatshop labor in Mexico itself) was called "Mexico: A Work of Art." When a nation becomes a work of art, reality checks are no longer necessary.

Upscale tourists will plan their trips to a city to catch the "Tibetan show" or the "Mexican show." In a trenchant essay focusing on the Mexican extravaganza, Brian Wallis points out the similar economic profiles of countries lining up to get their turn at a "festival year" in big American cities (Mexico, Ireland, India, Indonesia, South Korea, and Russia in recent memory). They tend to have "huge international debts (mainly to the United States); cheap, docile labor markets (attractive to U.S. businesses); and valuable exports managed by U.S. multinational corporations (principally oil). All of them have recently privatized state industries (with encouragement from the United States and the International Monetary Fund)."

Once a nation is shrunken into a museum exhibition, commerce is inevitably to be found crouching behind the thrones of King History and Queen Art. Department stores are on the bandwagon from the beginning, and the wagon is fueled by corporate sponsorship. Festival exhibitions tend to offer plenty of beauty for public delectation *and* not much educational substance. "It's cultural diplomacy," claimed one businessman (some prefer the word *propaganda*). Wallis points out that some nations conflate culture and tourism in one governmental department. And no one denies that boosting tourism is on a par with edification. The goal is in plain view: luscious photomurals of landscapes and monuments— that is, tourist destinations—provide backdrops that can overwhelm the exhibited objects. In the interest of speed and simplicity for casual visitors

and shoppers, places are spotlighted (rather than illuminated), then misrepresented in terms that reinforce the protective boundaries of "tradition" and "the good old days." The result is what Wallis calls "spectacularizing the nationalist myth."

What does all this mean for artists and writers who may puzzle or offend, those who may throw a wrench into the gears of progress? Censorship, in a word. A text for the Mexican show's catalogue by the respected critic Dore Ashton was censored in at least two places. For example, a reference to "the odious intervention of the U.S. in Mexico" was changed to "immense intervention." Real criticism doesn't make a good official export (though artists such as Andres Serrano and Karen Finley, constantly in trouble with the U.S. cultural comptrol-

lers, are in great demand around the world). Once culture is trussed up with tourism, which is in turn shackled to governmental and corporate image-building, damage control, and whitewashing, it is no longer permitted to play the role of free expression and wild vision that is integral to good art. This statement is as applicable to local cultural tourism ("arts districts" that augment tourist draws) as it is to these big-time extravaganzas. In both cases, culture becomes a vehicle for agendas beyond or conflicting with those of the artists. The arts can be used to restereotype trouble spots, creating benign pockets of "good" in the larger evil. Philip Morris has become the most dependable source for arts funding in this country, and few speak up to protest its ubiquity.

TWO-WAY MIRRORS

For years now, the question of what constitutes cultural authenticity and regional substance and how to profit from it has been repeated on both sides of the touristic and institutional fence: those who look and those who get looked at are equally concerned. At first the questions were relatively simple: How do we promote cultural literacy and preserve the independent artist? Then they got more complicated: Who says what's authentic, the people outside the culture or the people within it? How can people be empowered to speak for and frame their own culture for outsiders? Is *anything* authentic or genuine? Will any vestige of the authentic turn to salt on exposure to the tourist gaze?

As tourists, we are particularly vulnerable to the stereotypes and colonial constructions that remain at the bottom of our glass and on top of the tourist literature. Cultural pride and cultural tourism intersect in curious ways. National pride can serve as armor against tourism. And on the

other side of the coin, Dean MacCannell has noted the parallels between external ethnic tourism and the internal exaggerations of cultural nationalists. "As the rhetoric of hostility toward minorities is replaced with a rhetoric of appreciation," he writes, "the circle of their potential exploiters is dramatically expanded. Now with a clear conscience, even the Chinese can exploit the Chinese or 'promote Chinese culture.'" He presents the bemusing example of Locke, California, one of three Sacramento Delta towns founded since the 1860s by Chinese workers. Originally the land was leased, thanks to the Alien Land Law which prohibited Chinese from buying or selling property in the United States. Locke itself was built by local Chinese businessmen in 1915; in its boom years, it featured gambling and brothels staffed by white women. In 1977, Chinese farm laborers were fighting the sale of their town to a Hong Kong developer who planned to turn the entire community into a tourist attraction,

complete with giant Buddha and a narrow-gauge railway. The state proposed an alternative—moving the whole town to a nearby park, reinstalling its elderly inhabitants and maintaining it as a "living historic preservation." Both plans purported to raise a monument to ethnic history and to Asian-Americans' contributions to railway-building, ditch-digging and California agriculture. Neither went through. Today Locke's population has shrunk to eighty people, Chinese are no longer the ethnic majority, and it is struggling to survive with the aid of the Sacramento Housing and Redevelopment Agency.

Postmodern cultural studies books are full of such fascinating and gloomy analyses, as well as ghastly examples such as Hawaii's Polynesian Cultural Center, stage-managed by the Mormons. Most of the writing on the subject deals with "authenticity" encountered abroad—especially in "contact zones" (Mary Louise Pratt's acute phrase) and "primitive places" (Sally Price's bastion). Dealing with domestic tourism is touchier and less spectacular, though the United States has its own contact zones. It's harder to understand the separations when everyone looks alike and comes from a similar background. In monocultural areas such as Vermont or Maine, class is the vehicle of otherness. Fishers and lobsterers and loggers and quilters (like Appalachian "hillbillies" or white tenant farmers in the south) are either quaint or disdained to those on the outside. From the inside, they are as complex, intelligent, and "modern" as anyone else. In fact, can the romanticization of what is still sometimes called "poor white trash," "rednecks," or "trailer trash" be far behind when regional tourism becomes a must for all areas, even those devoid of ethno-possibilities? Journalist Rebecca Thomas Kirkendall, an Ozarks native, recalls working in the city and watching

"with amazement as my Yuppie friends hurried from their corporate desks to catch the 6:30 line-dancing class at the edge of town. Donning Ralph Lauren jeans and ankle boots, they drove to the trendiest country bars, sat and danced together and poked fun at the local 'hicks' who arrived in pickup trucks wearing Wrangler jeans and Roper boots."

Hawaiian Native Lehuah Lopez of the Native Lands Foundation says, "I feel trapped in a two-way mirror—I can look out, but people can't see in." Beginning with Thomas Moran and the Taos and Santa Fe art colonies, artists have produced those mirrors, playing a major role in the marketing of ethnicity and selling of the west, in both tourism and its boon companion—development. As anthropologist Sylvia Rodriguez explains in her groundbreaking work on Taos, New Mexico, the art colonies were the "mechanism by which a harsh environment and inequitable social conditions became symbolically transformed into something mysterious, awesome, and transcendent." The artists "functioned to convert the disparity between social reality and touristic fiction into a highly marketable set of images" consisting of scenery, hispanos, Indians, isolation, and rusticity (underdevelopment)—"a world best understood in relation to the world it negated." Another ingredient was the Indian peoples' own cooptation and "psychosocial investment in the fiction it perpetuated."

Ethnic tourism, well-intentioned and/or disrespectfully perpetrated, usually turns out to be another facet of the racism it claims to overturn by paying homage to or idealizing a group of people. Colonialism is (purportedly) distant enough to allow us to be anticolonialist even as we are re-inventing it, all the time, even in the very moment of analysis. The Jamaican poet Derek Wolcott has said that because his home island

was a tourist spot, he has always found it difficult to take holidays. One of the most outraged commentaries on tourism by a "native" is Jamaica Kinkaid's powerful little book, *A Small Place*, about Antigua, where she was raised. Condemning the corruption of the island's governors with both incredulity and compassion, she writes:

And it is in that strange voice, then—
the voice that suggests innocence, art, lunacy
—that they say these things, pausing to take
breath before this monument to rottenness,
that monument to rottenness, as if they
were tour guides; as if, having observed the
event of tourism, they have absorbed it so
completely that they have made the
degradation and humiliation of their daily
lives into their own tourist attraction.

Locals are usually enjoined to put up and shut up, lest the golden eggs get smashed. And we rarely hear from those tourists considered "atypical." A *Guide to Black Chicago: A Resource Guide to Black Cultural, Historical, and Educational Points of Interest* was published in 1996. Although it targets African-American visitors, it would undoubtedly be "educational" for "ethnic tourists" as well. In his satirical (in tone only) essay, "An Unwhite Tourist's Guide to the Rocky Mountain West," Cherokee writer Ward Churchill details the less than desirable aspects of traveling in the scenic state of "Red"—since *colorado*, as a Spanish word (for *red*), would be banned by the state's "Official English" law. (Mesa Verde, he remarks, must now be called Green Table, and so forth.) Looking prosperous while being the wrong color, for instance, can get you stopped and searched for drugs.

Debra Drexler, *Hawaiian Tourist Art in Honolulu Hotel,* ca. 1994, color slide. Drexler herself was making a series of expressionist paintings on tourism at the time, called *Postcards from Oahu,* having recently moved to Honolulu from the midwest and finding herself not only a foreigner but a *haole* —"part of an ethnic minority with a history of colonialism and residual cultural guilt." In his classic book *Ethnic and Tourist Arts,* Nelson Graburn wrote that the study of tourist art was the study of *changing* arts, "of emerging ethnicities, modifying identities, and commercial and colonial stimuli and repressive actions." He compares the trend to naturalism within such arts to pidgin languages, as an "obvious visual cross-cultural code," and points out that dye and shoe polish are used on light woods because tourists like souvenirs that match the skin colors of their makers.

Tourism's toll on privacy and self-esteem is equaled by tourists' blissful or arrogant ignorance of the social backgrounds of the places they tour. Whatever lies behind the stage sets is out of sight and out of mind. As Isabel Letelier remarked indignantly years ago in regard to Latin America, tourism "without captions is irresponsible tourism" (of course there are also irresponsible captions). A statement from the National Indian Youth Council makes the point:

Have you ever been to Gallup, New Mexico? Hundreds of thousands of tourists have... particularly during the Gallup Intertribal Ceremonial Week, sponsored by the Chamber of Commerce. These tourists see Indian dancing and pageantry. And in the process, they leave a great deal of money behind them. What they don't see is that in this city which calls itself 'the Indian Capital of the World,' no Indian has ever been elected to the City Council. What they don't see is that there is complete lack of responsiveness to the social needs of Indian people who represent 20 percent of the population there.

Within the United States, legally sovereign Indian nations fill the role of the "foreign." When the tourists arrive at the roots, at the more or less original context, the uprooted nation itself becomes a museum. The detrimental effects of tourism on internal community engender competition and fragmentation of place. The tourist-transformed village, says MacCannell, becomes an "empty meeting ground," the shell of former life, stripped of lasting human relationships, and with them any real sense of place. This is what the pueblo residents fear most. (The tables might be turned if a tribal nation were to produce a "living park" of Mormon life, or of white prostitution.) The harsh reality is that traveling the crossroads and increased cultural interaction has not brought us closer to the global village envisioned in the 1960s. In fact, that harmonious fiction recedes from possibility even as the technology that might accommodate it becomes more accessible (and more socially controlled). What is actually happening is more along the lines of Trinh T. Minh-ha's much-quoted dictum: "There is a Third World in every First World and vice versa." Or, as MacCannell put it, the "rapid implosion of the 'Third World' into the First constitutes a reversal and transformation of the structure of tourism, and in many ways it is more interesting than the first phase of the globalization of culture." It's the difference between grass roots and global corporate culture. New travelers also provide new sights.

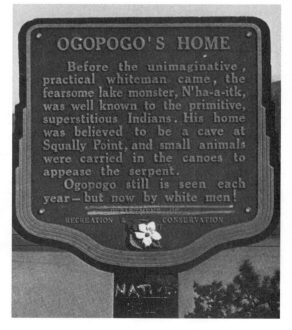

Melanie Yazzie (Navajo), *Okopogo's Home,* altered postcard of sign in Okanagan Valley, British Columbia; sent to author in 1992. Words added: "Natives Still Live Here!"

This is
not a
commercial,
this is
my
homeland.

DAMN!
There goes the
neighborhood!

Hulleah Tsinhnahjinnie (Creek/Seminole/Navajo), *Damn!,* 1998, digital images, unset dimensions
(photo: copyright Hulleah J. Tsinhnahjinnie). The man with the gun is a Ute, taken from an old photograph.
Tsinhnahjinnie was raised on the Navajo reservation and is now building her own house there.
She is increasingly involved with digital artwork.

A REAL TRIP

While tourism looked squarely in the eye is less attractive, almost shameful, to the principled and the actively curious, we are all addicted to it. The compulsion to travel—to look, to perceive, to absorb and perhaps even to understand something that will alter one's preconceptions—is deeply ingrained in Western culture. But must cultural tourism be a downer? Are tourists only interested in the sensational, the spectacular, and the superficial? Or are some of us seeking something else, something undefinable called "cultural authenticity"—our own as well as that of "the other"? Would we know it if we fell on it? If we fall on it are we likely to disrespect it?

In the mood for epilogues rather than conclusions, I look back with a certain nostalgia on serendipitous youthful tourism. Drifters and innocents abroad are more likely to get lucky in cross-cultural situations. A few years ago, X, a white musician in his early twenties, saved up and bought two tickets to Jamaica. At the last moment his girlfriend couldn't get off work; he invited another friend who after two days hurt himself in a minor bicycle accident and went home. At this point X abandoned his high expectations. Resigning himself to random acts of tourism, he made friends with a local youth who had sold him some ganja, gave him some money, and said let me just hang out with you in your life. They went up into the hills to the youth's family's home, lived poor, ate good home-cooked food, swam under a beautiful waterfall and smoked a lot of dope (which X also helped to harvest). Fate's travel agents had delivered an unexpectedly pleasant, oddly reciprocal, and ethnically "authentic" (if socially unbalanced) vacation for two. It could have been mightily uncomfortable for all concerned, but turned out to be a robust, and curiously reciprocal, exchange. This is the kind of turned-inside-out trip that can't be forced, where the inside track overlaps the beaten track.

EXHIBITIONISM

THE 8,200 MUSEUMS in the United States are on every itinerary. If a place lacks an art collection or a historical society, it often boasts a tourist trap or a locally valued random accumulation of objects *called* a museum. The Metropolitan Museum of Art is now New York's top tourist attraction, towering over the Statue of Liberty, the Empire State Building, Radio City Music Hall, Ellis Island, Broadway, and SoHo, though this may simply say something about who can afford to be a New York tourist these days. Usually museum-going involves "high art"—stuff in gold frames or on marble pedestals, art considered desirable for perusal but by implication out of reach for the average Joe (although the Met began as a museum of plaster reproductions intended to elevate working-class taste). Museums are still gendered for ridicule, from Helen Hokinson ladies endearingly bemused by art to the endless cartoons of earnest wives trailed by bored and weary husbands lost in the labyrinths of the Louvre or the Museum of Modern Art.

In my youth, at least museums were free. They were once like libraries, truly open to the public. They had a social mission, however patronizing. Now, in many places, museums cost as much or more than a movie, throwing them into another level of competition. Yet museums nationwide are claiming constant increases in attendance, even as (or because) they become more conservative, more spectacle-oriented, more dependent on their donors, less willing to take risks, more willing to censor, more confident that their audiences are on the same political wavelength (as too often they are).

Museums still inspire ambivalence in the American public, a combination of fear and fascination, pain and pleasure. Rather like the old Church, (before English and jazz masses), the old museum with its columns and porticos loomed ominously above the gum-chewing public like a palace or a courthouse. It was clearly a place where you didn't belong, a place you entered at your own risk, on your best behavior, to be quiet, properly impressed, even awe-struck, at the prod-

Andrea Robbins and Max Becher,
New York New York Casino, Las Vegas, 1997,
Chromogenic print, 28 3/4" x 33 1/2". A replica
of the Whitney Museum of American Art, built cheek
to jowl with the Statue of Liberty, Grant's Tomb,
and other Manhattan landmarks.

ucts created by alien beings (artists) and acquired by your betters. For all the long-standing scholarly criticism of museums' classism and their methods of accumulation, these powerful class icons still attract those curious about the lifestyles of the rich and infamous, along with those seeking beauty in lives bereft of such amenities. The socialization necessary to make children, soon to be adults, comfortable in such institutions is under way but may be too little too late and in too prosaic a style. The competition from other sources of pleasure is enormous.

The worst place that you could go to is the Museum of Nachroll Historey. They have a giant skwid. It's diskusting. I felt like throwing up they got a blue whale. What is a blue whale? I can tell you why they call it a blue whale because it's a whale and it sings the blues. Then they have alive spiders. The museum is not supost to have alive things. Say a kid nocks the glass over whos folt is it? the museums. And then they got Jungel musick. Where are we? In a museum and it supost to be quiet. Then they have the anamels moon us and who wants to see that? and they got necket people. This is no place for your kid only manyaks and outrayjus indavijels that don't know what to do with them self and that you choose to go or not, I say not.—Dominique Harris

This straight-from-the-heart response from a seven-year-old girl to a museum widely seen as the most popular in New York City says a lot about museums in this society. If the dinosaur-studded Natural History Museum, as close to a populist museum as they get, inspires this level of disdain, I shudder to contemplate the fate of art museums. However, for a more upscale audi-

ence, culture is cool again. New museums like the Getty Center in Los Angeles get raves. Older ones get facelifts to appeal to a new generation, if not a new class, of tourists. (The euphemism "visitors" is frequently used, but even at home, museum-going is for most a "foreign" experi-ence, so the consumer tends to be a tourist whether or not s/he lives elsewhere.) The artist, the scholar, the aficionado who will spend a whole day spellbound by works of art, is no longer the target audience. Neither is the work-ing-class—except, perhaps, for its children.

The working people, from their close contact with physical things, are apt to be more acute critics of pictures than the dilettanti themselves.—Thomas Eakins

Nineteenth-century paternalism initiated the trickle-down theory of art. Many well-intended contemporary projects might be construed as patronizing, comparable to the history of Lon-don's Whitechapel Gallery, constructed in the late nineteenth century in a poor neighborhood as a replacement for pubs and music halls. Then as now, the museum was seen as an instrument for self-improvement, with a little help from above. Most ambitiously, the Whitechapel was "a project to reshape the interior and exterior land-scapes of the urban poor." As Seth Koven points out, although the founders attempted to tran-scend "the competing interests of class" in favor of "consensual citizenship" in the midst of the fray between labor and capital, such efforts "endowed the London working class with the virtues and vices of a primitive people. In a curi-ous reversal of roles, however, it was the 'primi-tive' East-Enders who were invited to view the cultural artifacts of elite life." One working man who wished he hadn't had this opportunity unconsciously exposed the downside of high art as an instrument of social control: "my house'll seem a deal more squalid and dreary now that I've seen a picture like this."

It is only recently that museums have evinced any real interest in their audiences' identities and preferences, aside from their economic capacities and geographic origins. In several cases, such studies have been initiated by artists rather than institutions, as in Don Celender's *The Opinions of Working People Concerning the Arts* (1975) and Bill Beirne's video *You Connect the Dots...*, shown at the Whitney Museum in 1991. Beirne is an artist and teacher who gets his kids to research, write, and report on local events and institutions for TV. Described as "provocative investigation of the process of interpretation as it is applied to art and to everyday human behavior," his video includes conversations with visitors, the books and docu-ments used by the docents, and recordings of eight different museum guides expounding on the same paintings.

Although it is debatable whether the replace-ment of marble halls and gold-leaf ceilings with concrete, steel, and glass is a substantial improve-ment on the intimidation scale, the new museum is working hard at being more user friendly—open after working hours and considered a prime pick-up arena. (It remains to be seen whether our contemporary efforts will sound as insidious as the Whitechapel's in the next century.) During the 1970s, the architecture of contemporary art muse-ums abandoned the pursuit of mansion design and followed the living habits of artists rather than collectors into abandoned or appropriated light manufacturing spaces. Loft living had begun in New York in the 1950s as artists sought large, cheap spaces; it spread outward from artists'

communities all over the country. By the late 1970s, loft living for nonartists was determined by chic rather than necessity.

The museum's imitation of commercial spaces corresponded, as Reesa Greenberg has shown, to the emphasis on process over product in artmaking in the 1960s and 1970s, "when, increasingly, art is defined and described as work." British curator Ivona Blazwick describes this trend as "a metaphoric space of pioneering, new frontiers and rugged individualism.... Converted industrial buildings come to emblematize opposition, 'real' experience and the heroic ethos of American culture." From such modest beginnings has sprung the gigantism of recent projects like the billion-dollar Getty Center or the Bilbao Guggenheim. In the interest of cheaper real estate and room to expand, the new palaces of culture tend to be removed from the traditional downtown core into neighborhoods being gentrified or rehabbed. Greenberg also provides a gendered reading of this development, perceiving the move from intimate mansions to sterile factories as a reclamation of masculine space for (masculine) art at a time when feminist artists were gathered at the museum gates. Jo Anne Berlowitz has in turn suggested that the still newer "postmodern museum" is characterized by a nonindustrial "site of exhibitionism and voyeurism" that is "feminine, spectacular, curvilinear, sprawling."

Diane Neumaier, *Glasstopped Table and Pension chair, Museum of Modern Art,* New York, from *Museum Studies* series, 1986-1990, black and white photograph.

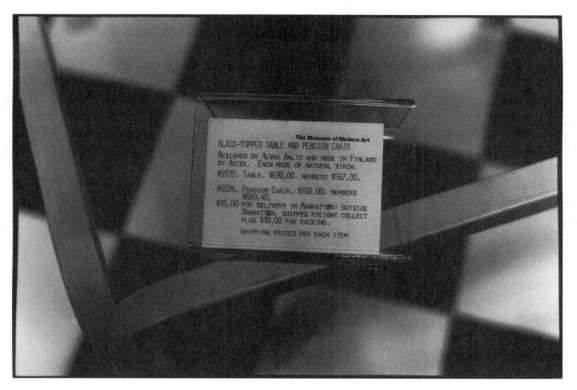

The blur between art and life—that unrequited love so many avant-garde artists futilely pursue while remaining safely within the art context—is paralleled by the blur between art and commerce. On Christmas Eve 1997, my local paper ran an editorial on the virtues of the Museum Shop:

The attacks on the merchandising around our cultural institutions...are misplaced and over-look the greater good that can be served by an M. C. Escher tie, a Monet coffee mug or an ersatz African mask.... Few people can afford original art, but many have grown to appreci-ate it. Some appear to want to live around art, using it to decorate their homes....The benefit to the museum-going public, including the critics, beyond the purchase profit, is the chance that while in the museum, these shop-pers do sometimes venture into exhibits.

Contemporary museums, having held themselves haughtily above stores and tourist attractions for close to a century, today fall ecstatically or reluc-tantly into the embrace of corporate sponsorship, full-page slick advertising, and dependence on their ever-bigger, ever-less art-focused museum shops—all geared to the needs of tourists. J. Ho-berman has broken down the "haute kitsch" of museum shops into department store, boutique, and curio shop categories. While the museum, assumed to be simply a repository for works of art and informational material, can also be understood as a work of art in itself, some museum shops actu-ally *are* works of art commissioned from artists such as Daniel Spoerri and Red Grooms. The "gift shop movement" has penetrated the museum market. Proponents of the crafts and so-called "minor" arts complain justifiably that their works are used to prop up the high arts but would never be shown on their own strengths in museums that perceive them merely as a service component.

Far more insidious than museum shops is the self-censorship that accompanies corporate sponsorship. As historian Tom Engelhardt asks rhetorically, "Is there such a thing any more as a museum show that is not an ad?" The increas-ingly validated corporate takeovers of museums by big business puts political pressure on muse-ums to be inaccurate or incomplete for a "cause." The blanding out of the Enola Gay show at the Smithsonian in 1995 was a classic example. In 1997 the preeminent museum did it again, with *Oil from the Arctic: Building the Trans-Alaska Pipeline*, "made possible" by a grant from Alyeska Pipeline Service Company, a consortium of Arco, British Petroleum and Exxon, et al., which built the pipeline. Alyeska also paid for the lavish opening party. It is, therefore, no surprise that such a toothless (and shameless) exhibition conforms to its donors' expectations and political agenda. Public and political ethics are diluted so they'll slide all the more easily down the drain. In art, as elsewhere, we are more and more dependent on (rare) individual integrity.

FOR ART'S SAKE

Contemporary art—large, flashy, in your face, mysteriously provocative, or bafflingly abstruse—is a big draw for museums today, bringing with it a greater need and role for docents and educators, the front-line museum staff who face the public to defend whatever the upper echelons have decided to impose on it. Modern visual artists typically have mixed feelings about museums. Everybody wants to have their work in them, but everybody also knows the institution itself often

contradicts everything the avant-garde (ideally) stands for—risk, innovation, adventure, information, and provocation. The museum is sometimes described as a salvage operation, containing all those fortunate objects and artworks that happened to survive. Yet once an object has survived, it has another gauntlet to run. It must prove "valuable" on some level. Precisely because museums decree what is valued in a society (by someone, somewhere, in any case), artists have a personal interest in passing their work through the museological needle's eye and on to posterity. Socially conscious artists would prefer not to be contextualized by a quintessentially capitalist and colonialist value system, but they are often powerless against co-optation. Urban museums today offer many scary examples of so-called rebellious creativity hung up—the off-the-wall put back on-the-wall, like a trophy head.

Sometimes artists create their own frameworks within the museums themselves—museums within museums. The idea has been in the air since the late 1960s, first manifested as good-natured internal spoofs rather than critical analyses. Among others, artists such as Claes Oldenburg (*Mouse Museum*, mid-1960s, reconstructed 1992), Andy Warhol (*Raiding the Icebox* at the Rhode Island School of Design Museum, 1970, an idiosyncratic personal selection from the museum's collections), and Marcel Broodthaers (the traveling *Musée d'Art Moderne*, 1968–72, described by one critic as "really nothing more than a collection of institutional gestures") had already made their own minimuseums as individual installation works.

During the anti–Vietnam War movement, convinced that museums help form public opinion, the Artworkers Coalition (AWC) targeted New York's Museum of Modern Art in 1969. Art Strike, a related group, zeroed in on the Metropolitan in 1970, pointing to the corporate figures who bedecked the Board of Trustees and supported the war. At the same time, the AWC's Decentralization Committee proposed cultural centers in a number of New York's poorer neighborhoods that would showcase culturally specific objects from the city museums' storage vaults. Also in 1970, the Ad Hoc Women Artists' Committee tackled the Whitney Museum of American Art and raised the glass ceiling a few feet for the next two decades.

Conceptual artists, some of whom had bypassed the art institutions for several years, got the ball rolling from within the belly of the beast in 1970 at the Museum of Modern Art's atypical *Information* show, curated by Kynaston McShine. In 1971, when Hans Haacke went up against the Guggenheim Museum with a captioned photo series scrutinizing not the museum but absentee landlords on the Lower East Side, his one-man show was promptly canceled. This experience only served to escalate his now-famous criticisms-as-art of corporate-museum collusion, exploring the infrastructures of the museum system itself. In 1973, Mierle Laderman Ukeles "maintained" the Wadsworth Atheneum in Hartford by washing its floors, calling attention to women's roles in these institutions at a time when very few women held top museum positions. The only artist to bore from within on a more sustained basis was Chris Cook, who directed the Institute of Contemporary Arts in Boston for a year, documenting the process as a work of art. (He then went on to direct the Addison Gallery of American Art in Andover, Mass.).

In 1976, Artists Meeting for Cultural Change (AMCC) was founded in New York to protest the way the art world was celebrating the nation's bicentennial, specifically the Whitney Museum's decision to exhibit the private collection of John D. Rockefeller III, (superciliously titled *American*

Art) as its patriotic contribution to "objective" history. An AMCC committee included Carol Duncan and Allan Wallach (who went on to make significant contributions to art historical analyses of the museum), "socialist formalist" painter Rudolf Baranik, conceptual artists Sarah Charlesworth, Joseph Kosuth (who would years later do an innovative artwork-as-museum show on censorship at the Brooklyn Museum), and Janet Koenig (who once depicted the Guggenheim as a spaceship). They published an anti-*catalog* (1977), which raised issues of representation in the Rockefeller collection (one woman artist, one African-American, no other minorities) and about the sources of Rockefeller money, recalling other less-than-proud Rockefeller-produced moments in American history. An anti-*catalog* also inspired Cherokee artist-writer Jimmie Durham's first

Greg Sholette, *Culture and Barbarism,* 1991, photo diorama and canvas, two panels, 40" x 30" each. Sholette departed from a quotation by Walter Benjamin: "There is no document of civilization which is not at the same time a document of barbarism." This piece, pairing two products of Rockefeller-funded enterprises—the opening of an exhibition of political art (which included Sholette's work) at New York's Museum of Modern Art (1988) and the Ludlow Massacre of striking miners in a tent city in Colorado (1915)—points out the unseen contradiction between aesthetics and history, and asks, "How is a serious political artist supposed to contend with this situation?"

critique of museology on Indians. In his essay "Mr. Catlin and Mr. Rockefeller Tame the Wilderness," he remarked on the Rockefellers' economic base in oil fields stolen from Native people. Durham later created his own sarcastic miniature museum displays of fake Indian artifacts and expeditionary souvenirs.

"Because it calls the neutrality of art into question, this anti-Catalog will be seen as a political statement," said the publication's cover text. "It is, in reality, no more political than the viewpoint of official culture. The singularity of that viewpoint—the way it advances the interests of a class—is difficult to see because in our society that viewpoint is so pervasive.... The critical examination of culture is thus a necessary step in gaining control over the meaning we give our lives." The

collective pointed out that the primary purpose of art museum catalogues is "to affirm the commodity nature of individual works and entire collections" and that "philanthropy in the form of cultural charity is also an extremely effective way of shaping the nation's perception of itself and its history." They went on to say (with illustrations of two "fortress museums"—the moated Whitney and the crenelated Denver Art Museum): "We are often assured that museums are central to our existence as civilized, spiritually complete beings. We are also told that museums bring art closer to people and help make art a part of life. A visit to almost any modern art museum teaches the exact opposite of these claims. Inside and out, modern museums are designed to keep art away from people...and to keep art removed from daily life."

MUSEUMIZING THE MUSEUM

The tenets of *an anti-catalog* laid the groundwork for the growing number of artists during the 1980s and 1990s concerned with institutional power, installation techniques, commercial connections, and collecting as theft and cultural insult. Art about museums is art about art—a popular mainstream subject for over thirty years—but many of these artists are also determined to fuse art and social life. This despite the fact that once an object or series thereof is in a box, a room, a building, a concocted context, once it is *framed*, it has been surrendered largely to the aesthetic—or to its alter ego, the anti-aesthetic.

When an artist takes on a museum s/he is consciously or not creating a Shakespearean play within a play. (German artist Thomas Struth has taken this to its illogical end by photographing people in museums, which are then shown in museums to be looked at by a new audience; if someone were to photograph this round, the

process could go on down the line to infinity like a mirror box.) In the 1960s, several conceptual artists (among them Daniel Buren, Lee Lozano, Robert Huot, and Stephen Kaltenbach) raised the issue of an avant-garde art that rejects museum contexts but welcomes the attention, by making works in museums that referred the viewer back out to sites around the city. In the next decade, Charles Simonds continued the notion with his permanent installation of a clay landscape and ruin on a windowsill in the stairwell of the Whitney Museum, which originally looked out at its counterpart on a building across Madison Avenue (now demolished) and, by implication, to the rest of the city where he was working in the streets at the time.

For a 1992 exhibition titled *The Power of the City/The City of Power* at the soon-to-be defunct Whitney Museum Downtown, Lois Nesbitt posted a simulated museum label identifying the museum

building as a "fossil-to-be" with "date of extinction" because corporate sponsors were withdrawing their support at the same time that forty-nine other New York galleries were forced out of business by a recession. She labeled the exteriors of those sites too. Andrea Fraser, a.k.a "docent Jane Castleton," provided guided tours to the New Museum's 1986 exhibition *Damaged Goods* (a comment on art-commodities), which included the security systems. In 1993, she made an audio piece at the Venice Biennale consisting of conversations between visitors that exposed hidden nationalistic

Hans Haacke, *Helmsboro Country,* 1990,
silkscreen prints and photo on wood, cardboard, paper.
30 1/2" x 80" x 47 1/4" (photo: Hans Haacke). A
portrait of North Carolina Senator Jesse Helms—friend
of the tobacco industry, enemy of the arts—appears on
the package. Also known for his racism and homophobia, Helms's connection with Philip Morris caused ACT-UP to call for a boycott of Marlboro cigarettes and for artists to withdraw from Philip Morris-sponsored exhibitions. Haacke's gallery was threatened with legal action if it showed this work; it did and nothing happened. Haacke has protested the involvement of Philip Morris in a number of museum shows, pointing out that in 1994 Philip Morris threatened to withhold its sponsorship of cultural events in New York if the City Council passed a ban on smoking, thus soliciting museum officials as tobacco lobbyists.

agendas; Ms. Castelton continues to find new ways to intervene in the museum interpretation process. On a different front, Diane Neumaier's photo series called *Metropolitan Tits* gave a hilarious overview of the museological fixation on the female body as aesthetic nourishment. Sophie Calle and Zoe Leonard have also performed gender surgery on the museums, intervening with incongruous images of the female anatomy.

Occasionally museums have sponsored "city-wide" exhibitions in which selected artists are commissioned to make public art. However, artists who overtly oppose aestheticization of social issues usually do so in a context that remains primarily aesthetic, and they can be clever about acknowledging this dilemma. Works like Hans Haacke's straightforward exposés of the money behind the art world thrones and Louise Lawler's subtle photographic intrusions into the spatial politics of collection and display are significant for bringing these issues to public attention. Haacke uses museums to reveal social realities that in turn undermine the museum's lofty goals (those in Europe are far more likely than those in the United States to let themselves in for his scrutiny). He decries the myth that the museum is set apart from those realities, pointing out the suspicious business and political backgrounds of collectors, devious corporate "cultural" advertising that whitewashes sponsorships, and censorship under corporate pressure. In a work called *Helmsboro Country,* for instance, he quoted the chairman of Philip Morris's executive committee in 1980: "Let's be clear about one thing. Our fundamental interest in the arts is self-interest. There are immediate and pragmatic benefits to be derived as business entities."

Questions have been raised about whether Haacke himself is co-opted by the art spaces in which he makes these works. He balances be-

Group Material, *Americana,* Whitney Museum of American Art, 1985.

tween preaching to the converted and successfully sabotaging the very hand that feeds him. Artists whose home context is the art world often prove too ironic and too sophisticated for the outside world. When Haacke installed the absentee landlords piece that closed his Guggenheim show at the union headquarters of District 1199, union members were unimpressed. They knew this story, new to many middle-class museum goers. On the other hand, within the art context Haacke has often been a lone voice of integrity. For example, he correctly contends that it would be "unthinkable" for his work to be shown at Harvard's Busch Reisinger museum, which specializes in German art and has a "Daimler-Benz Curator" holding a chair underwritten by Mercedes.

Beginning in the late 1970s, the New York artists' collective Group Material pioneered a consciously inclusive and formally striking exhibition style that lent itself to an aesthetic heteroglossia and political agenda. (In the early 1980s, they were joined by other rebellious artists groups, such as CoLab, World War 3, Fashion Moda, PAD/D, as well as Jerry Kearns and myself working in partnership.) Group Material's shows were "exhibitions as artworks," because the whole superseded the parts in both form and content. Exhibiting, like CoLab, with a "parasitic" approach (commandeering unused spaces or making shows within shows in alternative and in official institutions, including museums), Group Material often painted its walls red, cavalierly combining pop culture, found objects, and "art." They hung these *mezclas* innovatively, with art leaning against the wall or reaching to the ceiling, and dynamically used both material culture and didactic texts.

For instance: *Time Line: Central America* at New York's PS 1 in 1984 vividly told the history of U.S. intervention in Central and Latin America by means of a time line of dates and places and a great variety of art and objects below, including piles of coffee, bananas, beans, and sugar on the floor. In *Americana,* a one-room installation within the Whitney Museum's 1985 Biennial, the

collective unpatronizingly employed kitsch and commerce to question the American dream, bringing into the museum dozens of artists who would have been unlikely to show at the Whitney out of this context. Brand names like Wonder, Total, Home Pride, a blender, an electric can opener and a G.E. washer and dryer called Harvest Gold made their point about consumerism as strongly as the art did. The class struggle was introduced by Bold, All, Gain, and Cold Power. The soundtrack was a pointed collection of songs such as "You're Blind," "We're Not Gonna Take It," and "I Don't Wanna Play House."

Group Material brought to exhibition display a vital and unmistakable style as well as an openly social perspective that did not exclude a generational iconoclasm. While installation art is now a staple of contemporary art in museum exhibitions, museums themselves have not noticeably varied their own standard exhibition techniques. The "White Cube" of Brian O'Doherty's influential book is still the norm. Rich, dark colors may be employed in historical collections but contemporary art seems doomed to be hung white forever.

MINDING THE MUSEUM

A millennial interest in history, combined with the visual allure of historical "found objects" as raw material for art, led a number of contemporary artists in the 1990s to a preoccupation with historical and personal memory. But it was not until Fred Wilson came along that the historical museum was literally turned inside-out. Wilson built on and expanded artists' works about museums of the past twenty-five years. With several years of exhibition experience and employment by museums under his belt, he told the public art collective REPOhistory in 1992, "A historical museum has a different mind-set than an art museum—it's a repository. Sometimes they don't even know what all they have, but they have to try to keep it physically safe… old ledgers of what's in the collection are fascinating in themselves." Wilson's advice to REPOhistory artists who were proposing work within museums: "Tell them 'This is how artists work. This is what we need. Remember, you brought us here to make a leap. Let us make it.'"

In a remarkable conjunction of energies, Wilson got the chance to do just that in 1992 when he executed the genre's masterpiece, *Mining the Museum*. He had realized by then that "it wasn't so much the objects as the way the things were placed" that offended him as an African/Native/Euro-American. Facilitated by "The Contemporary" (a placeless institution in Baltimore), aided and abetted by curator Lisa Corrin, and surprisingly welcomed by the institution he chose for its conservatism (the Maryland Historical Society), Wilson was given a whole floor on which to recontextualize the museum's collections. He had led up to this work with a series of installations, beginning in the late 1980s, that questioned political assumptions and difference in: display and labeling techniques in art and ethnographic museums (*Rooms with a View*); cultural bias in art history and the dismissal of Egyptian sources for classical sculpture (*Panta Rhei*); colonialist collecting (*The Other Museum*); the role of the often African American guard (*Guarding the View*); and the problems of repatriation (in the New Museum's show *The Big Nothing*, where he showed empty vitrines with signs stating that the stolen objects once there had been returned to their countries of origin).

The title of *Mining the Museum* testifies to its scholarly and subversive intent. Wilson simultaneously excavated resources (the obscure and

Fred Wilson, *Guarded View*, 1991, from installation *Primitivism High and Low*,
at Metro Pictures, New York City (photo: courtesy Metro Pictures).

Fred Wilson, *American Metalwork 1794–1880*, 1992, from *Mining the Museum*
at the Maryland Historical Society, Baltimore (photo: courtesy Metro Pictures).

often-shocking objects he found in storage), reclaimed the museum for the artist, and blew up standard presentations of history. He worked at the Maryland Historical Society for over a year, unearthing the unexpected, reshuffling the collection, and in the process reorienting the audience's preconceptions about art, history, and race. The only objects he introduced from the outside were photographs of contemporary Native people in Maryland (the Historical Society had told him there were no more Indians in the state). These photographs on the wall were seen by the viewer through a "screen" of several cigar store Indians, with their backs to the viewers.

Inclusions and exclusions were given equal time. Works were renamed in order to give black protagonists an identity (*Country Life* became *Frederick Serving Fruit*), or to raise them from obscurity (the illustrated notebooks of Benjamin Banneker, a black mathematician-astronomer neglected in his home state). A Ku Klux Klan hood rested venomously in a baby's pram. Portraits of aristocratic children were haunted by the wistful, shadowy figures of slave children. One painting included a black boy with a metal collar around his neck, holding a dead bird; he was, literally, a "retriever." These children were given voices of their own by an audio device, and they asked, "Who calms me when I'm afraid? Am I your friend? Am I your brother? Am I your pet?"

The general public was occasionally more baffled than provoked by such internal criticism. The conventional museum itself can be enough of a jolt to those unaccustomed to its intricacies, without having other expectations rocked as well. Depending on their politics and background, visitors tended to love or hate *Mining the Museum*, but for the most part they seemed to get it. The casual presence of slave shackles in the same vitrine as a handsome eighteenth-century silver tea service,

the ensemble labeled with lethal factuality *American Metalwork 1794–1880*, left no escape. At this intersection, education and interpretation become major factors in the museum experience. One of the texts in the handsome book on the installation is a revealing conversation on race with the Historical Society's docents. Comments in the museum's fascinating guest book defined the abyss between the usual supporters of the Historical Society and a new African American audience attracted by Wilson's show.

Mining the Museum has become a model, almost infinitely expandable, for museum workers as well as for artists, sharing that role with *A Museum Looks at Itself* (1992) in which curator Donna De Salvo boldly examined some sacred cows—the history of the Parrish Museum in Southampton, N.Y., and the founder's collections and motivations. Inspired by Robert Smithson's classic 1968 photo essay, "A Tour of the Monuments of Passaic, New Jersey," De Salvo followed the institutional path backward, "acknowledging the museum itself as artifact." She "incorporated objects once esteemed by the museum's founder into new, critically reflexive displays," writes Lisa Corrin. "The exhibition looked at the way in which the values and political stances of those in power dictated the collecting practices of the museum, which is located between an elite summer playground and a year-round rural community that is home to many Native Americans and other people of color."

Nevertheless, museums have usually preferred to parody or examine their techniques rather than to change them. In 1992, the New Museum put on a show (*The Big Nothing ou le Presque rien*) about "turning the illusion of emptiness" (the museum space itself) "into a palpable experience... de-emphasizing the art object and calling attention to the museum as a display space." Next came

Vasif Kortun's show *Exhibited* at Bard College in 1994, accompanied by a booklet with two strong essays by Norman Batkin and Reesa Greenberg, then Trevor Fairbrother's *Label Show* at the Boston Museum of Fine Arts, focusing on recent art about museums by Lawler, Struth, and Alan McCollum, among others. Other reflexive museum shows were *Desire and the Museum* at the Whitney Downtown (1989), and *Art Inside Out* at the Art Institute of Chicago (1992). In 1992, Simon Grennan's and Christopher Sperandio's *At Home with the Collection* (at the Lakeview Museum of Art in Peoria, Illinois) dealt with the influence of museum curators' personal taste. In Ghent, the 1993 museum show *"Rendez(-)Vous"* featured favorite objects brought in by the public and rearranged by artists (including Jimmie Durham and Ilya Kabakov) to find new relationships.

OUT FROM UNDER GLASS

It's Saturday night, and the Brooklyn Museum of Art is buzzing with conversation. Four twenty-somethings on a double date stop to read about a Monet exhibit that is drawing crowds, three women engage in an animated discussion nearby, and a couple parks a stroller by a Rodin statue and hoists a baby high in the air to take a closer look. "It's all about exposing her to art," Michael Citron, 41, says of Tess, his 19-month-old daughter. Tess, gripping a Linnea in Monet's Garden doll from the New York museum's gift shop, bounces in agreement on her father's shoulders.—MARK MORRISON

Despite its new hours, its new buildings, and its new devotion to accessibility, the American museum remains contested ground. Like our television and our educational system, it is an arena in which differing tastes, cultures, needs, and ideologies battle it out. Every museum worth its salt takes up a real challenge now and then, reaffirming the lofty mission of art as spiritual advisor, risking institutional reputation, and defying the "religious" zealots at its gates. At the same time, museums have their own religion to defend: "The museum is a different social space in a spiritually indifferent society, a kind of sanctuary in a society from which there is no hiding. But it is rapidly losing its difference," writes Donald Kuspit from within his crusader's armor.

At this point, education—and not only for children—becomes a key defense. Entertainment versus education. But must it be either/or? Art is not just entertainment, but it certainly doesn't hurt to entertain while the aesthetics are sinking in and/or the message is getting across. Some think art tourism threatens "quality," an elitist stronghold that is always being threatened from front (avant-garde) or back (populist) doors. Art appreciators tend to be nauseatingly unspecific about any social issues the artist may be trying to raise, however obscurely. Good art educators urge people to think for themselves, while providing social context and background information. Bad art educators act as though there were a single interpretation to be handed down to the unwashed.

The conventional museum now appears to be an easy target for critical arts. What is far more difficult is coming up, as Fred Wilson has, with new ideas about how to show art *and* show its context. The artists tackling this situation will

provide their own definition of *quality* as they collaborate with curators and/or subversively usurp some of the curators' power. (The powerful board of trustees remains untouchable.) So far as I know, no institution has tried an orchestrated back-and-forth process through art, so that tourists channeled into the cultural institutions are called out into the streets to look around, and those in the streets who weren't planning to go to a museum are lured inside. In the future, maybe artists and curators will begin to emphasize a dialectic between what's inside and what's outside the museum, who's inside and who's outside, encouraging more coming and going between the two, a touristic strategy applicable to art.

CURIOUSER AND CURIOUSER

The Popular "Museum"

Art is what makes life more interesting than art.—ROBERT FILLIOU

Peter Woodruff, *Antique shop corner,* 1998, black and white photograph,
Cobblestone and Co., in Bath, Maine.

'VE BEEN GOING on for years about merging art and life to the extent that people can be exposed to art without knowing what hit them, without the golden curtain effect that makes too many people feel excluded or just plain bored. So at first I was pulled up short by Boris Groys's essay "The Display of Art in Totalitarian Space," in which he declares that the attempt "to create a single, total, visual space within which to efface the boundary separating art from life, the museum from practical life, contemplation from action," amounts to totalitarianism, engineered by a Soviet avant garde that was not just successful, but temporarily triumphant.

I will refer you to Groys's fascinating essay rather than trying to summarize it, but a few quotations are worth throwing out in this context of popular or populist "museums." At the time of the revolution, he says, there was a question of what to do with all previously collected art. "Hastily requisitioned from the former ruling classes, the artistic heritage of the past had been transformed into a single chaotic mass that was now supposed to be reorganized on the basis of completely new social and aesthetic criteria." This is of course precisely what many revisionist historians and progressive avant-garde art types, myself included, would like to see happen in this country right now. What a field day Fred Wilson disciples would have rearranging that chaotic mass.

But Groys goes on to say that museums were associated with the *vita contemplativa*, which in turn was associated with the upper and middle classes. Their "purely consumerist" approach to art was "unsuited from the outset to a dictatorship of the proletariat," supposedly oriented toward production and "embodying in itself the *vita activa* in pure form. For a proletarian to go to a museum to gaze on the beautiful meant that his labors toward the aesthetic transformation of life itself had failed.

The avant-garde aesthetic understood the museum-as-temple-of-beauty exclusively as compensation for an absence of beauty in life itself."

The new Soviet museums became purely didactic and utilitarian, "oriented not toward the heterogeneity of historical artistic styles or the representation of the historically original in art, but toward homogeneity, the establishment of common ground, and the elucidation of what is identical in all of world culture"—what might be called the liberal position. However, Groys observes, the avant garde insisted on seeing this space where "everyday praxis would coincide with art" as "stylistically opposed to tradition, which is to say that it continued to see it in a museum perspective," while the communist leaders chose not merely to liquidate the old culture but to requisition it "on the level of ideology." At the same time, the artist Kasimir Malevich suggested replacing the old art stuff with the non-art stuff of everyday life.

"A genuine triumph over the 'museum' perspective could be achieved not simply by destroying the museum," writes Groys, "which would leave in its wake a void capable of being filled with new representations, but instead by integrating the museum into the totality of production or the social process." The Stalinist period "brought about this very kind of integration by radically utilitarizing art instead of aestheticizing utilitarian reality."

These ideas resonate in contemporary practice, where the lack of social context for avant-garde art places it firmly and inescapably in the clutches of the museum. The revisionist strategy of literally appropriating art from the past to make it *conform* to current concerns, a kind of art historical "cannibalism," was a postmodernist staple in the 1980s, when pompous expressionism, social neglect, and Reaganistic consumerism rode roughshod over subtler concerns. The introduc-

tion of nonart into the museum can be understood either as a Duchampian gesture, as in the Museum of Modern Art's limpid High/Low exhibition, or, more significantly, as a political strategy, as in the hybrid exhibitions of the late 1970s and '80s that introduced a museumistic frame to everyday life. Among them: Group Material's *Arroz con Mango* in New York, Jack Baker's *Museum of Neighborhood Phenomena* in Seattle, the nomadic *The Unknown Museum* of Mickey McGowan (a self-described "lifework artist") in northern California, and Bolek Greczynski's extraordinary Living Museum made with patients at Creedmoor Psychiatric Center in Queens, N.Y., upsetting all preconceptions of the art of the mentally ill.

Artier, museum-within-a-museum collections include Joni Mabe's *Traveling Museum of Obsessions, Personalities and Oddities* (focused on Southern cultural kitsch, including Elvis memorabilia, hubcaps, plastic flowers, and the like), or Mark Dion's two-part installation at the Bronbeek Royal Veterans Home in Sonsbeek, Holland (which juxtaposed a recreated nineteenth-century curio cabinet with a motley collection of objects chosen by the resident veterans). Renée Stout's contribution to the important 1991 "Site-Seeing" exhibition at New York's Whitney Downtown offered the experiences of a fictional alter ego: "Colonel Frank" was an African/Native American seeking his own history in an environment that closely resembled but inverted the parameters of the nineteenth-century explorer and trophy hunter. Stout implied that Colonel Frank collected objects and places in order to understand his hybrid identity rather than to nourish himself on others' lives, though it is questionable how many people would get this subtlety, beyond the race reversal. This is by no means an exhaustive or historical list of artists paying homage with their imitations of the popular or populist museum.

Even among this eccentric gathering, David Wilson's enigmatic Museum of Jurassic Technology in Los Angeles stands alone. Primarily the work of an artist who has gone much further than making a museum for his art, or parodying official museums, it has become something of a cult object. The museum throws visitors off balance. No one quite knows what to make of it. This dimly lit, mysterious place opens up a whole new world with its pseudo-scientific exhibits about people and phenomena no one ever knew they wanted to know about. One exhibition was titled *No One May Ever Have the Same Knowledge Again* (consisting of "letters to Mt. Wilson Observatory 1915–1935). The works and installations (handsome cabinetry and old-fashioned glass vitrines abounding) are preciously beautiful in themselves, but it is the overall context that endows them with such an aura of wonder.

Credulity is strained at the Museum of Jurassic Technology as a matter of fact. Cultural critic Ralph Rugoff, one of its most eloquent fans, has arrived at the "irrevocable conclusion" that the museum isn't what it says it is—"an ethnographic and natural history museum of the lower Jurassic If not an outright imposter," he writes,

at the very best it has to be considered an unreliable narrator.... Even when the suspicion arises that fact and fiction have been deftly intermingled, it remains difficult to delineate their respective borders. By making use of information that lies on the edges of our cultural literacy—things we've heard of but don't necessarily know much about, such as bat radar, ultraviolet rays, or the Jurassic itself—the museum draws us into a shadowy zone where exhibits slip from the factual to the metaphorical with disarming fluency. It is this fluency which makes the seduction irresistible.

The Museum of Jurassic Technology avoids *being* kitsch while enshrining aspects of kitsch culture. Among its deadpan, turn-of the-century government-style publications, my favorite is *Garden of Eden on Wheels: Selected Collections from Los Angeles Area Mobile Home and Trailer Parks*. A modest, pocket-sized, brown-paper-covered text to accompany an exhibition that includes trailer dioramas and models, it consists mostly of straightforward close-up photos of the collectibles, which range from individual "jewels" in costume jewelry to antique laces and underwear, crocheted baby clothes, potholders, china, pincushions and glassware. The lead essay is written by the "Keeper of Folk, Traditional and Urban Handcrafts at the Eesti NSV üdhariduskoolide õpilaste töid in Tallinn, Estonia." (In Jurassic contexts, you are never sure if you are dreaming.)

In their "learning from Las Vegas" phase in the early 1960s, architects Robert Venturi and Denise Scott Brown, as well as the British writer Rayner Banham writing on Los Angeles, recognized a preexisting phenomenon that could be called "landscape camp." (The Center for Land Use Interpretation, based in the same building as the Museum of Jurassic Technology, shares its ambiguous approach to the apparently ordinary; see "Parking Places," below.) Appropriating commercial vulgarities and picking up on roadside/Pop Art esthetics, Venturi and Scott Brown learned from Las Vegas, and popularized the choice of brazen kitsch over classy solemnity or ruined and

Untitled, 1989, mixed-media display in the **Museum of Jurassic Technology'**s foundation collection, from an early exhibition (photo: courtesy Museum of Jurassic Technology). This complex piece had no caption or didactic text. The viewer made of it what s/he would. At either end of the case was a set of beam splitters that created a catoptric camera (a seventeenth-century invention). Viewers at either end could look into the splitters and see the cast head, which appeared to be floating in space. A concealed video screen and folding mirrors created the illusion of hands translating into American Sign Language a text retelling dreams, also heard through small speakers.

Michelle van Parys, *Salvation Mountain*, 1989, black and white photograph
(photo: copyright Michelle van Parys). For over ten years, Leonard Knight has been transforming this hillside—
on the edge of a bombing range, in a community of RVs and shacks called Slab City, near Niland, California—
with adobe, cement and paint into a monumental religious sculpture featuring in huge letters the phrase
God Is Love. He lives in his artful truck, which displays the same message.

faded elegance that eventually led into architectural postmodernism. The aestheticization or destigmatization of Las Vegas as the ultimate neon strip remains an outstanding symptom of this now long-term syndrome, most recently extolled by art critic Dave Hickey, who loves living in Las Vegas, and loves to flaunt his devotion.

It is context that determines whether kitsch is amusing, charming and meaningful or a blight on the landscape and a gag on our national consciousness. Intimate domestic contexts soften the edges of raw commodification. If everyone has a flamingo in their front yard, flamingos help define "yard," just as marble bird baths may define "lawns" and "gardens" in a more upscale context. David Lloyd observes that kitsch and folk

art and lore are two different responses to the longing for authenticity, to the search for sameness that provides community. Pop Art provided one milieu for looking at popular culture, and almost forty years later postmodernism promotes another. In the interim, we have indeed become a society of visitors, of onlookers, a society of spectacle, as Guy Debord and the French Situationists so brilliantly perceived. The hip postmodern tourist looking rather condescendingly for "significant cultural phenomena" wallows in inauthenticity. The belief that reality is prey at every turn to distortion by language, and therefore no longer exists, has led to virtual reality in the pop-culture domain and a mystification of the inauthentic in the academic realm.

There was so much junk in the shop, we either had to close down or think of something new.
I don't really know what an artist is. Depends on what you think art is.
You can call anything art.—VOLLIS SIMPSON, vernacular artist and creator
of Windmill Park, Moore's Crossroads, Lucama, N.C.

Official museums have become so clinically professional that life's inadvertent surprises are neglected and concealed within them. Even when a museum's staff thinks it is making the collections "more accessible," with computerized games and pull-out drawers, everything is still too well lit, too visibly insistent. The allure of mystery is absent. Darkness can be punctuated by light, by illumination, but not the other way around. The shadow is the arena of discovery and surprise. Like the Museum of Jurassic Technology, junkyards, thrift shops, bookbarns, and rural antique shops still offer the dark corner, the dusty pile, the collection caught *en deshabille*—pleasures usually reserved for curators or custodians. The embrace of disorder is welcoming to the collective unconscious. The search is the journey. An antique store even in one's hometown can provide the stuff of tourism, the hint of the strange, the foreign. So, for that matter, can the library or the historical society, but they're harder work. Either way you have to labor—like an artist—to make your own chaos into your own order.

The alternatives to the institutional museum ruled by those who own everything have ironically emerged from the realm of popular culture. If artists, being artists, can neither wholly escape nor wholly transform the museum context as it reflects corporate utilitarianism, there are other places out there—inadvertent collages—that may perform similar, if nonironic, functions. Long ago, I adopted the collage aesthetic as my modus vivendi. Because I'm drawn to found objects and found collections—conscious and unconscious,

in and out of their own contexts—and because art is my field, my own tourist experience has always included a preponderance of funky museums, historical societies, secondhand bookstores, roadside collections, thrift shops, rummage sales, antique shops, and their very close relative—the junk shop. (I don't buy much. My museum-going experience has made me an expert browser.) Such compendia are in themselves among the most fascinating artifacts of our own Western culture.

Object makers are challenged by the role of souvenirs—tangible, portable objects that mean memory. When we buy a souvenir, we risk conflating our memories with those of others, or those constructed for us by the very people we want to remember on our own terms. Susan Stewart observes that for the invention of tourist art, or the "exotic object to take place, there must first be separation. It must be clear that the object is estranged from the context in which it will be displayed as a souvenir." Can some objects, like those in yard sales, be *temporarily* exotic? Simultaneously absorbed into life and sporadically framed as exotic merely by the glance? It's like the problem of authentic and inauthentic: can we really tell them apart? Why not just mix them up and let the chips fall where they may, subverting the academic privilege of distinctions in the process.

Antique stores are beginning to serve as educational micromuseums for the "masses." It should come as no surprise that the general public is uninterested in the middle-class cultural status-climbing offered by museums ("members'

openings, private studio visits, cozying up to the VIPs, whoever they may be in any particular community). People who rarely darken the doors of a museum are far more at home in curio shops, which slowly become populist museums. Here the same "old stuff" is displayed in a relaxed and random fashion, distanced as in a museum (perceived as elitist) but in ways far more attuned to how we experience life itself. And it's for sale! This ups the ante on both risk and seduction. Things are at least vaguely within reach. Americans love to covet; if not to buy, then to know that the potential for bargains is there.

Stores are hands-on, museums hands-off. Stores offer another, more familiar brand of "chaotic mass." The inaccurately labeled odds and ends in many antique shops lack the insistent separation of museum pieces. You can take the stuff home and truly contemplate it instead of pausing for an instant in the exhausting trek through far too many museumized items. Short of ownership, these can be picked up, perused, and fondled. Like sediment, they have come to

rest in our own public space, beyond or beneath the rarified atmosphere and admission fees of institutions. (Some antique shops actually do charge admission fees, and some historical societies, which are free, rival the shops' curiosities; I think of the ballpoint pen collection in a tiny New Mexico historical museum.)

During a recent Fourth of July parade and "heritage days" in a New England town, the stores on the main street stayed open and did a roaring business—especially the antique stores, which have been replacing the old utilitarian small businesses at quite a rate over the last few years, thanks in part to a small shopping center and a nearby Wal-Mart that have replaced downtown for daily needs. This process has changed the main street's character dramatically. Except for one diehard and very popular bargain department store, full of discounts and funky enough to qualify as a tourist attraction in itself, this particular street, like many other main streets across the continent, is no longer about sustenance, no longer about fish and hardware, but about shop-

Peter Woodruff, *Tip Top Weekly*, 1998, black and white photograph, Pollyanna's Antiques, Bath, Maine.

ping in the abstract, about frippery and frivolity, casual education and entertainment.

Watching the customers in the antique stores (I was one of them) on that day, I was struck by the museum-like aspect of the experience. But it was a liberated museum experience. Most of us were simply moving happily through the stores picking things up, looking at them, and putting them down, commenting to our companions, wondering (as we do in museums) about information the "curators" had not chosen to tell us. In some antique stores these days, the price tags include brief "historical" descriptions and some-

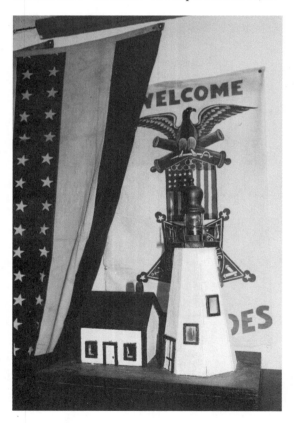

Peter Woodruff, *Welcome,* 1998, black and white photograph, Pollyanna's Antiques, Bath, Maine.

times generalized dates, which, of course, may or may not be accurate. (Nobody is held accountable for them.) But everybody learns a little something, a snippet, perhaps even a nugget, of oddball information. The history to be learned from these motley collections is not authoritative or continuous. It is full of gaps and pauses, like a collage, like a family album. Is inaccurate information better than none? In some cases, yes. A whiff of the past rather than a history course is all that most of us want or have time to take in. Oral histories, for instance, rarely coincide with documented dates, but that doesn't mean they are worthless. I know a "retarded" man who is a passionate history buff, and it is no less an intellectual pursuit for him than it is for me. So the antique store dates may be wrong. But a sense of history (and mortality) is transmitted by a worn old quilt, a cracked plate, a curious tool no longer in use. Familiarity *and* unfamiliarity are at play, in comfortable proximity.

Yes, some overheard responses are pretty dim ("Look, isn't this cute?") as they are in museums, or just plain curious ("I wonder what this is"); others testify to the connections made by familiarity ("Aunt Marge had one of those when I was little") or engender greed ("Whatever happened to that old afghan of Mom's?"). It's usually *this* instead of *that* when nothing is under glass, testifying to the level of intimacy. And we are a practical people: another common question is "What's this for?" or "What would you do with *that*?" Another familiar emotion is regret: "I had one of those, I wonder where it is now." (We gave it to the Working League Fair years ago because it was kind of unattractive and not yet old enough to regain its appeal.)

Perhaps because it was the Fourth of July, perhaps because elementary history in this country is imbued with a self-congratulatory national-

Artist's Collection of Plastic Shoes and Hats (salesman's samples), 1998, Lawrence, Kansas
(photo and collection: Roger Shimomura).

ism, perhaps because domestic tourism and shopping can be perceived as "America first" activities, I was also struck by the element of patriotism that pervaded antiquing. Exotica is "curious," but Americana is what people are after. The goods range hugely, from broken dime store frames to fish decoys to fine silver, from kitsch to elegance, rusty unidentified formally powerful hardware to vintage clothing, boat models to can openers. A man poked his head in the door and asked if they had any Stephen King novels (this was in Maine, Stephen King country). My unspoken reaction was *gimme a break, this is an antique store*, but the woman at the desk said pleasantly that she thought they did, though the books were in no particular order; he'd have to search it out, and he did.

The books aren't the only things that are all mixed up. It's a rare antique shop (or junk store) that offers much in the way of order. Items deemed most saleable are given pride of place.

The owner is the only one who knows where everything is, although there tend to be clumps of similar or related stuff at various places throughout the store. Order is not what people on vacation are looking for here. Maybe they want the spaces they visit to be as vacant as they are, so they can have the fun of making their own order (or becoming artists). And, of course, encouraging people to browse is an effective sales strategy as well as an educational tool. Such shops are like library stacks. You never know what you'll come across while you can't find what you came for.

Susan Stewart says "the antique as souvenir always bears the burden of nostalgia for experience impossibly distant in time" but the distance has become *very* elastic. My grandmother used to tell me that "antiques" meant anything over one hundred years old. At some point, this gap has diminished considerably. Twenty-five years may be the threshold now, or even less: vintage

clothes, for instance, may be from a 1980s revival. The borderline between antiques and junk is wavering. "How old is it?" is often the first question I find myself asking as I turn some peculiar object in my hand. If it's stamped *made in occupied Japan* it doesn't sound old to me, born as I was before World War II, but then I realize it's around fifty. And with that comes the shock of my own mortality.

Paralleling the antique shop as museum experience are roadside attractions such as the Snake Pit, Animal Safari, Mom and Pop caves, and small-time theme parks like Flintstones Village in Arizona. These are heirs to the sideshows, spectacles, and expositions of bygone times, as are the more staid and conservative "villages." Alexander Wilson has analyzed the affect and effects of a range of southeastern village theme parks: the Museum of Appalachia (notable for its unpretentious down-home atmosphere and massive, random collection of material culture), Dollywood (Dolly Parton's good-natured homage to her own Smoky Mountain childhood, crammed with crafts, artifacts and "hillbilly gewgaws"), Cades Cove (a local and transplanted collection of empty mountain buildings in a natural setting, minus costumed inhabitants and commodities, which Wilson found "enchanting"), and Heritage USA (a regimented Christian real-estate development near Charlotte, N.C., built by Jim and Tammy Bakker's PTL Club, a model of evangelical entrepreneurism and totally devoid of charm).

Bedrock City, Flintstones Village, Arizona, 1986 (photo: Brian Baker).

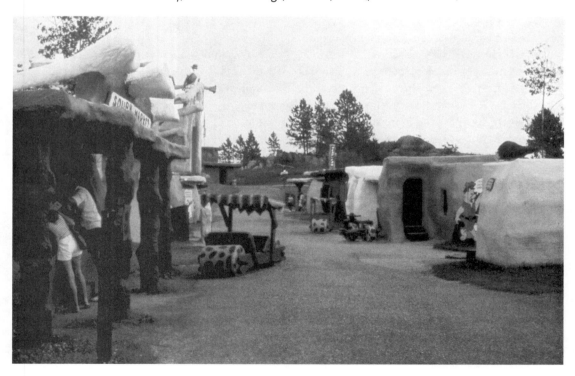

There are farm museums, machine museums, auto museums, sheriff's museums, and so on, from clean to canned, from malls to haunted attics. The variety of approaches evident in Wilson's small cross section of re-invented villages illustrates the complexity of the self-conscious remembering process and anxiety about the future, which are reflected in many populist museums.

Good-old-days rural theme parks (there are over one hundred such villages in the U.S.) can exist in isolation from the cultural and agricultural crises that surround them, ignoring issues of land use and local culture. On the other hand, they serve a function, well and badly, simply by triggering memory and calling attention to a continuity that neighboring towns may have lost sight of. Wilson preferred Cades Cove because it offers spatial access to history. In places like this, which are not artificially cordoned off as parks, the history of land can be read and contemplated in a certain peace and at a certain pace. An antidote to manufactured quaintness in Appalachia is found in the cultural and media work done by Appalshop, in Whitesburg, Kentucky, which also entertains and maintains memory but does so in its theater, video, and radio works with a level of, yes, *authenticity*, that isn't imported and superimposed on local lives, but emerges from contemporary collaboration. For a younger urban generation untouched by nostalgia for even the vestiges of such small-town and rural life, Sim-City—a hyperaccelerated demographic development computer game—replaces site visits. Why wander through melancholy pasts when exciting futures can be concocted without budging from the screen? Yet land-based history can best or only be experienced kinesthetically, within the spaces themselves. A lot gets lost in an armchair.

THE PRIMORDIAL BEATEN TRACK (and the primordial sculpture, according to Carl Andre, who was instrumental in deverticalizing sculpture in the 1960s) is the road—the modern counterpart of the desert as a place where revelations occur. Landscape, people, pleasure, disaster … the road is a microcosm of everything that "comes down the pike" in life itself. When our lives are going wrong, we follow the country music onto the interstate, or onto the "blue highways" (blues highways). Distinctions can be made between journeys and excursions, but once on the road, who's to say that this casual excursion will not turn into a meaningful journey?

A road trip highlight is the random sighting of vernacular art works—those independent "museums" where, as Mark Sloan puts it, "ordinary people have sought to elaborate upon their immediate surroundings in ways that help balance the relationships between themselves and the world." These are artifacts of what might be called a *private* public address system—the not-for-profit yard art and roadside sights that are obsessively constructed (like art) for sheer pleasure, or for communal decoration and edification. (I'd include bumperstickers in this category.)

Brother Joseph Zoettle's *Ave Maria Grotto* is a well-known tourist attraction in Cullman, Alabama. From 1905 to his death in 1971, the Benedictine lay brother created grottos and replicas of religious sites from all over the world—for sale. They evolved from devotional images into tourist art and finally into a large-scale environment where models of global religious architecture are crowded into a single manageable conglomerate for the edification of visitors to the monastery. Some time in the mid-1970s, while driving through the Olympic Peninsula in Washington, I spotted the Eagle Mountain Rockery's extensive roadside reproduction of the Egyptian pyramids

in miniature. I don't know who made it, but the time and skill that went into this homemade diorama left a lasting impression. Was the artist Egyptian? (Unlikely.) Had he or she been a tourist in Egypt? (Also unlikely.) I like to think that the maker was a "head tourist," someone who travels in his or her mind and imagination. I became part of this process when I went by and was briefly transported to Egypt (I've never been there either).

Sometimes these roadside attractions are commercial—a cone-shaped ice-cream stand, a hamburger-shaped hamburger stand, or the "bull on a stick"—the life-size cow, horse, truck, or car on a tall steel pole, visible for miles. These com-

pete with the more artful tourist monuments to small-town obsessions—the giant fish or ear of corn, the Paul Bunyan, about which Karel Ann Marling has written so fondly and perceptively in her *Colossus of Roads*. If miniature things recede into the past, giant things get closer, become our immediate future. All these unexpected fantasies come gradually into focus from a long distance away or appear delightfully around a curve, like instant postcards come to life. Speed flattens, leaving photos in the mind.

Roadside memorial shrines or *descansos* (literally "rest stops") in the southwest are motivated less by "I am here... somebody look at what I can do" than by devotion to religious figures who

Northwest Egypt, Eagle Mountain Rockery, Port Townsend, Washington, ca. 1974 (photo: Lucy R. Lippard).

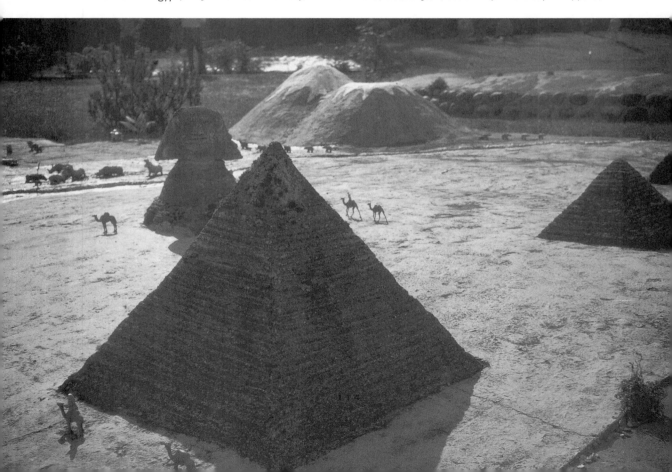

may or may not have appeared on or near this site (like the Tortilla Virgin in New Mexico), or to the memory of friends and family who may have died here or nearby. For the serious drive-by excursionist, such sites—from crosses with plastic flowers to more elaborate and personalized shrines—also contribute to the allegorical aspect of the journey.

Museums are tombs, and it looks like everything is turning into a museum.—ROBERT SMITHSON

Critic Donald Kuspit argues that the museum faces a choice between becoming a postmodern "anal universe" or remaining "the genital universe it has been in modernity." The distinction and terminology, borrowed from psychologist Janine Chasseguet-Smirgel, is between an anal universe "in which all particles are equal and interchangeable" (the "totalitarian" yard sale or curio cabinet) and the genital universe "of differences" (the "elitist" museum that picks and chooses its pleasures according to its directors' taste). He doesn't get into the power relations involved in a genital relationship, or the polymorphic perversity of *either/or* replaced by *and/or*.

The "anal" approach goes back to the beginnings of American museums, the nineteenth-century enlargement of the curio cabinet, the collection as spectacle, open to the public—like that of America's first museum (also our first "artist-run" museum, and our first museum as art work) by Charles Willson Peale, in eighteenth-century Philadelphia. He mixed art and life and life and death, juxtaposing live animals with stuffed ones, and proposing in perfect seriousness to stuff well-known people as well. In this Peale may have seen himself as heir to the ever-popular wax museums and their counterparts, the medical museums, which in turn have their popular counterparts in "freak" shows.

When artists make "museums" as art works, they too forego predictable order, because the goal tends toward shaking up the viewers, rather than just amusing or edifying them. Once a collection

as spectacle becomes art, people are led (or forced) to question their preconceptions in their search for the underlying idea, or, perhaps, to wallow in the freedom of chaos and apparent denial of "art," formerly defined as order and beauty. Chronology can be deliberately eschewed in favor of "creativity." Casual visitors happening into an artist's museum would probably be nonplussed by the loss of familiar categorization. In museums, viewers typically expect order and discipline, the pleasure of beauty, and the righteous simplicity of didacticism. When freed from the implied complexities of "art" and "education," though, in a manner reminiscent of the antique store, they are open to precisely the intended effect—a sense of relaxation into delight, a disorientation opening up into discovery.

This experience is also available in "real-life museums," places dealing with very specialized social microcosms: the Funeral Services Museum in Houston, the Cockroach Hall of Fame in Plano, Texas, the Exotic World Burlesque Museum near Los Angeles, the Museum of Bathroom Tissue in Madison, Wisconsin, the Crime Museum in Portland, Maine, the International Museum of Surgical Science in Chicago (or "Squeamishness Central"), and in New Mexico: the Museum of the Horse in Ruidoso, the UFO Museum and Research Center in Roswell, and the American International Rattlesnake Museum in Albuquerque. These places often verge on the theme park, but are more closely related in style (clutter, apparently random accumulation) to the local historical society and

other informal collection sites. Some of these museums have axes to grind, like the Museum of Southern History (predominantly antebellum and Civil War history) established by the Sons of Confederate Veterans. Or the Klan museum in Laurens, South Carolina, the POW Museum (in a former Civil War prison camp in Andersonville, Georgia), or the North Carolina museum proposed to honor Senator Jesse Helms, predictably sponsored by Philip Morris. At the other end of the political spectrum, there are the Peace Museum in Chicago and Eugene Debs's very ordinary home, much modified, in Terre Haute, Indiana. Socialist history is hardly overexposed in the United States; when I visited there, I was shown around by an old lefty caretaker who was tickled pink to talk about his idol with a younger lefty.

Such populist museums, which deserve individual attention, can be seen in part as protests against mainstream museums. The appropriation of the high-faluting name alone legitimizes them, even as it suggests a bit of pride or self-mockery. These museums are characteristically homemade, offering views that are either unpopular or neglected. The center of attention in the offbeat collection or junk shop is the object, not

Samsara: The Changing Body from *FATE: First American Transcendental Exhibition,* in brochure for exhibition in Culver City, California, ca. 1980 copyright and with permission of The Bhaktivedanta Book Trust International, Hoerby, Sweden. Life-size diorama sculpted after photo by AP's Eddie Adams; by **Mark Buchwald** and **Hayden Larsen**, among other artists.

classes of objects didactically tidied up into encyclopedic categories. Vernacular museums are activist strategies for preserving or promoting points of view not perceived as important in America. Moreover, they are no more biased than official museum culture, although their communication and presentation skills tend to be cruder—which can be appealing or just off-putting. Such populist museums testify to the contested ground that is not only high but popular culture at the end of the millennium.

THE FRENCH PHILOSOPHER Paul Ricoeur has proposed the whole world as a museum: "All meaning and every goal having disappeared, it becomes possible to wander through civilizations as if through vestiges and ruins.... We can very easily imagine a time close at hand when any fairly well-to-do person will be able to leave his country indefinitely in order to taste his own national death in an interminable aimless voyage."

This pessimistic message floats back to my initial discussion of "totalitarian space." Groys's message to the avant garde seems to be: watch out for your dreams. He offers the socialist realist museum as a horrible "fulfillment of the avant-garde's dream of bringing about the complete identity of signifier and signified," in which the distance between "a concept and its representation in reality" collapses, contemplation and

praxis coincide, completely erasing, or neutralizing, "the boundary between the museum and the surrounding world," and resulting in a "saturation of the whole visual field with monotonous objects. Under such conditions," he contends, "art becomes just as incapable of representing life as it is of opposing itself to life, for art and life are essentially indistinguishable."

Surely there are alternatives to this outcome. Wouldn't the fusion of art and life be quite different in the frame of a capitalist, partially democratic society? In the late nineteenth century, George Brown Goode advocated museums transformed from "a cemetery of bric-a-brac into a nursery of living thoughts." Either/or again. Having long hoped for the emergence of art forms "buried in social energies not yet recognized as art," I'm eager to see what they are and how various they might be. We need to know what art looks like when it no longer represents only the taste of the ruling classes. In the populist and would-be populist museums, collections, and accumulations perused here, kitsch may rule, but there's no real threat of homogeneity, as there is in corporate theme parks and high art institutions. The vernacular is above all inclusive, and the single "chaotic mass" is reorganized in many different lights. The *vita activa* is the province of the organizer, the maker, the artist. The *vita contemplativa* is up to the viewer.

TRAGIC TOURISM

WHAT ARE WE TO MAKE of the popularity of such tourist targets as celebrity murder sites, concentration camps, massacre sites, places where thousands have been shot down, swept away in floods, inundated by lava, herded off to slavery, crushed by earthquakes, starved to death, tortured, murdered, hung, or otherwise suffered excesses the rest of us hope we will never experience? Are these our sacred sites? Are we drawn to such places by prurience, fear, curiosity, mortality (there but for the grace of god go I), or delusion (it *can't* happen to me)? Or have we been blindly conditioned and sold a blockbuster bill of goods, convinced that it is not only all right but socially responsible to wallow in others' miseries? That it is "respectful" to follow

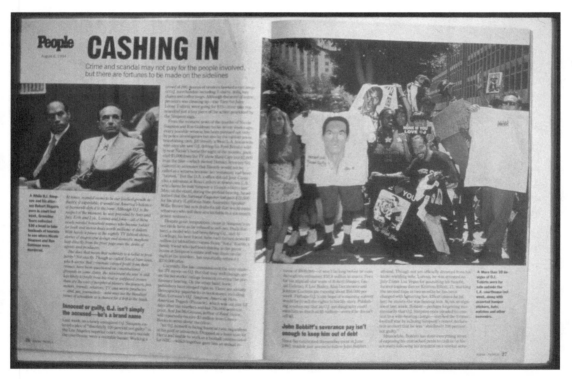

Mel Chin, *Evidence from the Truth Hertz T-shirt Investigation, People Magazine,* 1995, T-shirt/performance (photo: courtesy Mel Chin). The artist (at far right) is standing outside the courthouse in which O. J. Simpson was arraigned, where, with different motives, he joined the other T-shirt vendors cashing in on the tragedy. At a later workshop in Aspen, Colorado, students sold Chin's "Truth Hertz" T-shirts so they could see what it was like to be part of the service industry rather than tourists enjoying their vacations.

the paparazzi to Diana's grave, simultaneously imitating and vilifying them?

At these tragic sites, these vast memento mori, we can contemplate mortality and evil. We can pay homage to those less fortunate than we have been (so far), enjoying vicarious restitution for our relatively good luck, a knock on wood that it continue. Yet however high-minded our approaches, the insidious elements of voyeurism and sensationalism will creep in. Tourists visit such sites to get a whiff of catastrophe, to rub a bit closer against disaster than is possible in television, movies, or novels—although the imagination has to work a little harder when confronted with the blank terrains, the empty rooms, the neatly mowed lawns, the negligible remains of real tragedy.

Tragic tourism, more than any other branch of the industry, raises the question of motivation. Tourism in general gets its bad name—travel in search of the sensational or the merely entertaining—from motives that are virtually unmeasurable, generally by those who presume their own to be purer or "higher." We have no way of knowing what other people are feeling when they visit those redolent places. False reverence may be paraded; deep sadness may be hidden.

The conflict between spectacle and engagement is heightened at the site of tragedy, mediated by awe if the site itself is visually overwhelming. If people travel to find what is missing in their daily lives, the grandeur of catastrophe and cataclysm is, oddly, right up there near the head of the list, along with adventure and hedonism. Modern lives are often seen by those living them as petty and meaningless. Of course, we too live in "interesting" times, according to the Chinese curse, though our own heroics are harder to perceive, and the collective misfortunes of the middle-class are more difficult to frame as tragedy. Even as some tourists relish the tragic,

others prefer not to be exposed to it, aided by a national propensity to denial that endows tragic tourism with a social mission. The Ellis Island Immigration Museum recently agreed, after some hesitation, to display three (out of fifteen) graphic photographs of the mass murders of Armenians by Turks; they had been suppressed as "too gory and gruesome" for public consumption.

Passive, or indifferent, tourism might be seen as "memory without consequences." "The shape of memory cannot be divorced from the actions taken in its behalf," writes James E. Young in his brilliant book *The Texture of Memory*. "Memory without consequences contains the seeds of its own destruction." Historical tours are billed as educational fun but can equally function as anecdotes to the onset of amnesia, which is perhaps the ultimate tragedy. The closer we are to forgetting, the closer to the surface of events and emotions alike, the further we are from the depths where meaning and understanding reside. Public memorials and visited sites are the battlegrounds in a life-and-death struggle between memory, denial, and repression.

SIGNIFICANT STONES

Humanity has lost its dignity, but art has rescued it and preserved it in significant stones.
— FREDERICK SCHILLER

Cairns, or stone piles, are the oldest known human mode of memorializing. I was driving across Eastern New Mexico a few years ago when I came across a memorable modern example. Having been somewhat disappointed by the Billy the Kid "Museum" (junky, but not funky enough), I stopped at the remains of Fort Sumner, site of the Bosque Redondo, where over nine thousand Navajo were interned from 1864 to 1868, before

the survivors were forced to return to their diminished homelands in a second lethal Long Walk. The monument to their exile is simply a pile of multicolored (often red) stones taken from all over the multimillion-acre Navajo Nation, each one standing for a specific place. Although stones usually imply permanence, these symbolized travel, and at the same time testified to the enduring bond between the people and their homelands. At the same time, a pile of loose stones is always in process, individually created, never completed, so long as the memories stay vibrant. Young mentions family memorials placed on holocaust sites, among them biblical cairns, as well as wooden tablets nailed to trees. A few pebbles laid on top of the marker often distinguish Jewish graves. After the 1998 schoolyard massacre in Jonesboro, Arkansas, little girls handed out stones to arriving parishioners at one local church, in an attempt to understand the child murderers: "Let he who is without sin cast the first stone."

In recent times, few greater tragedies have overtaken the western nations than the genocide of six million Jews during World War II, accompanied by the murders of antifascist resisters, homosexuals, gypsies, and people with disabilities. Thousands of monuments to the Holocaust have been erected all over the world, and there are hundreds of museums and institutions devoted to this tragedy, which has come to represent (and overshadow) all human inhumanity in the modern mind. These monuments attract some 900,000 people annually to Dachau, 750,000 to Auschwitz, 600,000 to the Anne Frank House, 1,250,000 to Yad Vashem in Jerusalem. Many of these people are perhaps better defined as "pilgrims" than as "tourists." Young observes that "it seems likely that as many people now visit Holocaust memorials every year as died in the Holocaust itself."

All known tragic sites are heavy with associations and fantasies. Unpeopled places marking the sites of human tragedy must be repeopled by visitors who, if they are open and attuned enough, become surrogates for the absent, the commemorated. Each tragic site has a different impact on different groups and individuals. Young wants to break down the notion of national "collective memory"; he prefers instead the "collected memories" or vast array of real responses to various monuments and memorials. How many visitors, for instance, are aware that between 200,000 and 500,000 Roma (gypsies) were killed by the Nazis in what the Roma call the *Poraymos*, or the Devouring. As nomads, they are not monument builders, but in August 1997 a vigil was held in Budapest and compensation demanded.

Each site also has its own local context and character, its own landscape. The subtleties lie in gauging the power of what remains, physically and informationally. Is a neatly restored torture chamber more impressive than a poignantly deteriorating ruin? Can we picture better what it was like to be there through detailed documentation, or through our own imaginations piqued by place? For me, an empty field with a forlorn weathered marker is more evocative than an antiseptically manicured lawn with an elaborate monument. The weed-choked Jewish cemeteries in Poland may be more poignant because their neglect continues as testimony to an antisemitism that colors Polish memories of World War II, a bias that still echoes the conditions of the war itself.

Whatever the site, scholarly debates boil around what to focus on, what degree of realism is palatable or offensive, who gets the last say about the wording on the markers, and so forth. Each factor depends on location, ownership, audience, agenda, commitment. The artist team

Andrea Robbins and Max Becher, *DACHAU, This Gas Chamber Was Used,* 1994, Chromogenic print, 29 w/4″ x 34 1/2″ with frame. Dachau, near Munich, was the prototype for Nazi death camps. It opened in 1933, added the famous gas chamber disguised as a shower in 1942, and was liberated in 1945.

of Andrea Robbins (an American Jew) and Max Becher (a German immigrant), when photographing Dachau, pointed out that "often the very techniques used to memorialize specific areas of the site hide or even destroy the visible links to the past." Their decision to photograph the camp in color, in cheerful sunlight, was intended not only to replace the black and white in our minds but also to make Dachau part of our present and to call attention to how we deal with this necessarily unburied past. The thirty original barracks were destroyed to create the memorial, and then two barracks were reconstructed for exhibit. Much of the farmland that once supported the camp is excluded from the monument, and has been developed for low-income housing.

More chillingly, "The former SS headquarters complex is off-limits to the public as it now serves as a police training school."

"To the extent that we encourage monuments to do our memory-work for us," writes Young, "we become that much more forgetful. In effect, the initial impulse to memorialize events like the Holocaust may actually spring from an opposite and equal desire to forget them." Commemorative structures, often pompous and inadequate to the occasion, inspire secondary memories that can color or even interfere with responses to the primary event. When an emotionally riveting site is visited with a crowd, the surrounding company can be a turn-off or a turn-on. If the responses of others are reverent, emotional, respectful, an ambiance arises within which one feels those emotions oneself (unless, of course, sentiment disgusts you). If the responses of others are noisily casual, disinterested, or even insulting, unrelated anger can overcome homage and melancholy. If the mood of disrespect is contagious, the site or event can slip from one's grasp. The inevitable hermeticism of a tragic site is matched by a silence that is often the most appropriate response. But there's also something to be said for the sounds of children whooping it up in blissful ignorance around a field of graves.

Certainly the journey's rhythm counts; it is far more mind-boggling to come suddenly upon a massacre site than to arrive after lines of highway billboards have bragged and begged for visitors. Is this a side trip or a pilgrimage? Is the tragic site sandwiched between a picnic and a theme park, caught on the run during a work trip? Are our ties to it powerful enough to disrupt business as usual? Tourists, or those consuming the sites, are not always from elsewhere. To what extent should the local, everyday audience be taken into consideration? Their responses are bound to be different from those arriving for the first time. Does proximity breed indifference? The constant reminder is one quiet but powerful local strategy. In the wake of revelations about the hording of Jewish money in Swiss bank accounts, for instance, a proposal was made to put historical plaques on all apartments and all museum-housed art works stolen from Jews who died in the Holocaust, detailing the life and fate of the lost owner. Maybe the banks should be marked as well. Remembrance is the only way to compensate the dead.

DUST DEVILS

For the smoke that rises from crematoria obeys physical laws like any other: the particles come together and disperse according to the wind, which propels them. The only pilgrimage, dear reader, would be to look sadly at a stormy sky now and then.—ANDRÉ SCHWARZ-BART

A few months before the fiftieth anniversary of the first nuclear bomb test, in 1995, I visited the Trinity site near White Sands in southern New Mexico. It was a clear, windy day. Blue mountains rose in the east, and dust devils spun across the vast rangeland like miniature explosions. Having driven through the gates to "Armyland," on the way in through the missile range, we passed monuments to the militarism of the past—those of the present are inaccessible, of course—in the form of launching pads, machinery, a grounded plane, and ominously less recognizable shapes and structures. Because of the anniversary, the Trinity site was open to the public twice in 1995, rather than once as in ordinary years. The infrequent visiting hours heighten the sense of secrecy and high security, making tours seem privileged, a rare opportunity to enter sacred grounds.

I came from the northern part of the state in the company of some local peace activists and a small group of Japanese who were in the United States to confer with the antinuclear movement. Conceiving of it as a kind of pilgrimage, I expected a pacifist lovefest, some anger, some healing rituals, among like-minded individuals who shared my feelings about the site's tragic significance. When we reached Ground Zero itself, we found a carnival mood, barely if at all muted by associations with death and destruction, suggesting that we were parties to winning the war all over again. Children played happily in some giant rusting (irradiated?) culverts in the parking lot, beaming couples had their pictures taken at the monument, and earnest military buffs perused the literature. I was not prepared for the majority of my fellow tourists: pronuclear enthusiasts, spectacle seekers, enthusiastic aging veterans and their neatly coiffed wives, camo- and leather-bedecked would-be warmongers, self-consciously ragged teenagers and hippie remnants. Many were clearly proud of this monument to America's global power. Blurred class rifts in attitude could be surmised from clothes, vehicles, bumperstickers, although it was sometimes hard to tell where people stood. One youth wore a T-shirt that read THE COST OF LIVING IS DYING/ EVERYBODY PAYS/ NO FEAR.

One of the arguments raised by Santa Fe's progressive Los Alamos Study Group against the reintroduction of plutonium use at Los Alamos (it happened anyway) is that the "dust in the wind," a fallout plume from uncontained accidental explosions, would reach Santa Fe, leaving a permanent swath of contamination and exterminating property, business, and tourism—the venal centers of concern. The conflicting emotions of politically disparate tourists and pilgrims at Ground Zero raised dust devils of their own.

The monument at Ground Zero, really only a marker, is woefully inadequate to commemorate the chain of events that began there. The squat obelisk of volcanic rocks—presumably local and therefore irrevocably altered—resembles a Park Service gatepost. The bronze plaque makes no mention of the dire consequences of the explosion it commemorates, stating simply: TRINITY SITE, WHERE THE WORLD'S FIRST NUCLEAR DEVICE WAS EXPLODED ON JULY 16, 1945. When there was a lull in the picture-taking, a number of anti-nuclear activists held hands and ringed the monument in a silent "never again" ritual for those in Bikini, Hiroshima, Nagasaki... or Nevada. An artist placed grimacing Asian masks at each of the monument's four facets. Our Japanese friends (one of whom, a young woman, had a withered arm, though we never asked if it was radiation-related) took it all in their stride, with little comment, though they must have been bemused by the behavior of Americans holidaying at this particular site—especially one older photographer, who had spent years working with Hiroshima atomic survivors.

A photography show was hung on a section of the chainlink fence that surrounds Ground Zero. Mounted on wood, minimally captioned, the small black-and-white images held their own surprisingly well against the landscape, partly because of its "emptiness," partly because they were pictures of that landscape, projecting past onto present in situ. The images offered a straightforward sequence of the momentous activities we were there to ponder: the wooden ranch house before it was overtaken by historical urgency, the construction of the launching pad, the explosion of the bomb. Perhaps because the unspoken, unmentioned events being memorialized—Hiroshima and Nagasaki—were distant and barely conceivable, the immediate destruction of the ranch buildings

Tourists looking at historical photo show on fence of Trinity site, ground zero, 1995, color slide
(photo: Lucy R. Lippard)

and "pastoral" life lived in that space before it was annexed forever into war and war-thought was poignant in a more accessible way.

On the other side of the Ground Zero enclosure, the material culture of this history was offered like a yard sale. An array of twisted melted down Trinitite pebbles lay on card tables surrounded by other melted artifacts and reassuring pronuclear propaganda on safety: there is more radiation in a cross-country plane trip, or emitted by a microwave.... Meanwhile, a few yards from the table, a visiting activist's geiger counter was leaping out of control, contradicting

these declarations of beneficence. One young man, bearded and wearing a skirt, had crawled for miles to Ground Zero on his knees, and intended to continue his penance on his way out (shades of the region's *hispano penitentes*).

Later, I stood at the fence with my back to the crowd, staring out into the huge uncaring spaces, finding the landscape itself more conducive to thinking about the unimaginable wastelands created by atomic and hydrogen bombs than anything at the site itself. I recalled feeling the same way in a similar landscape—desolate only because of my own desolate thoughts—where

another modest and conventional marker stands in Ludlow, Colorado, over the cellarhole in which eleven women and children died during the massacre of miners by management's (the Rockefellers) hired guns.

Such peremptory monuments may in fact permit more intimate contact with the commemorated events than inappropriate glorification of more ambitious piles, which tend to be self-referential impediments to communication with the space and its events. Dwarfed by the landscape, a modest monument provides at least a visible center for the place itself, which contains the real power. Marginal histories are called in now and then to reflect upon the central focus. Monuments can make you a once-removed witness to memories (or guilt) you never had. When it comes to memories of the memorials themselves, I find I usually recall the place and the events more clearly than the marker, which has functioned primarily to channel memory, to guide me to the empty center.

In cities, tourists pass the urban counterpart of memorial stones and Latino *descansos*—not often though, because few tourists frequent the neighborhoods where drugs and shootings are part of life. RIP (rest in peace) walls in inner-city New York are integrated into daily life. They don't stand out as a "destination," but their often-powerful imagery and bright colors offer the kind of serendipitous sight in which active tourists revel. "I don't have the power to save their lives," says a local community organizer and RIP wall caretaker in Brooklyn, "but I can keep their spirit close." In Philadelphia, little shrines for the dead appear in the rear windows of cars. Crosses and ankhs—the ancient Egyptian symbol of life—have been seen on New York sidewalks. In Miami, Caribbeans place plastic flowers and alcoholic libations at the site of murders. Writer Joseph Sciorra says, "It is people being honored in a public way for a death

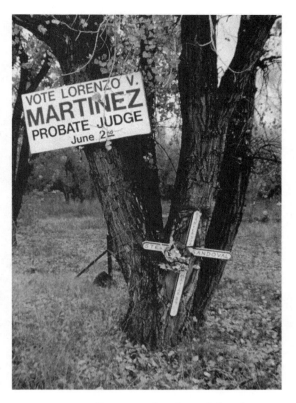

Cara Jaye, *Descanso, Southern Colorado*, color photograph, 1994.

that was in most cases also public." Names are sometimes added spontaneously to existing walls. The sister of a murdered white cop from Crown Heights who "was a hero there because he treated people with respect," says she feels his presence at his street wall rather than at his grave. A local minister says the walls "do tell the legacy, they tell the history, of our community. And that is young people who did not live out their potential.... Where are all the live heroes?"

The living tend to be more interested in dead heroes. Death itself may be the real hero, when celebrated by history and posterity. On the steps of Gianni Versace's Miami Beach mansion, where an

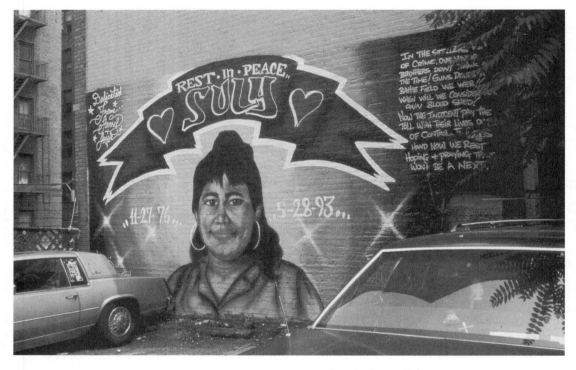

Alfredo "Per"Oyague, Jr., and Omar "Nomad" Seneriz, *Rest in Peace Suly,* 1993, Soundview, the Bronx (photo: copyright Martha Cooper). Noemi "Suly" Villafane was seventeen years old and three months pregnant when her boyfriend shot her to death. Per and Nomad are a collaborative team of graffiti artists who specialize in memorial portraits on commission. The photo is from the book *RIP: Memorial Wall Art* by Martha Cooper and Joseph Sciorra.

Italian fashion mogul was shot down, Chicago trucker Roland Garcia explained the attraction of this new tourist spot: "He was one of the most famous stylists, you know what I mean? It's being part of history. It makes you feel good to be part of that." The Titanic phenomenon is related, though still more commercially complicated. There is a package tour to visit the Titanic museum in Halifax, Nova Scotia, along with memorials, gravesites, and other Titanic-related places; and then there is the very expensive trip to the wreck site itself. Titanic touring is being touted as "a new travel niche." The monuments we visit as tourists usually bury meaning under myth or nationalist agendas. Or they vanish, taking significance with them. "There is nothing in this world as invisible as a monument," wrote Robert Musil. "They are no doubt erected to be seen—indeed, to attract attention. But at the same time they are impregnated with something that repels attention."

The most affecting monuments for me *are* invisible. At places where something awful happened but its traces have disappeared leaving only the voids to speak, we fill the blanks with our own experiences, associations, and imagery. On photographer Drex Brooks's first visit to the vacant site

Drex Brooks, *Sand Creek Massacre Site, Kiowa County, Colorado,* 1987, from Brooks's book *Sweet Medicine.* The Sand Creek massacre of Cheyenne and Arapaho men, women, and children on November 29, 1864, was one of the worst to take place during the "Indian Wars." The text accompanying Brooks's image is an eye-witness report from an American soldier, and reads in part: "There was one little child, probably three years old, just big enough to walk through the sand.... I saw one man get off his horse, at a distance of about seventy-five yards, and draw up his rifle and fire—he missed the child. Another man came up and said, 'Let me try the son of a bitch, I can hit him.' He got down off his horse, kneeled down and fired at the little child, but he missed him. A third man came up and made a similar remark and fired, and the little fellow dropped."

of the Sand Creek massacre in southeastern Colorado, a dust devil whirlwind set the tone for what was to become his book *Sweet Medicine,* commemorating massacres and treaty sites with Native people in the United States. One of the Cheyenne-Arapaho killed at Sand Creek was a man named Old Whirlwind. Brooks sees *Sweet Medicine* not so much as a documentary as a way of "looking at your own humanity and what it's capable of." He says his whole approach to photography has been

"a kind of snapshot approach, a way of remembering and looking at things that I've done.... Memory has an out-of-focus feel to it."

Monuments may also exorcise memories, as burying a friend offers a certain closure through ritual, and repeated ritual at a site can offer periodic catharsis. What if a truly cathartic performance were socially acceptable at these sites? What if one could go to Sand Creek (and I guess one could, since it is not often visited) and

scream, tear one's hair, run down the riverbed where women and children were shot down as they fled, cry out their names and our belated, useless sorrow?

GUILT TRIPPING

Monuments serve as reliquaries, repositories for memories we prefer not to carry around with us. They encourage pious gestures more than real memory—the jolt and pain of actual recall or connection to the present. Currently operating sites are out of bounds. The public sees little at Trinity to remind them that what goes on today at nearby White Sands may also be "monumental."

In the inappropriately named town of Independence, California, 1997 marked the beginning of guided tours of Manzenar, where some ten thousand Japanese-Americans were unconstitutionally held prisoner from 1942–45. (The first and only tour guide is a Paiute schoolteacher named Richard Stewart who is interested in Japanese culture.) The internment camp is on its way to becoming a full-fledged national park, although still privately supported, thanks to Congressional reluctance to cough up more than a pittance for site development. Maintaining Manzenar as a monument to a shameful episode of U.S. history will no doubt be an uphill battle, since few remember or want to recall it. A small group of local World War II veterans object to the site's attaining parkhood, calling it "Un-American"; threatening phone calls have forced the historic site's supervisor to maintain an unlisted number.

These small-time terrorists are unconsciously playing a role in Manzenar's ongoing narrative, demonstrating the kind of bias that brought so many of these tragic sites into existence in the first place. On the one hand, it seems important to open them to the public so a suppressed history can be made known. On the other hand, how far

can the "I feel your pain" approach to history go? How much does and should guilt play a role? Japanese Americans will make their annual pilgrimage to mourn the lives lost—economically and emotionally, as well as physically. Other Americans will visit in sympathy and empathy. This does not guarantee a huge number of visitors. How would such a site have to advertise itself to attract the guilt tourists, the vengeful tourists, the merely curious, as well as the reverent and respectful? As Ralph Appelbaum, designer of the United States Holocaust Memorial Museum's permanent exhibition, has said, "How do you even approach something as horrific as this without turning it into Holocaust Disneyland?... We needed to present the unspeakable in a manner tolerable to the general public who visit Washington museums essentially in tourist mode." This was done by turning all visitors into Jews with ID cards at the entrance, and then by the experiential manipulation of evocative spaces, including a cattle car used for transportation to the camps. Closer to home is a ca. 1939 American living room, to remind us how Americans heard the news, and how little was done about it.

In the United States it often seems that memories of mass suffering are the key to identity politics: Slavery, Native American genocide, Jewish Holocaust, Japanese internment, Latino labor exploitation and deportation... How much is cross-cultural understanding aided by these uneasy tourist moments? Do they divide and conquer, setting up a kind of competition of suffering? I once saw a Native American stand up at a university gathering to state that she was tired

of hearing about the Jewish Holocaust—what about *her* genocide? A step in the right direction, prompted by tragedy and protest, was made in 1998 in Albuquerque. After protests by Native leaders, a decision was made to abandon plans for a monument to Don Juan de Oñate's brief stay in New Mexico in 1598, during which time he punished the Acoma Pueblos for defending their home by cutting the feet off a number of warriors. In 1997, the right foot was clandestinely cut off of a giant metal statue of the "hero" at the Oñate Center in Alcalde, New Mexico, calling attention to canonization of the conquistadors. In Albuquerque, the aristocratic, individual hero will be replaced by a monument to the *hispano* and *mestizo* rank-and-file settlers who accompanied him.

James Young ends his book on a note hopeful for a coalition of consciousness:

Public Holocaust memorials in America will increasingly be asked to invite many different, occasionally competing groups of Americans into their spaces. African Americans and Korean Americans, Native Americans and Jews will necessarily come to share common spaces of memory, if not common memory itself. In this, the most ideal of American visions, every group in America may eventually come to recall its past in light of another group's historical memory, each coming to know more about their compatriots' experiences in light of their own remembered past.

The commitment to develop the memorial form as part of an artist's lifework is not only valuable but necessary to a fully realized social art. In 1984, it occurred to me in regard to Athena Tacha's proposals for *Massacre Memorials* that "an effective memorial recalls the dead in order to make the survivors responsible to the living. At the same time nature reminds us of our own mortality and of the relationship of individual deaths to grander cycles." But how to spark a sense of responsibility instead of guilt? Tragic tourism can raise consciousness or merely provide a kind of prurient entertainment. The death camps in Ireland (workhouses where 2,700 a week died during the famine) are now commemorated; a Famine Museum occupies the home of a cruel landlord who was assassinated in 1847 for forcing 3,000 of his starving tenants to emigrate. However, despite a fragile peace accord, any memorial to the ongoing Irish Troubles would still only mean more trouble. In the former Yugoslavia, or in Rwanda, war memorials might create new wars. Further abstraction of such internally combustive events is not called for. But a work like Sol LeWitt's 1989 black rectangle titled simply *Black Form Dedicated to the Missing Jews* (installed in 1989 in Munster and then in Hamburg-Altona) is affecting precisely because of its abstraction, its universalizing of events that need no introduction; it remains open to the loftiest aesthetic interpretation or reminder. LeWitt presents a cipher, a sign of the unspeakable and incomprehensible, a void, metaphorically placed in front, and blocking the full view, of an ornate, highly "Germanic" official edifice. He represents absence itself, and in so doing, represents the ultimate futility of the tragic monument.

The ramifications of monuments' centrality to tourism are rarely scrutinized. The real question is whether tourism itself has any relevance to the depth of memory that monuments hope to induce. Possibly all tragic tourism cheapens and trivializes the events memorialized, from individual to mass tragedy. At the same time, an unvisited monument is not fulfilling its function. For better or worse, tourism is the visiting mechanism available to most monuments. Monuments are by definition permanent, but times change,

visitors change, and what tourists *know* about the tragedies changes. Great art is often not the best monument (notions of great art change too), nor are those objects glorifying heroism or victimhood instead of exerting a multifaceted emotional pull on the site, the story, the history. While some artists feel that literal depiction trivializes such events, that the scale of tragedy can be confronted only by abstraction, the general public appears to prefer, even to need, figuration or simple markers. The tragedies themselves change in the context of different times and places where history may be repeating itself. Some sites mark

socially mandated memories or rituals that we visit now and then like church; or they mark memories shared only by certain cohesive groups (Memorial Day and Veterans Day prime among them). Different monuments seem appropriate at different points in the process of coming to terms with tragedy. Civil War monuments—the lone soldier on his pedestal in the town square—were once deeply moving for those who had lived through the war; now they are widely considered negligible kitsch. It is difficult to imagine that Maya Lin's brilliant Vietnam Memorial might someday meet a similar fate.

PROCEED AT YOUR OWN RISK

The photographer is perhaps the ultimate tourist of tragedy, and the photograph the ultimate memorial. Long after a tragic event that needs to be brought back into the public eye, literal, documentary evidence may be the most affecting. A Cambodian museum exhibits the thousands of ID mugshots of those who were soon to be on the killing fields. Their faces stare out at us with a

disbelief we share in retrospect. Few if any "significant stones" can make such an impression. From Weegee's gritty and exuberant scene-of-the-crime photos to Joel Sternfeld's photography book *On This Site:Landscape in Memoriam*, dedicated to "those who will not forget," photography defies the grandeur associated with monuments.

Sternfeld's younger brother was killed in an

Sol LeWitt, *Black Form Dedicated to the Missing Jews,* 1987, concrete blocks 60″ x 205″ x 68″, Platz der Republic, Hamburg, Germany, Freie und Hansestadt, Hamburg Kulturbehörte (photo: courtesy of the artist).

automobile accident, and his older brother died of leukemia. The book is not about them directly, but it is clearly the legacy of their deaths. Brief, crisp accounts accompany each color photograph and throw a glaring light on our society, its values, its greed, its preoccupation with death and violence (which this book of course reinforces, even as it deplores). Sternfeld has produced a visual history of an era through images of tragic sites as disparate and as ordinary as Mount Rushmore and the Mississippi Grocery where Emmett Till sealed his fate by speaking too casually to a white woman.

A partial list of Sternfeld's subjects says something about the nature of public tragedy in late twentieth-century United States: the Texas movie theater seat where Lee Harvey Oswald was sitting when he was arrested; the innocuous Queens street where Kitty Genovese was stabbed to death as thirty-nine people listened without calling the police; the Lorraine Motel in Memphis where Martin Luther King was assassinated; the Cuyahoga River which once burned for an hour; the Stonewall Bar; the Kent State parking lot; a crumbling little house at Love Canal; the San Francisco City Hall office of Dan White, who murdered George Moscone and Harvey Milk; the drunk-driving murder site of the teenager whose death inspired the founding of MADD; Waco; the ordinary suburban streets in Iowa where a boy disappeared; the Morton Thiokol factory, emblazoned with the American flag and admonitions to THINK SAFELY, ACT SAFELY, responsible for the loss of the Challenger; and the scenes of various infamous crimes including a development owned by Charles Keating of the Savings and Loan scam, the murder of a Pensacola abortion doctor, and the Happy Land Social Club fire in the Bronx.

Sternfeld's choice of image is often subtle. A worker sitting at a bank of computers at 911 oper-

ations occupies the desk where Nicole Brown Simpson's calls for help during domestic violence were received. A major theme of the book is silence—not merely the silence that has descended on the places themselves, but the frequent silence of those who might have helped before it was too late, the silence that equals death. The sensationalism with which these stories are heralded in the media becomes part of the tragedy. But they end on a hopeful note with the room in the Los Angeles mosque where the Bloods and Crips signed a truce in 1992.

Sternfeld writes of his visit to Central Park to find the site of the Jennifer Levin murder, "it was bewildering to find a scene so beautiful… to see the same sunlight pour down indifferently on the earth." He wondered if each of us has such a list of places we "cannot forget because of the tragedies that identify them." I used to feel that way about the spot on the sidewalk on East 9th street where I first saw a dead body up close, and the house on West 11th Street where several young members of the Weathermen died concocting a bomb.

Those photographers who try to counter the overgeneralized "timeless" syndrome in landscape by bringing both hidden history and current events into view are sometimes accused of "political tourism." And it's true that jaded tourists, innocents abroad, or solidarity proponents occasionally travel in war zones. During the 1980s, I traveled in Nicaragua and El Salvador, believing that if I and my colleagues (largely journalists, photographers, and Central America activists) could return home and raise hell about what the U.S. government was supporting, then such "political tourism" would be validated. Motives vary. A woman who ended up in Bosnia simply for the thrill boasted to the media: "I was the only American tourist around, with United Nations health relief people, UN military people, and

medical personnel.... After about a week I realized it wasn't a safe place and decided to leave."

Hans Magnus Enzensberger wrote that "tourism of the revolution" is attracted by a possible future from the viewpoint of a rejected present. "This reverses the usual tourist viewpoint, which rejects the present for an imagined past and considers no future realities." However, because of the ghettoization of the Left in the United States, work has little effect on the pleasure-seeking tourist population. For instance, through the 1980s and into the present, Guatemala has remained, incredibly, a favorite tourist destination even as the Guatemalan Army massacred the very

Joel Sternfeld, *Cleveland Elementary School, 20 East Fulton Street, Stockton, California, August 1994,* color photograph (photo: copyright Joel Sternfeld). Courtesy Pace Wildenstein, MacGill, New York

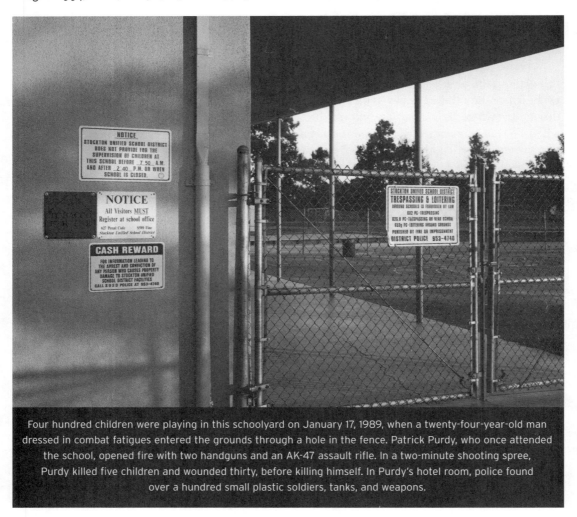

Four hundred children were playing in this schoolyard on January 17, 1989, when a twenty-four-year-old man dressed in combat fatigues entered the grounds through a hole in the fence. Patrick Purdy, who once attended the school, opened fire with two handguns and an AK-47 assault rifle. In a two-minute shooting spree, Purdy killed five children and wounded thirty, before killing himself. In Purdy's hotel room, police found over a hundred small plastic soldiers, tanks, and weapons.

indigenous people who were producing the tourist landscape and attracting visitors. And as more and more bodies are unearthed, tourism is booming. Lost among the cheerful statistics is the fact that Guatemala's new "stability" was "constructed on a foundation of horror and suffering" for the indigenous majority. Anthropologist Leigh Binford reports that the site of the notorious El Mozote massacre in El Salvador is also becoming a major tourist spot.

Progressive photographers in their documentary and muckraking roles are committed to the power of the image to empower, educate, and awaken varied audiences. Wary of the beauty that can ride on or within poverty and brutality in pictures of people and landscapes, these "political tourists" armed with cameras try to use and not be used by their information. They try not to succumb to the tourist inclination toward sensation, exoticism, or victimization. These are not reporters sent to tragic places, but independent photojournalists who choose to spend time in war-torn countries, working and photographing within the struggle. Others search out environmental devastation and the private, corporate, and governmental culprits at home and abroad. All the while they must confront the colonialist history of the camera in occupied territory and issues of decontextualization and depersonalization, unconscious bias, and socially constructed images. Distributing their images "instrumentally" in oppositional publications and leaflets, they are often homeless in the commercial world. They tend to play down drama by photographing ordinary people and everyday lives, often sacrificing style for information. Photographers like Susan Meiselas, Mel Rosenthal, Jean Simon, Steve Cagan, among others, communicate places and events very differently than do most war correspondents and *National Geographic* employees. Their goal is neither touris-

tic voyeurism nor media-immediacy but incitement to thought and action. They can complicate the underlying issues by reaching out, bringing real faces and places into play so that viewers have to think for themselves while being looked in the eye by those who are "living the news." At best, these photographers succeed in interrupting North American complacency, communicating the pain and pride of people who have flashed by on TV so rapidly as to be virtually anonymous.

LIKE TRAVEL and exploration in previous centuries, tourism today carries its own dangers. There's something for everybody—even for masochists. TOURISM'S HOTTEST HOT SPOT IS DEATH VALLEY, reads a 1997 headline. In the summer, when temperatures regularly hit 120 degrees, Death Valley attracts almost exclusively Northern Europeans, Germans in particular: "It is a thrill to us to travel across so much miles. There is nothing empty like this in Germany," says one of them. In July 1996, a German couple and their two children disappeared in Death Valley. In November, their minivan was found, but there was no sign of the occupants. "Their remains probably were scattered by the 50 mph winds and the coyotes," said a park employee.

In another case of insouciant obliviousness to risk, hikers in the Dolly Sods Wilderness, West Virginia, take their children on trails where unexploded ordnance have been found, leftovers from World War II military maneuvers. Dolly Sods is only one of over two thousand sites in the United States where people might be exposed to live bombs, grenades, or mortar rounds. But it doesn't seem to faze recreational tourists, and some have actually gone home with ticking souvenirs.

Although the majority of tourists will go out of their way to avoid risks, the dangers of ordinary tourism are escalating. In the summer of

1997, for example, a group of tourists were captive on a ferryboat between the United States and Canada while angry fishermen blockaded traffic in a dispute over salmon fishing quotas. As tourism becomes big business, turf wars ensue. Visitors have been injured and killed in St. Lucia as tour companies vie for their custom. Tourists in Egypt are targeted by Islamic extremists. Since the Oklahoma City bombing, "domestic terrorism" is a fearful specter even for those staying home, as is street crime.

Florida, haunted by tourist murders, natural disasters, and human-made environmental catastrophes, becomes a Paradise Lost as doomsday scenarios are written for a state where tourism generated 663,000 jobs and $31 billion in 1992. Florida is home to Disney World, which opened in 1971 to become the world's greatest tourist attraction, overwhelming the endangered Everglades, sun-sand-and-sex tropical paradise appeal, Weeki Wachee mermaids, alligators, dolphins, flowers, parrots, manatees, and snake-a-toriums. It is a state described as early as the 1890s by promoter William "Pig Iron" Kelly as living "on sweet potatoes and consumptive Yankees, but mostly we sell atmosphere." However, the piper must be paid. "Floridians must confront the specter of a society splintered by individuality and restlessness," writes Gary Mormino, "a state where image is more important than reality." The Fort Lauderdale Visitors Bureau was recently reported to be changing its target tourists from "beer-swilling fraternity boys staging belly-flop and wet T-shirt contests" to "well-groomed and hand-holding men who favor art galleries and fancy restaurants." "This town has grown up," a city commissioner announced as he curried favor with the International Gay and Lesbian Travel Association.

As the terrain of tragic tourism is opened up to other national and natural disaster areas, to earthquake or tornado as well as military devastation, to strip-mined mountains, clear-cut forests, the former nesting sites of endangered birds, and polluted and over-fished waterways, perhaps what is called for is a wildlife ghosts park, or a tourism theme park that would bring the process full circle. Smog has clouded the famous views from the top of New Hampshire's Mount Washington, and the question is raised: "how much is better visibility worth to people? Are they willing to pay higher electric bills for cleanup?" Protection of the tourist industry is part of the package. In addition, Environmental Defense Fund scientists warn that global warming could wound New Hampshire tourism by disrupting the fall foliage season, shortening the ski season, and harming both the maple sugar and timber industries. (Less is said about the people who remain desperately poor in places where others spend millions.) The consumer approach to nature may be a last defense. As Alexander Wilson has pointed out, nature is now experienced and marketed in undifferentiated parts rather than as a whole. The future can be seen in Europe, where there are no old-growth trees, where overpopulation and lack of space has reversed evolution's direction for large vertebrate mammals; according to Reg Saner, "Euronature is not nature any more."

The be-all and end-all of tragic tourism may well be the Armageddon theme park, now in progress near Tel Aviv. By the year 2000, if all goes well, this classic example of short-term thinking will turn an unprepossessing (but historically blood-soaked) archaeological site into an apocalyptic tourist attraction aimed at fundamentalist Christians who believe Christ will arrive for his second coming in the year 2007—a lot of work for a park that will last only seven years.

PARKING PLACES

*This essay is dedicated to the memory of my grandfather, Judson Lewis Cross,
who was a summer ranger at Yellowstone National Park in the 1890s.*

THE SILVER PLASTIC "parking angel" on my dashboard arrived in my Christmas stocking. Now and then she rises from her stupor and finds me a place. But she has yet to pass the acid test—at a national park in season. On a typi- cal summer day, the 6,000 cars that enter Grand Canyon National Park are competing for less than 2,000 parking places concentrated along thirty miles of scenic rim roads. By the mid-1960s, a ranger could describe Yosemite Valley as "a fair-

sized city (40,000 to 60,000 people) complete with smog, crime, juvenile delinquency, parking problems, traffic snarls, rush hours, gang warfare, slums, and urban sprawl." At first people couldn't get to the national parklands *without* cars. Today it's hard to get into them *with* cars.

Plenty of people arrived in the scenery from the 1850s on, via shank's mare, horses and mules, wagons, and then carriages. Hiking and camping were a lot cheaper than guided tours and resort hotels, and helped to democratize the national parks. But modern transportation was the key to increased public access to parks and "wilderness." The next wave of growth came with the automobile and a renewed emphasis on often-luxurious accommodations, which now include elaborate sports facilities. By the 1930s, the automobile had refocused the movement of tourists from specific resorts to the journey itself, opening up a more generalized, and populist, notion of travel. At the same time, hotels and then motels replaced the sprawling old Victorian hotels and spas, erasing any communal atmosphere. In a similar overriding of local communications, trailers and mobile homes replace motels, so travelers remain in their own "home," or bubble, even as they traverse others' turf or "hook up" and dump in a temporary oasis. Yet the counterpoint between journey and sojourn hardly operates when more time is spent in the car, plane, or train than in any single location.

As modes of travel changed, so did the act of looking around. Alexander Wilson remarks on the "horizontal quality" cars impose on landscapes: "The faster we drive the flatter the earth looks... distance is experienced as an abstraction Seen from a plane window the landscape flattens out to something like a map." Except for the dedicated few who seek out the diminishing alternatives, most park visitors respond by resorting to on-site simulacra: photography in various forms, scenic overlooks, visitor center videos, interpretation, and artificial nature—a postmodern redundancy that has not escaped scholarly attention. If the park itself has at times been conceived as an artform, its simulacra ride the information superhighway in search of more lucrative havens. Hyper-reality, someone said, is when constructs become places.

THE DISSOLVE

The most famous national parks have come to resemble television shows or photography books —controlled or static sequences of scenery and sights. Tourists see and remember with visual aids. All the travel magazines feature a plethora of ads for expensive camera equipment. Yet even as photography has opened up views to faraway places, it has offered ways to avoid experiencing them. The gap between reality and photography closes a bit more in the process. The camera spreads the aura of an invented identity from the center of direct experience to rippling peripheries. I'm told that at the Mount Rushmore Visitor Center, tourists are taking videos of the video show of the carved mountain that looms visibly just outside a picture window. The images fade. Photographic collections, like *National Geographic*, are surrogates for travel. Even when one is actually on the spot, the camera becomes a prosthetic for direct experience. Places that can't be enjoyed at the time can be perused in the privacy of home, away from the camera-toting hordes. You can forget them if your picture has successfully leaped out into the void, avoiding the signs of elbow-to-elbow civilization. Unconsidered experiences surface later as apparently considered images—

the infamous after-dinner slide shows for captive audiences. Armed with a camera, every tourist is an involuntary artist, learning to frame and focus, if thoughtlessly. And conversely, every artist armed with a camera is an involuntary tourist, whatever lofty goals s/he may have in mind. Slides are the active and artistically inclined traveler's postcards, dissolving the distances more convincingly. They are a nuisance in terms of projection, but you can edit them for different audiences, creating a different trip each time.

Photography is the ultimate intrusion, extending the temporary stare (humiliating enough in itself) to posterity. When we run out of film, or if we're shy about taking pictures of toured people face-to-face, we can always fall back on the postcard, instrument of innocent oversimplification and insidious misrepresentation. "Falsely naive, the postcard misleads in direct measure to the fact that it presents itself as having neither depth nor aesthetic pretensions," writes Malek Alloula. "It produces stereotypes in the manner of great seabirds producing guana. It is the fertilizer of the colonial vision." Postcards provide a lens that facilitates and reinforces ersatz or limited experience.

Jin-me Yoon, *Souvenirs of the Self,* six color postcards (4" x 6") in a perforated strip, 1991, project for the Walter Phillips Gallery, Banff, Alberta, Canada (photos: Cheryl Bellows). These images were researched in Banff and an edition of 2,800 was made available in local retail stores as part of Dana Augaitis's and Sylvie Gilbert's *Between Views* exhibition. Yoon remarks that while she was doing her research she was "disturbed by the chronic flattening of my identity, as the 'other,' the ubiquitous 'Japanese tourist.'...I was amused and annoyed with the active construction of the 'European heritage' touted by 'locals' and enforced in the archives and the touristic brochures" (1992 statement on work). Each card has a trilingual (English, French, Korean) text about intersection of the site and the artist/visitor. Three examples:

"Lake Louise—Feast your eyes on the picturesque beauty of this lake named to honor Princess Louise Caroline Alberta, daughter of Queen Victoria. She discovers the lake on a sunny day. Before that she did not exist."

"Banff Avenue—Banff has been charming visitors from around the world for over a hundred years. She has trouble finding that perfect souvenir for herself."

"Bankhead (1904-1922)—Explore the riches to rags drama of this historic coal mining town. She discovers that Chinese workers lived on the other side of the slag heaps."

They are usually photographic clichés, comforting in their familiarity. At best they are a consensus of what viewers hope to see. They are also a gift, or a taunt: "Wish you were here... *nyah, nyah,* you're not." Eventually, most tourists can be tempted to accept the postcard image over our own lived experience. "It didn't look like that when I saw it, but then the weather was bad, or we went by kind of fast..." Susan Stewart says that "the photograph as souvenir is a logical extension of the pressed flower, the preservation of an instant in time through a reduction of physical dimensions and a corresponding increase in significance." She writes about "the silence of the photograph, its promise of visual intimacy at the expense of the other senses (its glossy surfaces reflecting us back and refusing us penetration)."

The now-popular process of "rephotography" lends itself to the notion that there are only two times—then and now. That may be a condition of photography itself, irreversibly divorced from the viewing moment in time as well as in space. Richard Prince's rephotographed tourist ads somehow become ominous when wrenched out of context and re-presented as art. Thoughtful photography by a visitor or by a so-called tourist provides a thicker view, in the sense of Clifford Geertz's "thick description" or William Least Heat-Moon's notion of a "deep map." Yet artists have been oddly reluctant to get into postcards as a mass-produced, widely distributed medium, as a way of teaching people how to see what's out there. I guess there's still a stigma against their small-scale, cheap prices, and random usage. Too bad, because there is no reason why tourists as well as locals shouldn't be exposed to the sort of depth of place that artists can provide. Photographs of vast empty places are still used to lead tourists to believe they will be alone in the wilderness, and the plethora of human presences often comes as an unpleasant surprise. Pictures could, however, prepare us for travel rather than blinding us to what we're going to see. As photographer Robert Adams has observed, "We rely on landscape photography to make intelligible to us what we already know. It is the fitness of the landscape to one's experience of life's condition and possibilities that make a scene important to us." Iconoclastic desert chronicler Charles Bowden both contradicts and bears this out in his own disdain for landscape photography. He remarks that the quintessential tourist magazine *Arizona Highways* "has thrived for most of this century by seldom, if ever, printing the photograph of an actual highway. We might call this school of underpopulated imagery 'Neutron Photography.'"

Photography is only one medium through which nature is reported and distorted. Alexander Wilson, a writer and landscape designer, contended that while our relationships to nature have always been mediated by culture, in the twentieth century we have invented new ways for this to happen. They include promotion and advertising, access to countryside and so-called wilderness, the objectification and enclosure of nature in parks, trails ("pathology") and signage, information and display technology once you get there, and TV nature shows (someone called them "Granola TV—two bugs making love to Mozart"). One ripple further from the center would include green marketing, vine bars, climate controls such as heating or air conditioning, as well as the more obvious kinds of representation in advertising, where, as Judith Williamson has observed, "real things are constituted as symbols.... Nature is absolutely fundamental to all this because it is the hunting ground for symbols, the raw material of which they are all made. But as nature is ransacked for symbols, it is, of course, transformed."

We take snapshots and buy postcards when the place goes by in a blur. There is a dreamlike aspect to tourism. And when we wake up, we have to persuade ourselves, not to mention everybody else, that we have indeed been there. Sometimes we haven't. In an era of electronic postcards and virtual reality tours, "nature worship no longer requires nature." The Japanese have already taken the production of natural attraction farther than any art installation. Entire landscapes are reproduced indoors—"technological marvels of engineering that mimic the best of Mother Nature," like the Seagaia Ocean Dome, a whole temperature-controlled, palm-bordered beach where you can swim, surf, and picnic in mid-winter beneath what is billed as "the world's largest retractable roof." (Every now and then, for only a few hours, so as not to tarnish the artificial environment with too much nature, the roof is rolled back and the sun is invited in.) Should your tastes run to cold rather than hot, Japan offers another kind of lala-land—LaLaport, the world's largest indoor ski area for after-work skiers.

Such places are not intended to replace nature, merely to offer recreational convenience and proximity for city dwellers. Yet it is ironic and perhaps appropriate that the Japanese—whose culture is historically embedded in the appreciation of nature and supported by a genius for the artificial—are the first to combine the two in such massive environments. Young Japanese artists have rejected the traditional bonds to, and idealization of, nature (an exhibition of their art traveling in the United States in the early 1990s was called "Against Nature"). Such attitudes are perhaps the "natural" consequences of the designed environments that globally dominate most major cities, from "vine bars," to the thicketed courtyards of Hyatt hotels, to prim pocket parks, to cement channeled rivers, to the world's largest malls, to the regimented suburban parklands that claim to imitate the environments they replace. Already parks are not enough. The slogan of San Diego's Sea World (the jewel of a corporate chain) is "It's not just a park, it's another world," or from another viewpoint, "Sea World is like a mall with fish."

THE OVERLOOKED

The only venue I know of that is as dedicated to avoidance of experience as a designated natural viewpoint on a scenic highway is a topless bar.—Charles Bowden

The view, or the scenic overlook, is a ready-made photograph waiting to be snapped. It is removed from actual experience, even as it may move us deeply for a moment. We go to a place only to stare off into another place where we can't or won't go. If we live in the place we are looking at, if we have been "there" many times, we have one foot here and the other there. Just as the postcard is a substitute for firsthand photography, the scenic overlook is a substitute for exertion. The scene beckons you in, but just so far. This is

comforting. You don't have to go there; no need to climb that mountain, struggle down that slope, get muddy shoes on that trail, stand in the rain for long. The average tourist probably spends a few minutes gazing out into each place s/he will never really see.

Although scenic overlooks do have a practical function (accidents happen when people are gawking at the landscape on scenically curvaceous roads), they are also places selected by the highway bureaucracy for us to pull over and look

at a view that has been chosen for us. They are controlled views of landscape—itself already something of a controlled abstraction. The scenic overlook represents our environment the way the mass-media represents us and current events. Usually these views are far less interesting than those we've just driven past too fast to take in, so they are always kind of a letdown—paralleling the way history is also handed down to us.

Photographer Roger Minick, whose *Sightseer Series* (p. 135) was made at National Parks around the country in 1980–81, perceives sightseeing in America as "a kind of national ritual." The rite of "visiting the famous overlook" reminded him of religious pilgrimages and "the big game hunter on safari, except the prized trophy, in this case, was the home movie or snapshot of Mom and Pop and Granny and Gramps and the kids at Inspiration Point."

The scenic overlook was developed because, in many areas, ordinary bucolic and scenic routes are relics of the past. By accident or occasionally by design, a few backroads have remained relatively free of commercial interruption. The first artificial "country roads" were originally conceived as "parkways" and "drives" at a time when auto-tourism was new and slow. Scenic overlooks made less and less sense as speed limits increased. Stan Abbott, the architect of the Blue Ridge Parkway, was unashamedly didactic in his desire to create a motorist's landscape that doubled as mountain reclamation and an unfolding work of roadside-as-art to the motorist—"a museum of managed American countryside," as he put it. Sixty years later, the word parkway has become a euphemism for highways with monotonous views of grass and trees: a purely functional road that funnels us through space too fast to appreciate perfunctory landscaping or the occasional scenic effort—bits of buffalo juniper perched on cement dividers and

Jane Greengold, *Scenic Overlooks,* June 1990, Seventh Avenue subway station on the F line in Park Slope, Brooklyn, enamel-on-steel sign (20″ x 30″) and photomural (4′ x 6′) sponsored by MTA/Arts for Transit, Creative Stations Program (with the Park Slope Civic Council and R.O.S.A.S.). The sign in the upper-right corner reads: *Scenic Overlook Ahead.* This image is one of five signs and three photomurals, all scenes near the subway station, in or at the edge of Prospect Park. An anonymous *New Yorker* contributor wrote, "The images poke fun at the sometimes arbitrary selection of traditional overlook sites, but they also provide a glimpse of the park's beauty. They make you want to pack a lunch, get the kids, and throw a ball around on the platform" (July 30, 1990). Despite some vandalism, most of the work remains on site and the artist was recently contacted by the Prospect Park Alliance about adding specific directions to the pictured locations.

buffer zones of homogenous vegetation between passengers hurtling by in their car wombs and the "real world" of trailer parks and clear-cutting just beyond the "beauty strip." What we see is not what we're getting.

Telescopes are popular at scenic overlooks and in parks. The forests or mountains or crash-ing surf or canyonlands seen through their

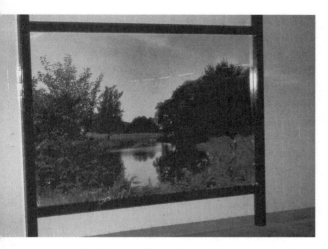

scratched lenses close the gap between armchair, television tourism, and actual presence near (but not at) an extolled place. For that matter, why get out of your car? A few years ago, I read that at the entrance to Zion National Park in Utah, the park experience was to be simulated (or telescoped) on a giant IMAX movie screen; it was not yet in place at the entrance I used recently. The ubiqui-

tous visitor center videos present another dilemma. Should you see them before you venture into the actual place? (They might contain information that would help you see where you are.) Or after? (So you won't have the simulated experience in mind before you get the real one.) Generic park and history videos can be pretty sappy—another area an artist would be useful. At indigenous "prehistoric" sites, with luck, there is some ethnographic testimony from local descendants—stilted, but useful to prove that "they" are not all gone. (At the Anasazi Heritage Center in Colorado, the video features animated recreations of Indian life on the site in which the women appear to be wearing flesh-colored T-shirts; bare breasts might offend.) These videos—the expensive counterparts of postcards and photographs—are usually for sale in the bookstores, to be enjoyed at home and to entertain friends. They can be an impersonal "improvement" on amateur slide shows and a way of "reliving" the visit.

COMFORT STATIONS

If the scenic overlook is a not a place, but a point from which to look at a place, and thus twice removed from experience, the park is a place to stop, to park. We finally enter the view physically (so long as we stay on the trail, which is eroding from overuse). But even this more expansive place remains cordoned off from harsh reality, and, supposedly, from the corporate devastation of most American nature. Parks have developed in a macrocosmic parallel to playgrounds. Recreation is re-creation, rebirth, a way of transforming ourselves. Kids used to be left to their own inventive devices outdoors. Hikers started from the edge of town, or wherever the fences stopped. As our "national playgrounds," the national parks

are the sites of the most intensive debates around cultural production of nature, and their physical, infrastructural decay signals the faltering of the relatively new concept of parks as places where "the masses" experience nature.

Democratization has not made tourists more popular with those who serve them. Park employees at Yosemite have described "the average tourist" as someone "who comes in a car, buys a hot dog, looks at the waterfalls and big rocks, then leaves... usually overweight, poorly mannered, physically unfit, and aesthetically insensitive proletarians, who as often as not drive a gas-guzzling station wagon filled to the windows with noisy youngsters whose chief concerns are the locations

of the nearest comfort station and soft drink dispensing machines." Like it or not, Stanford Demars contends, all of these people are the park's constituency. If they come for the "scenery," and (dis)miss the "wilderness experience," so be it. Live and let live.

If one goal of travel or vacation is to meet and hang out with "equals," for some this includes avoiding contact with "social inferiors" (unless, of course, they are quaint or exotic locals). Demars recalls a visit to Yosemite in the early 1960s, when the Ahwahnee Hotel (named after the original locals) presented an island in the midst of what was "more like an urban amusement park than the pristine beauty and wildness of a national park." At the hotel, a "barbed-wire enclosed bastion of elitism," the rich played golf at another kind of distance from both nature and the hoi polloi. Protests against such displays of wealth have exposed varying motives. Thirty years earlier, a visitor had complained that the flaunted luxury of the Ahwahnee offered "too big a contrast" to the "unwashed thousands" and caused "the restless to be more restless."

Average tourists are not back-country devotees. Bewildered by the wilderness, many Americans are culturally unprepared for its lack of predictability. Most prefer those places accessible

Renée Green, *Site/Scene,* 1990, postcards, binoculars, Plexiglas, wood, stands, 66" x 66" x 135" (photo: courtesy Pat Hearn Gallery). What the viewer peering at the images on the walls sees are scenic postcards with one-word clues ("performance," "leadership") mounted on maps, in a visual microcosm of expeditionary imperialism. Grand and petty, near and far, inside and outside, giant and miniature are called into play.

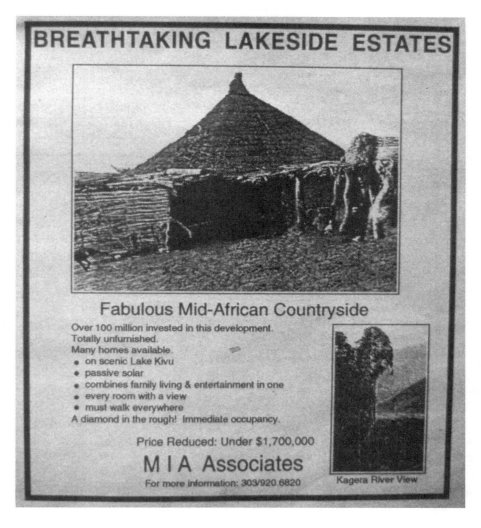

Mel Chin, *Breathtaking Lakeside Estates,* advertisement in the nationally distributed *Aspen Times Weekend Real Estate Guide,* 1994 (photo: courtesy Mel Chin). This art work referring to the "real state of Rwanda" with contact numbers of relief organizations, made the front page of the *Wall Street Journal.* It was concocted during Chin's workshop at the Anderson Ranch in Aspen, Colorado—a chilling response to the disregard of landowners, globally, for context and community. In a second piece designed to make people think about who lived in Aspen and how, the workshop participants distributed a "parking permit" that was an outspoken demographic survey of Aspen parkers. A form requested color of car, cultural identification, sexual preference, and annual income. The questions were marked so as to invert the "normal"; Anglo American, middle income, heterosexual, became "other."

by automobile and to doctors. (An increasing number are retired people with specific needs for comfort and health.) Extreme discomfort and a stiff upper lip was the nineteenth-century badge of a real traveler. But by the end of the century, the puritan attraction to hardship as a force for moral improvement had pretty well vanished. We marvel at those dedicated nineteenth-century travelers tromping along in their heavy leather boots—the women in bulky long skirts—carrying a wool blanket, a knife, a canteen, some jerky, and a gun, making pine-bough mattresses and leantos, hunting their food as well as water.

At the end of the twentieth century it is virtually un-American to welcome discomfort, and comfort in nature is mediated in the most pragmatic ways. Portable TVs and generated electricity replace campfires; the fully-equipped RV, the comfort station, and the visitor center replace tents, bushes, and firsthand experience. Accelerating speeds have also altered sport within travel. Off-Road Vehicles, all-terrain vehicles, and trailbikes replace horses, mules, and the occasional llama. Outboard motors and the obnoxious jet-skis replace paddles, oars, and sails just as snow-mobiles have often replaced snowshoes and skis. Western "camping ranches" protect visitors from what they supposedly came to enjoy. "Nature" hides shyly in the thickets, captured by an occasional lens.

Even the revival of backpacking and back-country travel since the 1960s has been accompanied by the introduction (and fetishization) of increasingly lightweight and high-tech gear to dispel the hardships of roughing it. Air mattresses, Gor-Tex or Thinsulate shelters and clothes, and freeze-dried foods leave water the weightiest matter to burden the affluent trekker. Only a few diehard "buckskinners" scorn the "gear junkies" and relish their proximity to nature via simplicity. Linda Hasselstrom, who is one of them, suggests (somewhat tongue-in-cheek) that we construct fake wildernesses for those who aren't up to the real thing, and subject those who think they are ready for the real thing to a sort of Boy Scout self-sufficiency test before they enter. Moab-based journalist Jim Stiles blames sports for the decline of the West; they make the wilderness familiar rather than hostile, changing the reasons people (trailbikers at the top of the list) come to Utah's Canyonlands. "We went from mystical to macho, from watching a hawk to 'riding the rock.' From 'desert mystics' to 'adrenalin junkies.'"

A song I loved as a kid went something like: "I'm an old cowhand from the Rio Grande. / I learned to ride before I learned to stand. / I know all the trails in the Lone Star State / cause I've rode them all in my Ford V-8 / yippee ay o kay ay..." While the above-mentioned "improvements" further diminish the exertion of entering the landscape, they also carry an illusive aura of freedom, rarely available in society itself. Road movies and Westerns prey on that longing: their appeal is a relic of the exploratory urge that fueled Western expansion. The "maverick" hero, the car cowboy (and maybe cowgirl) set out across the asphalt horizon, the radio blaring country music, to seek adventure—often of the criminal variety (given the popularity of murderous tourism in *Pretty Poison*, *Bonnie and Clyde*, even *Thelma and Louise*). Whining children and often even those who can't pee standing up beside the road are not invited. But anybody can toss a beer can or fast-food styrofoam container out the window, some of which will be collected by adopt-a-highway volunteers who may come from the same family or club as the violators.

Natural beauty was once perceived as a resource for moral uplift and inspiration. North American parks were inspired in the nineteenth century by the healing power of the wilderness.

Like so much else in the tourism paradigm, concepts of *inside* and *outside* are crucial. Going "out" to nature is supposed to recharge our batteries, run down from staying "in" our own social niches. The biocentric arguments for wilderness areas as strongholds for freedom, and for the rights of wild, nonhuman communities, are contested by anthropocentric demands for more comfortable park experiences as well as so-called wise-use policies. Local support for doing away with parks and wildlife habitats is often strong, according to the hunting, fishing, snow-mobiling lobbies (although when Native people spearfish according to their treaty rights, these same lobbies tend to reverse their positions and raise hell). There has been Congressional support for getting rid of parks not used to the saturation point and opening them up to development. As early as 1969, the National Recreation and Park Association quantified responses to photographs of different landscapes so the most popular could be preserved, a hasty and inaccurate process that parallels our flawed electoral politics and feeds into the increasingly conscious production of natural and historical attractions. Today, certain self-proclaimed moralists are opposed by a wilderness movement that itself can seem like a reincarnation of the romantic movement, including a spiritual element and nostalgia for the primeval past. The outdoor recreation movement's emphasis on health and physical rigor, the noble savage and return to nature, has also been seen as ominously reminiscent of early fascism.

When Margaret Cerullo and Phyllis Ewen made a study of local family weekend camping in New England in 1978–79, they concentrated on working-class families who camp in member-ship groups with tents and recreational vehicles, seeking not privacy for individual contemplation of nature but a public camaraderie. While the campers initially appeared to be simulating home life, camping was in fact an antidote to the isolation many feel in today's so-called communities. The authors concluded that the ideal of family togetherness in fact "*required* other people" for the desired connections. The "real neighborhoods" and sociable ambience lacking in most towns and suburbs today were reconstituted on weekends. "We found a cross between America past and present, a small town recreated in this open field, yet with the density of a claustrophobic urban neighborhood."

Neither nature nor activities played much of a role. The constantly stated reason for communal camping was "getting away from it all"—the clock, the telephone, the rigid demands of both work and housework—but not to anything in particular. The greatest pleasure was "relaxing," defined as doing absolutely nothing. Women shared this feeling although their homework continued, because the men were right there and helped domestically, at least more than they did at home. Yet the interior spaces were unquestionably the women's domains; the outdoors belonged to everyone.

In a variation on the tourist/traveler hierarchy, these campers vehemently distinguished themselves from "vacationers," who represented unfamiliar outsiders. Even as they were critiquing daily life in America, they remained "deeply entangled in the web of the culture" they defied—by leaving home but going nowhere. For some people, the kind of family camping described by Cerullo and Ewen would barely constitute "travel." Yet it fulfilled the usual aim of tourism—arrival in a desired place and translating movement into stasis.

THE ECO-NOMICS OF TOURISM

On the rise along with the mostly white or unbleached stores selling expensive, ecologically correct household linens and clothes, ecotourism (also mostly white) is the fastest-growing sector of the tourism industry. One travel agent breaks nature-based tourism into five categories: basic ecotourism ("in which travelers learn about the interrelationships between living organisms in the different natural areas"); scientific (research tasks performed in the field); "soft natural history" (vague outdoors focus); "hard natural history" (interest-specific); and adventure (rock-climbing, whitewater rafting, and so on.)

Even the Forest Service has jumped on the bandwagon with natural history "heritage expedition" tours, although some protest federal involvement in such for-profit enterprises. Bird-watching, redwood reconnaissance, and archaeological field schools are the latest ways of alleviating urban stress. On "eco-safaris," animals are photographed rather than killed: "take only photographs, leave only footprints." Trouble is, too many photographs turn animals into hams; too many footprints devastate fragile landscapes. Described by the World Wildlife Fund as travel "to protect natural areas, as a means of economic gain through natural resource preservation," ecotourism is proposed as a way to save the rainforests and other endangered species and environments —admirable and vital goals. But it also contributes to the notion of a shared global ecosystem, in which the casual destruction of "nature" in most places is artificially balanced out by preservation in a few places; where "outdoor museums" provide the stages on which to display the spectacle of nature—an idea that had its day in the dawn of public parks, but in our currently endangered world seems ominously fragmented.

Ecotourism only deserves the name when it includes humans in its ecosystems; otherwise it's likely to be "ecolonialism." Ideally, ecotourists come home to recognize that the overgrazed field next door is as important a microcosm of nature as a glamorized rainforest. Grass-roots control of so-called alternative tourism has to be a prime consideration, and no community is so homogenous that it will immediately agree on what is both economically and ecologically best for its own turf. As community land use plans begin to be considered seriously in rural areas, conflicts between traditional uses and subdivisional incursion are bound to occur. In order to encourage a new kind of tourist who is aware of basic issues like water or intercultural relations, the nonprofit Global Exchange of San Francisco has begun running "reality tours" to places like migrant workplaces, border towns, and struggling timber towns. "This is not a voyeuristic, fluffy, drink-Chardonnay-and-watch-the-people kind of thing," says tour guide Lisa Russ. "We work really hard on these trips. We're trying to make sense of the world around us."

UNNATURAL ACTIVITIES

The more the West is populated, the more rules there have to be—and wildlife is now expected to toe the line. Socially impaired wolves, bears, coyotes, mountain lions, and rattlesnakes are mercilessly exterminated or kept at bay by legisla- tion and bounty hunters. Now we have not only private game parks and duck-shooting parks (Alexander Wilson reproduces a picture of a cute duck-shaped artificial pond on which its living models are slaughtered) but elk hunting is to be

allowed in some national parks. Yellowstone bison are being shot if they overstep park boundaries and endanger domestic lifestock that might catch brucellosis from them (although the disease originated with cattle, not wildlife). At the same time, wolves are being reintroduced; when they turn out to be too wild for their own good they are exported again at judicial or sharpshooters' whim. The absurdity of managing nature is highlighted in these ongoing struggles and debates, with animals being moved around like pawns on the governmental board.

Canadian photographer Marlene Creates has written about the total absence of birds in the apparent wilderness of Banff National Park, Alberta, where the first nature trail on the conti-

nent was built in 1959. She was told that an ornithologist had pronounced the forest "over-preserved," artificially protected beyond its normal lifespan. The birds had abandoned it for more diversified habitats. "I felt I was looking at a museum of nature," she writes. "The vacation landscape is no longer a place—it's a movie set and it's postcards. The grizzly bears all have names, for heaven's sake. And someone said,

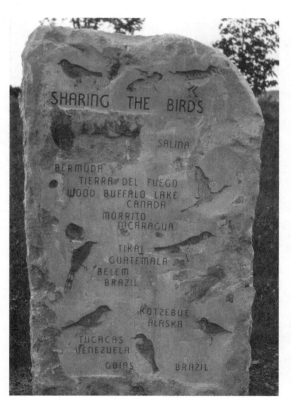

Lynne Hull (in partnership with the Salina Commission for the Arts and Humanities and the Salina Parks and Recreation Department with assistance from the Land Institute), *Sharing the Birds,* from *The Exiled Oxbow,* Salina, Kansas, 1995, native postrock limestone (recycled from racetrack bumpers), 40" x 24" (photo: copyright Lynne Hull). When Hull first saw that this park—formed by an old river oxbow, diked and drained of wetlands—was scheduled for development, she "realized it was a metaphor for the loss of wetlands everywhere." This piece is part of a wetlands memorial. *Sharing the Birds* (with *Sharing the Waters*) is accompanied by two boulders for seating and a center stone with a hydroglyph (configured as an abstract map of the oxbow site) that serves as a catch basin for rainwater for birds migrating through Salina. Hull's design also called for planting alfalfa, sunflowers, and scarlet clover in the shape of a river meander, in recognition of Salina's agricultural history. It would eventually be overtaken by native grasses and wildflowers, also to be planted as part of the project, which may become a model for wider-ranging pieces called *Outpost Oasis* and *Migration Milepost.* These would link communities and reserves by shared migratory birds. Hull first worked with parks (collaborating with the Wyoming Game and Fish Department) at Pine Bluffs, Wyoming, where she built "interspecies" art including waterholes, shelters, and raptor roosts. Her latest work is in Mexico, consisting of owl houses at the Huitapec Reserve in Chiapas, and a tree bridge across a road for spider monkeys cut off from their habitats in Quintana Roo.

'Nature is not as natural as it seems.'"

The relationship of such a "museum of the outdoors" to the natural history museum, with its artificial dioramas and stuffed creatures emulating and embalming nature, raises once again issues of inside and outside. Zoological gardens lie somewhere in between, where "nature" is still breathing but denaturalized.) In 1832, painter George Catlin imagined the grandest site-specific installation to date—"a magnificent park" that would incorporate the entire Great Plains from Mexico to Canada. It was also a prototypical theme park, in which Native peoples would pursue their buffalo-based livelihoods forever,

frozen in time. In 1864, Frederick Law Olmsted held that parks were works of art in themselves, not just frames for nature. The National Park Service's first director, Stephen T. Mather, envisioned parks not only as show places, vacationlands, and outdoor museums "but also vast schoolrooms of Americanism." And the very term "managed nature" approaches art.

The educational value of nature tourism was brought to the fore in the 1920s. As tamed nature became for an urbanized society a cultural activity rather than a force to be dealt with on a survival basis, prescriptive guidebooks became the instrument of transformation. In fact, education is the

Ruth Wallen, one of *12 View Points*, Fiberglass embedded hand-colored photographs and mixed media, 1994, temporary site-specific installation at the Tijuana River Estuary, southwestern San Diego County (photo: Ruth Wallen). Wallen used the Claude Glass (a convex mirror that frames but also distorts the landscape) as a metaphor for the ways we view nature. All of the texts, which explore contemporary ecological debates, were reviewed by both California State Parks and the U.S. Fish and Wildlife Service. This is the only wetland in the county, and perhaps in southern California, not covered by highways or railroads. A valuable wildlife habitat, it harbors several endangered species and is a birdwatcher's paradise. Three-fourths of the wetland lies in Mexico, and much of Tijuana's untreated sewage flows into the Tijuana River, resulting in the frequent closure of local beaches on the United States side of the border. When Wallen was working there it was also a popular route for undocumented workers to cross the border. *"La Migra"* (U.S. immigration officials) often posed as birdwatchers. The artist wanted to call her public art work "Looking for Sanctuary," but the title was rejected.

Center for Land Use Interpretation, *Selected Photo Spots,* postcard book of photo opportunities
re-published by the Hemingway Western Studies Center, Boise, Idaho; there are also a video,
a souvenir camera with fourteen selected views, and T-shirts available from the Photospot project.

excuse for much of this scurrying around trying to balance nature, and education of some sort is also an excuse for goal-oriented tourism. Nature trails are duly labeled like museum displays. Uniformed rangers act like uniformed museum guards. Originally, rangers were there to protect the visitor from the park; now they protect the park from the visitor. "Many an old-time park visitor was both nonplussed and a bit angered by his change in status," writes geographer Stanford E. Demars. "Rather than being welcomed to the park by the genial gentlemen in green, he suddenly found himself treated with condescension as an unschooled, rather bungling persona non grata whose presence in the wilderness was an intrusion and possibly even a threat."

As modern life increasingly distanced nature, the landscape itself was labeled. "Environmental Interpretation" is a new field for which artists would seem eminently qualified, if it hasn't already gone too far in the direction of didactic paternalism. Lynne Hull and Ruth Wallen are the only individual public artists I know who have taken advantage of it, with their nature trails markers in

Wyoming, Kansas, and California. In a more ironic devolution, conventional visits to "unspoiled" sites are sometimes countered by postmodern tours of spoiled sites. Degraded ecosystems are trotted out as an educational strategy.

The most interesting "art" (in quotes because it pushes the boundaries of the term) being made on the subject of "humanature" (as photographer Peter Goin calls it) is by the interdisciplinary artists' group that runs the Center for Land Use Interpretation (CLUI) in southern California. The center is disengenuously dedicated to "the increase and diffusion of information about how the world's lands are appropriated, utilized, and perceived." A three-part project, CLUI dissects (analytically rather than critically) "anthropic" (human-made) landscapes—urban, wild, and everything in between. The Land Use Database is a public resource on-line catalogue of over one thousand sites. The peripatetic Land Use Museum is a network of institutions and exhibition sites. And the Site Extrapolation Division conducts real and virtual tours of "unusual and exemplary land use sites" listed on the database.

CLUI's projects are identifiable as art because of the eccentricity of its choices, but outward language and format are studiously institutional. Social history is subtly embedded in apparently "unbiased" descriptions. Sites scrutinized include "remarkable roadways," "deleted communities" (replaced by reservoirs and military projects), submersions and burials, event markers, and an audio program of interviews with German tourists in the southwest. CLUI sponsors an ominous artist's residency at the Wendover, Utah, military base (where the Enola Gay was prepared for action). Among its deadpan publications is *The Nevada Test Site: A Guide to America's Nuclear Proving Ground*. The *Hinterland* exhibition/publication was accompanied by three multimedia bus tours including stops at military properties, the water bureaucracy, and outsider art in the environs of Los Angeles (p. 20). The *Suggested Photospot Tour Guide* was a place-specific installation of "PHOTO SPOT" signs highlighting ironic photo-opportunities. *The Event Marker Project* focused on obscurities such as the place on the Oregon coast "where a car was crushed by the falling blubber of a detonated whale." Kate L. Haug writes that CLUI defies "a polarity imposed both by ecological organizations, which seek to preserve, and organizations like the U.S. Military that test the land's physical limits." Doug Harvey likens CLUI's bus tours—of sites first introduced by photographs in an exhibition—to the sightside telescope, by declaring a "shift in magnification" the prime characteristic of the center's artistic and political significance. Instrumentally activist rather than overtly political, putting its potentially explosive eggs in no particular basket, the CLUI makes accessible a vast amount of information about the way nature is produced and perceived, while subtly molding the process according to its own lights.

Other artists have taken the opposite tack, using angry humor and parody to bring home their traveling points of view. In the early 1970s, photographer Stan Denniston shot a field of vertical missiles in Rocket Park at the Alabama Space and Rocket Center in Huntsville, in a series called "The Rhetorical Park." In 1989, Sharon Stewart put together a booklet for "A Toxic Tour of Texas," hitting all the eco low points in the Lone Star state. The Denver area, already the proud home of the hopelessly contaminated Rocky Mountain Arsenal, a national sacrifice area which has become an unplanned wildlife preserve, is a hot target for such gallows humor. Local journalist Kenny Be suggested that the Rocky Flats plutonium trigger plant, cleverly situated upwind from the metropolis, should become a national park, not a cleaned-up "open space," already a popular option, but a preserved landscape along the lines of Colonial Williamsburg, "where buildings are renovated and park employees wear period clothing and re-enact the lifestyles of a time gone by"—the Cold War.

Be envisioned thousands of jobs in reenactment and visitor services. Among the park's highlights: the "Welcome Center," where everyone is fitted with a complete body suit, gas mask, and dosimeter; a "Daniel Ellsberg Protest Pavilion," where volunteers organize encirclements and sit-ins, artists paint signs, and so on; the plutonium-dusted buildings, including one from which 2,200 pounds of plutonium were lost into the land and atmosphere; a Pollution Laboratory, where "real scientists work to create the technology needed to decontaminate Rocky Flats. As of now, none exists." Then there is the Don Gabel Memorial Cancer Tumor Research Center where autopsies are performed on dead Rocky Flats workers; a petting zoo for mutated local animals; and the Dow Chemical/Rockwell International

Hall of Lies, Deceit, and Misinformation, where "you can watch management conceal, shred, and dissemble before your very eyes."

Along the same lines is Richard Misrach's proposal for a national park on the grounds of the Bravo 20 Bombing Range, where he has photo-graphed for years. His Swiftian proposition focuses on the destruction of place and replacement of its history. The Bravo 20 park would be an educational project on sixty-four square miles of bombing range—"a contemporary version of a Civil War Battleground." This superficially humor-

Richard Misrach, *Bravo 20 National Park,* postcard, 1990 (illustration by Rico Solinas).
The text on the back of the card offers a choice of three boxes for the addressee: "Mr./Ms. President" or "Mr./Ms. Congressperson" or "Friends/Family"; there are three texts and the sender is to indicate which one applies, depending on the addressee. The message to the president asks that the Bravo 20 Bombing Range "unlawfully used and contaminated by the U.S. Navy for thirty-three years, should be turned into a national park—America's first environmental memorial." The message to Congress asks "Could you push the President on this one?" and the third says, "Check it out! What a great idea for a national park. I sure hope Congress gets off its duff and does something about it."

ous suggestion in fact continues the mission furthered for years by Misrach's strikingly beautiful critical landscape photography. Particular attention, he says, "will be paid to the circumstances surrounding the Lone Rock region, with focus on the military's illegal activities, its despoliation of the environment, its infractions of civilians' rights and the incredible cost to the taxpayer. To put the consequences and the implications of the Navy's actions into perspective, the geological, archaeological, environmental, religious, economic and cultural (Indian) significance of the area will be highlighted."

These conscientiously indecent proposals may not be so farfetched. For all we know, they are simmering in the unironic bureaucratic mind this very moment. The Department of Energy (DOE) actually gave public tours of parts of the Nevada Test Site in the early 1980s, and the Desert Research Institute has been doing archaeological work there on an extraordinary array of blast craters, blown-out buildings, and twisted metal that mark more than forty years of "controlled"

atomic explosions. DOE's public tours of the WIPP site in Carlsbad, New Mexico, have served as bulwarks against ongoing protests.

Conflicts between tourism and cultural/environmental survival might be resolved by conceptual archit-artist Kyong Park's "Office of Strategic Architecture," which proposes as a subsidiary of his "nuclear heritage park" the Corsican National Defense Entertainment System (CONDES)—"a project to reservice the island's coastal abandoned sixteenth- and seventeenth-century observation towers into a network of electronic scanning and projection services, to deliver a satellite linked 'pay per experience,' all sensory, digital fly-through of Corsica's natural beauty to a wide range of home viewers who seek the regenerative quality of a pristine landscape to balance today's multi-national incorporated life." (Taxation on the digital pleasure of Corsica would underwrite the island's historical pursuit for independence.) "The purpose of this project," says Park, "is to invent a virtual vacation, exploration without travel, the separation of visitors and sites.... tourism without tourists."

TAKEN ABACK, OR,
THE NOSTALGIA TRAP

IS THERE NO WORD aside from the overly discredited *nostalgia* for the complex emotions we harbor about the past, about childhood, about loss and return? Nostalgia (from the Latin "return home") is defined in my dictionary as "severe homesickness—a form of melancholia caused by prolonged absence from one's country or home." (The Sufi say everyone longs for true home, which is not on earth.) This is not the way it's used in contemporary scholarship, however. The word has acquired a veneer of duplicity, of sentimental inauthenticity, an evil "construction" that seems distant from the original meaning, or at least from the way I use the word—to suggest the dreamlike process of memory. Will the complexity of undeniable if contradictory emotions that

Boyd Webb, *The Conservationist,* 1978, color photograph (photo: courtesy of the artist and Sonnabend Gallery). Webb, a New Zealander based in England, is known for his wry commentaries on contemporary life. This image is more than an observation on history and nostalgia, also referring to the art world's consistent (minimalist) "overpainting" of its own recent pasts.

make up our responses to history and to our own pasts disappear from our cultural vocabularies because nostalgia is "constructed"?

Such a reading, in turn, is a construction (what isn't?) inadequate to the pleasures of thinking into the past as a means of illuminating the present. Constructed identity—the enthroned cliché of millennial cultural studies—is subject to various upheavals depending on what rumbles by on the freeway of scholarly fashion. It is useful so long as it's kept in its place as one of a series of factors in the process of *reconstruction* from the ideological rubble of the last two decades. Deconstruction merely for deconstruction's sake leaves me nostalgic for the lost nuances of "sentiment" (another taboo, innocently defined as "personal experience, one's own feeling").

History, created and recreated, is the motherlode of tourism. (The other extreme—recreation, with its emphasis on immediate gratification—is its greatest, and perhaps generational, rival.) Many Americans are obsessed with history as the year 2000 approaches; Colonial Williamsburg sold almost a million tickets in 1997. Distinctions should be made between nostalgia, history, and heritage, though the tourist industry does its best to broaden its appeal by conflating the three. Nostalgia, like memory, is personal and subjective; history is purportedly specific; heritage is often concocted, generalized, and idealized. Historical tourism thrives on anachronism, which jolts perceptive participants into consciousness, and synchronism, which perpetuates their enjoyment of historical myth. An archaeologist friend recalls an eerie experience when digging near an eighteenth-century fort; looking up, he was startled to see faces in bonnets and tricornes peering at him from the restored fort's windows—the costumed employees of the historic site, appearing as ghosts nostalgic for their unearthed posses-

sions and transformed places.

We are often reminded of the ways the past or heritage is manipulated by reactionaries to bolster the companion conceits of home and "family values." However, tourism and childhood reminiscence, curiosity about one's own family's or place's history need not involve any severance or escape from the new home one has constructed for oneself as an adult. They are not the same as a longing to *return* home (and to stay there), to reconstitute the mythical "good old days," or a "golden age," refusing to confront the present, seeking purity and isolation that allegedly characterized some past somewhere... but probably not anywhere we live.

Try as I may to de-construct the obvious artifices negatively attributed to nostalgia, it has not helped me kick the habit of pondering places and ways of life that are out of reach of my own memory. Nostalgia in the broad sense, as the word is used today, suggests thought-provocation laced with a certain poignancy that need be neither gloomy nor reactionary. Inherited layers of class, race, and gender attitudes (not to mention familial resentment and regret, or realistic childhood history) can be excavated from its depths. As in sexual practices, the complexity of such musings is lost when they are divided into good and bad. A history that gives events and places no context, a history that does not share its story with people unlike its creators, devolves into commercial "heritage."

The context (sensuous and intellectual) in which I began to think about the nostalgia trip and trap is a longtime summer home in Maine, about which I seem to be writing a lot lately, having never considered it much when I was younger. After reading Dona Brown's engrossing book *Inventing New England: Regional Tourism in the Nineteenth Century*, I began to scrutinize the needs, tastes, and restlessness I inherited from my

grandparents and parents, and to wonder about the ways early twentieth-century New England tourism carved my family's stories.

Our culture and liberal politics are those of WASP "New England," despite one and a half generations' adventurous migrations to the west, where some of our best stories come from. Yet my WASP New England forebears might be surprised to find someone like me claiming their identity; some might want me disinherited on the spot. If my lifestyle, my lovers, my language, my socialism, my New York tenements and lofts furnished from the streets were anathema to my parents (their dissimilar class backgrounds had merged into upper-middle-class attitudes by the time I was conscious), they can nevertheless rest assured that certain values, class belligerencies and anxieties, loves and obsessions they had planted in their only child thrived in these foreign milieus.

I've never really lived in New England, except for summers, and some school and college, though my parents were raised there. While I lived with them, we were enthusiastic tourists in new places where we never stayed long enough to exhaust the possibilities. We moved from New York City to New Orleans to Charlottesville, Virginia, to New Haven, Connecticut. There I got bored and got off the parental train to return to New York, my childhood home. Perhaps nostalgia had already struck. Across thirty-five years of relative stasis in New York City (where it is possible to be a regional tourist for a lifetime and never see it all), I became increasingly interested in the maintenance and transformations of cultural, cross-cultural, intercultural, and cross-class movement and its geographies. Although I have been a tourist on several continents, "foreign" travel per se doesn't interest me now as much as movement to and fro within a lifetime.

If my parents and I were tourists in our winter lives, summers brought a return to the roots, to New England, to Maine, visiting relatives in Massachusetts, Vermont, and New Hampshire along the way. I never thought of our summers as tourism. Tourists were the day-trippers, the Sunday snoopers, the people eating at the lobster wharves, buying postcards at the store, or driving wistfully as far down the road as the PRIVATE PROPERTY: PLEASE TURN AROUND HERE sign, before the ocean views and beaches opened up. When we partook in these same pleasures ourselves, we did so rather smugly: we were disguised "property owners" and "residents" only visiting tourism. Tourists were those less fortunate than ourselves who had to drive by and stare at our houses because they had none of their own. It didn't occur to me until I began driving around Maine myself, that they too had houses, and perhaps a good deal fancier than ours, but they were still interested in staring at ours, as I was at theirs. At that point, I discovered how unwelcome I was when I moved out of my own place in Maine—just as unwelcome as these people when they came to us.

Of course to the Yankee "natives," we *were* just another kind of tourist. Summer people who retire here or move to Maine to work year-round, or visit often in the winter, as I do, can't get over how different "our place" is "out of season," when it is no longer our place, which is actually a time, a season, a fragment of the place we think we know so well. Perhaps this too is why the local history has such a powerful hold on many of us; in order to know the beloved, we go back in dotted lines of broken time instead of circling the calendrical year.

The tourist's New England was first invented in the 1840s and worked its way up the coast to Maine. Meanwhile, the vacation and the summer home, respites from the city's heat, social prob-

lems and bewildering cultural diversity, worked their way down through the economic spectrum from mansions and elaborate "cottages" to modest cabins to weekends at a nearby beach. Artists were among the first tourists, and the most effective propagandists, to be attracted to picturesque Maine—the pines meeting a rockbound coast, the crashing surf, the inland farms, the distant lakes and waterways, the deep woods.

The most committed modernists and even postmodernists continue to *visit* traditional values, a need fulfilled by rural tourism and the "summer place." (Rural, as opposed to suburban, is defined as a productive landscape rather than a bedroom community.) We tend to visit tradition without questioning the contradictions involved. Today, vacations are from urban stress rather than

from urban germs. Such visits do not constitute a return to nature or resistance to urban modernity, but a dilettante's temporary retreat from its crowds and rapid pace.

In the 1890s, the fate of the northern New England states (perceived as the last stronghold of the old pure WASP values) was becoming "increasingly significant for the many people, both outside and inside the region, who looked to the region for the preservation of values threatened by the explosion of the great industrial immigrant cities" to the South. At the same time, economic decline led nineteenth-century New England state governments (like now) to devote themselves to "harnessing and profiting from the nostalgia of fellow city dwellers" as a means of recouping the fortunes of those left behind by

CENOTAPH, CONTAINING BONES OF THE PILGRIMS, PLYMOUTH, MASS.

Cenotaph Containing Bones of the Pilgrims, Plymouth, Mass. old tinted postcard, n.d.

railroads, highways, and modernized industry. These two contrary paths were headed for collision. Dona Brown describes the 1890s as "a battle for control of the vacation, and ultimately over the meaning of rural life." After a century of ambivalence, nurtured by need, greed, and innocence, agriculture has succumbed not to tourism but to development, suburban sprawl, and its rural imitations; "the nostalgia industry" sets most local teeth on edge.

Reading and thinking about travel, tourism, and the temporary and enduring mixtures of cultures, I begin to see why this has turned out to be such a personal obsession. It was my maternal grandmother—Florence Emily Isham Cross—born in Connecticut, taken at an early age to a sod house in Dakota Territory, raised and educated in

Wyoming and Colorado—who framed our family history for us. An egalitarian grande dame living on a clerical shoestring, she was into genealogy for its historical treasures and for its possible returns in aristocratic status. She got me going on local history and her tales of a Western childhood made me long to be riding through arid landscapes, visiting with Indian people, and climbing Pike's Peak, even in a cumbersome long skirt.

My maternal grandmother's selective stories of her family's Western travels and travails and her husband's silences on his own rugged Western childhood in the 1870s were balanced by the less mentioned but equally intriguing bits and pieces I garnered from my paternal grandfather's odd journey. He had gone from Cockney orphan living under the Tower Bridge in London to cabin

Peter Woodruff, *Georgetown Center,* 1993, color slide. The former parsonage and the First Baptist Church.

boy to factory worker in Massachusetts, where he met again his grandmother's bastard son by (so the story goes) an English lord. I never heard a word about how my paternal grandmother (a schoolteacher whose Tory family had left New England in the 1770s) got from Nova Scotia to Marlborough, Massachusetts. My mother's teenage and college-age experiences in France were thrown onto my pile of building materials, along with my father's sojourn in a wartime South Pacific. These were heightened by all the lurid historical novels I read before I was old enough to understand them.

Brown's book has made me look at my treasured summer experiences with fresh eyes as I try to fit my family into the narrative. In 1915, my grandparents were invited by a parishioner to visit on the coast of Maine; they found several empty houses there and eventually bought one with half an acre as a summer home that was a haven for the rest of their lives. Because of their frontier youths, my grandparents may have been particularly susceptible to the nostalgia trap baited across an economically strapped New England that was forced to embrace middle-class tourists and "summer colonists." They had already gone home again, left the west to live in New England, haunted, perhaps, by their own mothers' nostalgia (in the true sense of the word) for the more comfortable lives they had given up to follow their pious, hardworking but aimless men across the new territories. In other words, perhaps my grandparents, having skipped a New England generation, were making up to their ancestry for lost time in the ahistorical West. Nostalgia may be an antidote to the betrayal constituted by forgetting.

The great days of prewar tourism in Maine were just ending. The myth of New England and the colonial revival were in full bloom. The coastal villages had been spruced up and painted white to reflect the supposed purity of the Colonial period and attract the urban nostalgia trade. The Kennebec River was still plied by sail and steam; crowds of jolly excursionists landed at the huge docks now reduced to mossy piles; the average fisherman still went out in a double-ended dory; the now-forested land was still cleared for farms, though many were by then abandoned and the rock-edged fields were filling in with puckerbrush.

In the nineteenth century, writes Brown, "New England's countryside was imagined as a kind of underground cultural aquifer that fed the nation's springs of political courage, personal independence, and old-fashioned virtue." This is precisely the image of my cultural background that was handed down to me (despite evidence to the contrary when family stories got down to brass tacks). I was raised with a taste for the picturesque, the gracefully aged, the "nice old house," the "lovely view," the "charming little town." "How Dear to My Heart Are the Scenes of My Childhood" is a song I remember singing around the wheezing, permanently dampened piano at my grandparents' house in Maine. At some point, I lost the old, fragrant, balsam pillow inscribed STATE OF MAINE, FOR YOU I PINE, FOR YOU I BALSAM, which I took to bed as a child in the New York wartime winters, so I could hear the waves lapping on the summer shore as I fell asleep.

The environments we build after leaving the nest offer obvious clues to our relationships to our cultural identities and their constant reinvention. My mother hated things like that balsam pillow. She had the clear eye for pathos and pretense of a child raised "genteel" but poor among the better off. Once when I was writing about class and domestic interiors, my mother reminded me that the rich (with whom she was more familiar than I was) often had abominable taste. Like her frontier-bred mother, she disdained clutter, too

much color, and chintzy, ornate, bric-a-bracish, pseudo-colonial pretentiousness, although both of them loved the "genuine" artifacts and architectures of the eighteenth and nineteenth centuries in the Northeast.

I now live in a small pseudo adobe house in an overgrazed pasture in New Mexico—a far cry from the little white cottages nestled in trees that were my imagined childhood idylls, unedited versions of New England mythology. My place is equally far from the thrifty elegance in which I was raised—the dark green walls and white woodwork, a few handsome heirlooms (literally "tools" of inheritance). My own interior is lemon-yellow with red, turquoise, and black trim, its random decor rife with patterned textiles and tchotchkes from nature and culture, a riot of raucous detail. This is the identity (or its packaging) I have constructed for myself, having long ago decided to reject my parents' hard-earned lifestyle. Only some chipped ironstone and willow-ware china—the basic blue and white that evoke New England—are material remnants of the identity constructed for me.

These are literally *souvenirs* from childhood, from the monoculture—British, Canadian, and long-time "American"—of my original identity. They are as curious to me now as the other objects of affection (and affectation?) that surround me— the rocks, photos, artifacts, or a 1940s metal Lone Ranger and Tonto bread sign that reminds me of the days when I galloped around the living room each evening as the William Tell Overture rousingly announced my favorite radio program, in the days before I questioned Tonto's role.

Susan Stewart, who writes brilliantly on longing, says the souvenir temporarily "moves history into private time." Many of these souvenirs among which I live are quite literally foreign to me (or vicarious: I was, after all, an art critic, the

ultimate in vicarious professions). A ceramic tile depicting San Francisco with his animals at my door was given me by a neighbor (though I am not Catholic). A Haitian vévé flag and metal crucifix were also gifts (I've never been to Haiti and I'm not a Christian either), as are a beautiful bone rattle made by the uncle of a friend on Tuscarora, where I visited the reservation as friend and guest but also as a tourist in a sixth-grade classroom and at a family maple sugar camp. Closer to home are a disintegrating snakeskin I found right after I moved west (a symbol of my own changing skin), old family photos and new ones, and endless postcards, representing a network of friends and a peculiar map of our mutual comings and goings. Very little of this stuff was garnered from formal tourism, but each object brings back direct or indirect memories of the unfamiliar, nostalgia for the abstractions I've embraced. Given my work on multicultural art, these can certainly be attributed to what Caren Kaplan has called "theoretical tourism" or less kind epithets involving the word colonial.

It's no wonder that tourism is frequently based in attraction to now-unfamiliar aspects of what we think was once part of our culture's daily life. The general outlines of the past may not be comforting, but they are known. We have survived, now it's our mulch. The future, unknown, is ominous. Family and local history interest most people far more than broader views of national and world history. The less powerful one is, the more one fears the power of others. At the same time, not everybody has a happy childhood, and longing for someone else's past can fill the gap. By definition, tourism is about going "away"; time is as good a destination as space. Islands in particular, but also isolated villages, mountains, and peninsulas anywhere, maintain the mysterious aura of Brigadoon; your travels through the

foggy night end on a bumpy dirt road, and in the morning you awake in a different world. There are those who feel that in certain places they pass through a gateway into the past—an intense psychic experience only distantly related to superficial nostalgia.

In a way, my summers in Maine provided that gateway. During World War II, my mother and I often stayed down the road at my grandparents' house. The deep porch looking out to sea, the dark wooden living room with its fireplace, over which we roasted peanuts in a little black iron pot that swung on an arm over the flames, the kitchen with its woodstove, slate sink, rain barrels and hand pump, the wooden bucket of chilly well water, the outdoor privy, spooky to visit on dark nights—all this was "history" to an urban child, just as the nineteenth-century impresarios of the nostalgia industry had planned.

I was at home in a different space but a tourist in a different time. Some people already had motor launches, but most of us rowed and sailed. When I was little there were no speedboats, no phone, no electricity, no indoor plumbing. We ate a lot of fish caught by my grandfather; Will Oliver, from up the road, delivered milk; Gil Lewis (a gentle giant who was a eunuch, to my great fascination) delivered chunks of ice. The bad memories, the fears and tears, are also real enough, but they belonged to the self, to the present, detached from the warm embrace of the environment and the past.

It was in the process of getting there, getting back that the liminal contrasts emerged. On our way up to Maine from the south, where we lived in the late 1940s and early '50s, before highways were homogenized, we traveled within a series of intriguing contexts. We drove past farms and harbors, across rivers, along the ocean, through scenic and agricultural and industrial and developing landscapes, through rich and poor neigh-

borhoods; that's probably why I still love to travel by bus, slow and occasionally terrifying though it may be. We stopped in real gas stations, diners, and mom-and-pop motels, not chains, franchises, convenience stores, or "Puffin Stops." While we dreaded the traffic-clogged main streets of towns like Charlton City, Mass., at least we were there, and we knew where we were.

Once into Maine we followed the meandering Route 1 (now choked with tourists and avoided like poison except for local business) past the vast rocky beaches of York, crowded with cabins and thronging weekenders, the down home strips of Wells and Ogunquit, the Catholic cemeteries of Biddeford, and Portland's imposing Deering Oaks Park (the swans' house was always a highlight), and finally an acute smell of the sea along Baxter Boulevard.

It was hot and slow going, but clearly defined and richly varied, not the numbed-out amnesiac air-conditioned path we travel today through what James Howard Kunstler calls "the geography of nowhere." Random practical pitstops were more unexpected than the tourist spots. An oft-told family story involved my best friend from Virginia, who took her first trip North with us at age fourteen. Everywhere we stopped, the proprietor had an "accent"—perhaps Italian, Yiddish, or just New Yawk or Bawston. "Yankees sure talk funny," remarked "Southern-Fried Chicken," as our teenage friends in Maine called her.

Whenever we stopped in a motel and listened to the radio, a local accent rang out at us, and we'd imitate it all the next day until taken by a new one that night. As we drove through the unfamiliar landscape, we sang earsplitting versions of popular songs, collected license plates from different states, played alphabet (apple trees, Burma Shave, cow, dump....) Today, northeastern highways glide between dreary expanses of grass

and identical trees, placeless and featureless, providing little stimulus for the imagination, no local color. And the trips are hours shorter.

If we were making good time, we stopped at historic sites, veering off at signs for old houses, forts, and other landmarks. Both Virginia and Boston, of course, were full of such photo opportunities. Williamsburg was fun, especially the stocks, but even at age fourteen I could tell it was too clean to be real. Far more evocative were the overgrown houses and collapsing barns we passed along back roads. Into these empty shells I could insert my own stories, resisting the master narratives I learned in school.

I remember less of Paul Revere's house near Boston (it was small, wooden, dark, hemmed in by more recent buildings) than of Louisa May Alcott's house in Concord, which is confused with my own images from *Little Women* and the madcap aspiring writer Jo, with whom I identified along with my other "historical" (fictional) heroines of the time—Forever Amber, National Velvet, and the two Adelaides of Mazo de la Roche's Jalna books. I haven't seen Alcott's house for close to fifty years. It may by now be totally imagined, though I can easily bring a picture to mind—a pleasant grayish (or yellowish?) house set back on a broad velvety (inauthentic) lawn, with an orchard and a peaceful room featuring a little writing desk that filled me with envy and ambition.

I remember the swan boats in Boston Common (why is New England so swan-ridden— some aristocratic code?) and a lot of regional cemeteries. I've never lost my taste for overgrown graves, ornamental fences, and moss-covered inscriptions. (The height of nostalgia is memento mori.) A certain rebellious iconoclasm reigned in terms of churches, which we avoided, perhaps because my mother had put her past as a church mouse behind her. We admired church architec-

ture, pondered the decontextualized history, but indulged in nothing approaching worship of deity or state (the McCarthy era had soured my parents' taste for jingoism).

The history these places communicated to me as a child was curiously impersonal and naively patriotic, partly because of the time period available. New England tourism leans heavily to the Revolutionary, the Colonial, the replicated revolutionary and ersatz colonial. (On my mother's side of the family there was a sense of "we were there"; my father's side was the Tory enemy.) We visited the monuments of Lexington and Concord, peered through a fence at Plymouth Rock, and climbed around on the revolutionary ship *Constitution* as she rode the gentle dockside swells. In 1997, two hundred years after her launching, the *Constitution* has set sail again, escorted by fighter planes and helicopters. This curious leap backwards, notable for its unabashed anachronisms, overshadows other tall ships in historical clout as well as temporal and physical scale (her fighting crew was four hundred and fifty men).

Today, thanks to progressive scholarship, the choices are broader. My father, who once worked in the shoe factory with his own father, would

The author, age 14, visiting Colonial Williamsburg, 1951 (photo: Vernon W. Lippard).

have been bemused to find the milltowns of Lowell and Lawrence historicized as tourist attractions. "Nostalgia tours" still avoid overt ideology. God forbid that potential visitors should be scared off by the specter of politics or class struggle. Yet the presentations of the sites themselves are often ideologically loaded, appealing to the Left and Right in the same preservative language. The "mixed bag of unexamined impulses and emotions" that motivated nostalgic tourists in the nineteenth century still operates today, when, as in so many other areas, the rhetorics of conservative and radical extremes merge queasily.

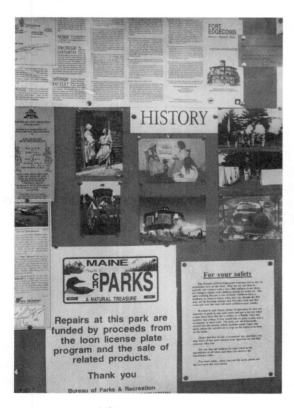

Peter Woodruff, *History,* black and white photograph, 1997. Public bulletin board at Fort Edgecomb, Maine.

MOST CONFLICT over public interpretation takes place privately, but there is no denying that beneath the backwater serenity of New England villages, then and now, lies the promise of monocultural safety and racial "purity" of a selected past. Immigrants cannot afford to live in places with few jobs, so out-of-the-way villages remain strongholds of "historic" homogeneity, interrupted today by constant reminders of modern commerce which sometimes includes a darker face (Vermont and Maine are the two whitest states in the union). The poor—and there are plenty of them—are perceived as "local." The nostalgia tourist in New England learns to ignore such obstacles, to head for the stage sets—the historic district, the landmark houses, the restored waterfront, reserving McDonalds and Holiday Inns for familiar comfort after the show is over.

American tourists are conditioned to respond to the automatic charms of sheer old age (in buildings, anyway). Ye olde house may or may not be "the oldest," but it might offer a positively retrospective moment to passersby, if the romantics, the generalizers, and the simulators haven't gotten there first, blocking or obscuring the layers of history that have produced the artifact before us. (The Historic Charleston Foundation, in South Carolina, has gone so far as to issue a brochure of color paint chips for "the authentic colors of historic Charleston"—produced, appropriately, by a firm in business since 1865.) If the building is sufficiently dilapidated, or else authoritatively spruced up and labeled, and if its context is compatible with the given public history, or is at least neutral, then it has the power to evoke a general past, to tweak the nostalgia nerve. Yet Frank Matero, chair of the graduate program of Historic Preservation at the University of Pennsylvania, insists on the other side of the coin as well, observing that while progress is "the antithesis of

nostalgia," it too can be "a seductive fiction" used to "invalidate the past as irrelevant and harmful.. .. Everything has history; thus it is the obligation of preservation to provide the means by which those stories can be made relevant to the present through the built environment."

However, if the tourist's landscape is perceived as the past, then present concerns need not interfere with superficial pleasure. Maine is a poor state, and tourists learn to avert their eyes from the less ingratiating sights, those incompatible with the invented past and our modern expectations thereof, as though only the nice old houses, shady lanes, and harbor vistas were visible; as though there were no shabby side streets, edge-of-town strips, tall old multifamily houses cowering in their tarpaper coats against the elements, no yards full of rusting cars, no toothless elders, and pale, overweight teenagers pushing strollers, no convenience stores on the corners.

Even for those who already live in New England and may be jaded by quaintness and the "oldest house" syndrome, the Maine coast remains distant, a foreign working environment embedded in natural beauty that obscures local duress. It's easy to be nostalgic (as I am for arched wooden lobster traps) for things that look nice and make other people's lives hard and dangerous. Today the lobsterers use motor boats, sophisticated navigational technology, and rectangular wire traps, but in their rubber boots and coveralls, with their graceful, high-powered boats, they remain a romantic sight, if for no other reason than the fact that they must collaborate with the sea to make their living. (This may be an epitome of nostalgia as negative distancing.) Tourists and summer colonists alike are seldom aware, or seldom care, that fishermen are struggling for their livelihoods in the face of over-fished stock and sometimes unrealistic government and environmental regula-

tions. As yet there is no "living history" reconstruction of a Maine fishing port, but with the fish disappearing it could happen in my lifetime. At the heart of tourism lie class power struggles that most tourists prefer to ignore.

If I'm longing for anything, I guess it's for the earlier days when the New England myth still had some rough edges. The occupants of historicized sites are (often involuntarily) drawn into the myths, building or decorating their houses to conform to imagined pasts. They are accused by other locals of impeding progress and fearing change. The quaintness industry is still going strong, and residents don't seem to know when to stop. Historic districts are so manicured that they look newer than the recent ruins in the declassé neighborhood around the corner. Old rural houses fallen into the clutches of the middle class are constantly "improved" and fussed over, surrounded by more and more elaborate lawns, gardens, and ornaments, incongruous suburban fences, additional doo-dads such as overturned boats in the front yard, or dignified old fishing dories still upright but filled with petunias. (Some of this diatribe can be attributed to my own perverse—and downwardly mobile—taste for overgrown yards and peeling paint.)

Driving through Wiscasset, billed as "Maine's prettiest village" even though traffic-clogged Route 1 runs like a moving spike through its heart, one is reminded of still more manicured sites further south, like Litchfield, Connecticut, where, as Brown comments, nineteenth-century emigrants from New York "created a 'New England village' appearance for their summer colony that was more 'colonial' in 1870 than it was in 1770." By 1998, no reincarnated colonial would recognize her purportedly "authentic" home.

Such lily-gilding is nothing new—nor is the level of cynicism that appears endemic to our age

and encourages a theme-park approach to history. In the nineteenth century, tourism was characterized by wild exaggeration, concocted myths, and bogus restoration, which follow current taste rather than historical accuracy, although in the past, people seemed willing to work a lot harder to get to places, to see the sights, and perhaps to reflect on their philosophical ramifications, on "the picturesque" and "the sublime," even as they swallowed the tall tales. Things tend to be preserved not because they are the best or most significant, unique, typical, or beautiful, but because they are what is left. We worship fragments as though they were the relics of saints—an old gate here, a barn there, a millstone here and a spinning wheel there. Provenances, even dates, are often lost; but the objects of our veneration remain. They are collective souvenirs, objective remainders subject to subjective and ideological re-assessment. One constructs one's life from such touchstones. Some of my own souvenirs are literally that—stones often touched, on and off site. Though I cannot always remember where they came from, it doesn't matter, for they are now part of my present life. I've considered writing a memoir as a guided tour of my "stuff."

As we look back, we see things in the distance. They get smaller and fewer. Modernization, by destroying the old, makes it scarce, valuable and desirable. Susan Stewart suggests that miniaturization is part of the nostalgic impulse, evoking a tableau rather than a narrative. According to her, my preference for the worn and shabby authenticates the past and discredits the present, while the antique souvenir creates "a continuous and personal narrative of the past." This is not, of course, a bad thing. I would say that "bad" nostalgia operates in precisely the opposite way, disrupting past and present, creating a past that is merely a refuge from the present rather than inherited significance.

Stewart sees nostalgia as a "social disease." Although her writing on the subject is filled with fascinating insights, I disagree with her basic premise regarding nostalgia's utopian inauthenticity: "Nostalgia," she writes, "is sadness without an object, a sadness which creates a longing that of necessity is inauthentic because it does not take part in lived experience.... Nostalgia is the desire for desire. The prevailing motif of nostalgia is the erasure of the gap between nature and culture, and hence a return to the utopia of biology and symbol united within the walled city of the maternal."

What does it mean, then, that nostalgia is part of my lived experience, that it is desire unremoved from the senses, that I consider it a seamless and positive part of life, a reminder of breadth and depth, a confirmation of continuity? Utopia too is a necessary and authentic goal, the object of a longing that may never be fulfilled but functions positively and authentically for just that reason. I even mistrust the rigid separation of nature and culture and approve of blurring the boundaries; either/or positions have been responsible for many of the worst aspects of both nature and culture in our society.

I meant to redefine and also exorcise nostalgia in this essay, but it's obviously been an uphill battle. Recurrent doses of critical analysis have not been able to dispel nostalgia, the good stuff, especially when I am sitting, as I am now, before the foggy view of all those summers stretching back, manipulating my educated guesses, blowing theory out of the window and down east.

NOTES

For full references, when omitted, see bibiography

On Rubbernecking

2 CAROLYN CHUTE, *New York Times*, Aug. 25, 1995.

EVELYN WAUGH quoted by Ingrid Schaffner, "Every Traveler a Tourist," in *The Cultured Tourist*. Woodstock, N.Y.: The Center for Photography, 1995, p. 11.

immigrants: Poet Gary Snyder is working on a unique project with Hmong immigrants in California to show them the place, the natural surroundings, in which they have arrived, as a means of locating themselves more firmly than is possible through initial social encounters. Frank Sanchis has encouraged the National Trust for Historic Preservation to "interpret" the lives of those who built and worked at sites—such as the full-time gardeners at Jay Gould's mansion Lyndhurst; he suggests designing a tour around their diverse backgrounds and skills. See *Historic Preservation News* (Nov. 1990), p. 6.

4 **400 million:** "More people are meeting people than at any time in history." In 1996, Florida, California, and Hawaii were the favorite U.S. destinations for the fifth year in a row, with Nevada and New York tying for fourth place. American tourists traveling abroad go most often to Mexico and Canada. Americans spend the most of all international travelers and the United States earns the most from tourism, though France is the top destination (the U.S. is second). "Travel is one of the basic human rights now," says a World Tourism Organization official. See Barbara Crossette, "Surprises in the Global Tourism Boom," *New York Times* (April 12, 1998), Gregg Stein, "Vacationers Ready to Go, Spend," *Portland Press Herald* (May 15, 1997).

JOHN URRY, *The Tourist Gaze*, p. 2.

CAPTAIN BASIL HALL quoted by Dona Brown, *Inventing New England*, p 58.

5 ALBERT CAMUS, quoted by Yang Lian, "The Sea of Ulysses," *Documenta Documents*. (Kassel, Germany: Documenta X, 1997), p. 5.

LAWRENCE DURRELL, *Spirit of Place*, (New York, E.P. Dutton, 1969), p. 158.

vacation: According to Nelson Graburn ("Tourism, the Sacred Journey," in Valene Smith, *Hosts and Guests*, p. 23), the word comes from the Latin *vacare* "to leave (one's house) empty" to go to work and "emphasizes the fact that we cannot properly vacation at home."

6 DEBRA DREXLER, "Postcards from Oahu," unpublished manuscript and painting series, 1995–96.

travel and tourism: For example, "travel" writer Paul Theroux's disdain for the "tourist" is pointed out by Sallie Tisdale, who muses "Tourists don't know where they've been.... travelers don't know where they're going." See "Never Let the Locals See Your Map: Why Most Travel Writers Should Stay Home," *Harpers Magazine* (Sept. 1995), p. 67.

7 **king or queen for the day:** quoted in John Urry, *Tourist Gaze*, p. 11.

8 **Maine tourist questions:** Shoshana Hoose, "Mainers Have the Answers," *Portland Press Herald* (May 23, 1997).

9 ARMAND MATTELART, *Transnationals and the Third World*, pp. 104–106.

traveling only called tourism around 1800: Dona Brown, *Inventing New England*, p. 16, citing the *Oxford English Dictionary*.

DONA BROWN, *Inventing New England*, p. 6, 13.

11 D. H. LAWRENCE, letter to Catherine Carowell, quoted in *Aperture 150* (Winter, 1998), p. 17.

EDWARD RELPH, *Place and Placelessness* (London: Pion, 1976), p. 83.

DEAN MACCANNELL, *The Tourist*, p. xv.

DAVID HARVEY, *The Condition of Postmodernity* (Cambridge, Eng.: Basil Blackwell, 1990), p. 205.

The Tourist at Home

12 SANTIAGO CHUB, from *Maya Atlas: The Struggle to Preserve Maya Land in Southern Belize* (Helena, Mont.: Indian Law Resource Center and GeoMap, 1998), as quoted in the center's Spring 1998 newsletter.

concept of the authentic: Dean MacCannell, "Tradition's Next Step," Scott Norris, *Discovered Country*, p. 162.

13 JODY BURLAND, "Traveling Correspondence," pp. 8–9.

ALEXANDER WILSON, *The Culture of Nature*, p. 22.

JIM KENT, quoted in Harlan C. Clifford, "Aspen: A Colonial Power with Angst," *High Country News* (April 5, 1993).

14 **"what defines you as a local":** Michael Kinsley, quoted in *ibid.*

DONALD SNOW, "Selling Out the Last Best Place," Scott Norris, *Discovered Country*, pp. 29–30.

JOHN GREGORY PECK AND ALICE SHEAR LEPIE, "Tourism and Development in Three North Carolina Coastal Towns," Valene Smith, *Hosts and Guests*, pp. 203–222.

JOHN STILGOE, "Locally Popular: On Foot-hi Pies and Other Economic Indicators," *Harvard Design Magazine* (Winter/Spring 1998), pp. 4–7.

DEAN MACCANNELL, in Lubell, MacCannell, and MacCannell on Chinatown, "You Are Here (You Think)," Brook, Carlsson, and Peters, *Reclaiming San Francisco*, p. 149. The book itself is a model of how to get to know a city.

17 **"a little bit of the underworld":** from *New York Times* May 25, 1914, quoted by Marshall Berman, "The Marriage of Heaven and Hell: On the Synthesis of Times Square," *Harvard Design Magazine* (Winter–Spring, 1998), p. 23.

ANDREAS HUYSSEN, "Fear of Mice: The Transformations of Times Square," *Harvard Design Magazine* (Winter–Spring, 1998), p. 28.

MICHAEL SORKIN, "Status Quo Vadis?" *Harvard Design Magazine* (Winter–Spring, 1998), p. 31.

In the summer of 1994, Creative Time (in cooperation with the 42nd Street Development Project, and the City's Economic Development Corporation) sponsored a major public art show, "42nd Street Art Project," between Broadway and Eighth Avenue. Twenty-five artists, architects, and designers made site-specific projects to celebrate "the world's busiest, bawdiest" intersection as it bit the dust. Many of the art works were made in storefronts that had been closed by the cleanup/development of the neighborhood.

DAVID SOLNIT, "1984 Democratic Warchest Tours: Voting With Our Feet at the Altar of the Electoral Ritual," from "Shaping San Francisco, An Interactive Multimedia Excavation of the Lost History of San Francisco," CD Rom in association with Brook, Carlsson, & Peters, *Reclaiming San Fransisco*.

REBECCA SOLNIT, "The Right of the People Peaceably to Assemble in Unusual Clothing," *Harvard Design Magazine* (Winter–Spring, 1998), p. 43.

18 BERNIE LUBELL, DEAN MACCANNELL, and JULIET FLOWER MACCANNELL, "You Are Here (You Think)" in Brook, Carlsson, and Peters, *op.cit.*

SUSAN SCHWARTZENBERG, *Cento*, n.p.

19 ELIOT WEINBERGER, "Paradice," *The Nation* (Feb. 10, 1997), p. 36.

22 **bumpersticker jingoism:** Jim Robbins, "Tourism Trap: The Californication of the American West," Scott Norris, *Discovered Country*, p. 84.

JAMAICA KINKAID, *A Small Place*, pp. 18–19.

23 JOHN NICHOLS, "Some Thoughts on Humiliation," Scott Norris, *Discovered Country*, p. 102.

Surprise Packages

33 JOHN BALDESSARI, quoted in press release from Santa Monica Museum of Art, 1993.

34 **Tunisian onlooker:** "Boudhiba," quoted by Ron O'Grady, *Tourism in the Third World*, p. 10.

LUCY R. LIPPARD, "The Ten Frustrations, or, Waving and Smiling Across the Great Cultural Abyss," *Artforum* (June, 1980), reprinted in Lippard, *Get the Message?* (New York: E. P. Dutton, 1984), pp. 211–228.

35 MARGO MACHIDA, "Out of Asia: Negotiating Asian Identities in America," in *Asia America* (New York:

Asia Society Galleries and The New Press, 1994), p. 96.

because they represent: Tseng Kwong Chi, quoted in *Longing and Belonging: From the Faraway Nearby* (Santa Fe, N.M.: SITE Santa Fe, 1995), p. 188.

37 In 1991, Kelly Ann Hashimoto made *Come See the Para/dice* for the Whitney SITE/*Seeing* show. She framed in gold her deliberately unexceptional tourist photos of the South Pacific in order to commemorate her first foreign tourist experience and to highlight the complexities of her own "foreign" status as an Asian American.

38 There are precedents for **caged artists**. Bonnie Sherk performed in a public zoo cage in the 1970s as an ecological gesture; Valery Gerlovin and Rimma Gerlovina were naked in a cage labeled *homo sapiens* in their 1976 *Zoo*, a gallery work and "actionist gesture" by members of the Moscow Romantic Conceptualists.

39 COCO FUSCO, "The Other History of Intercultural Performance," *English Is Broken Here*, pp. 37–63. See also Barbara Kirshenblatt-Gimblett on exhibiting humans in her "Objects of Ethnography," Karp and Lavine, *Exhibiting Cultures*, pp. 386–443.

40 **bedlam:** quote from *The World* (1753), by Tad Friend, "It's a Jungle in Here," *New York Magazine* (April 1996), p. 45.

McAloon: quoted by Barbara Kirshenblatt-Gimblett, *op cit.*, p. 407.

Renée Green's 1990 piece on **Sarah Bartmann** was called *Sa Main charmante*.

ZIG JACKSON, letter to the author, April, 1998.

43 KATHY VARGAS, Chon Noriega, *From the West*, p. 73.

44 RENÉE GREEN on *Peak: Lost Illusions: Recent Landscape Art* (Vancouver: Vancouver Art Gallery, 1991), p. 15.

45 **Renée Green:** Wallis, "Excavating the 1970s," pp. 98, 122; and in lecture at SITE Santa Fe, March 1998.

M. CATHERINE DE ZEGHER, *Andrea Robbins and Max Becher* (Kortrijk, Belgium: The Kanaal Art Foundation, 1994), and the artists' captions.

47 **Old Tucson burned down:** *Boston Globe* (July 10, 1995).

ANDREA ROBBINS and MAX BECHER, "The Oregon Vortex," *Blind Spot* (6, 1995).

48 **Hock and Sisco:** For more on Western tourism's dependence on undocumented workers, see *High Country News*, special issue on "El Nuevo West" (Dec. 23, 1996).

49 **drawings from different viewpoints:** The Swiss Institute in New York actually did a *Grand Tour* show in 1993 in which it asked three artists to envision consecutive fragments of landscapes in the *cadavre exquis* tradition. See p. 58.

DEAN MACCANNELL, *The Tourist*, p. 13.

Seduction and Hyperbole

50 REBECCA SOLNIT, "Uplift and Separate," *Art Issues 50* (Nov.–Dec. 1997), p. 14.

51 SAMUEL ELIOT MORRISON (1942), quoted by Karen Atkinson and Andrea Liss, *Remapping Tales of Desire*, p. 21.

52 **Statue of Liberty:** Dean MacCannell, *Empty Meeting Grounds*, pp. 149, 155.

53 "'Sex Tour' Industry Grows in U.S.," *Marin Independent Journal* (March 16, 1998).

COCO FUSCO and NAO BUSTAMANTE, "Stuff," *TDR 41* (Winter 1997), p. 63.

54 KAREN ATKINSON and ANDREA LISS, *Remapping Tales of Desire*, p. 18.

56 **power relations:** See Gillian Rose, *Feminism and Geography* (Minneapolis: University of Minnesota, Press, 1993), p. 128.

57 ELLEN ZWEIG, "The Lady and the Camel," p. 29. Her *She Traveled for the Landscape* was part of a larger NEA-funded collaborative project called *Ex(Centric) Lady Travelers*—individual works by Zweig, Dorit Cypis, Leeny Sack, and Leslie Thornton; the other productions took place in a Victorian house in San Rafael, California. See also Jean Ducey, "The Journeys of Celia Fiennes" (*British Heritage*; [Feb. 1998], pp. 48–53) for the story of a seventeenth-century Englishwoman who traveled alone "through the Whole Island of Great Britain."

Santa Fe's Tricultural Trip

59 CHRIS WILSON, *The Myth of Santa Fe*, p. 8. What follows is a drastic oversimplification of a story that Wilson's book illuminates in critical detail.

60 WILLIAM DEBUYS, "The Threads of Time and Place," *El Palacio* (Winter 1994), p. 21.

Kokopelli: The mysterious flute-player, apparently an ancient Native fertility symbol, is often portrayed in rock art with a giant phallus; this has been omitted from his endless permutations as a tourist icon.

DAVE HICKEY, "Dialectical Utopias," *Harvard Design Magazine* (Winter–Spring 1998), p. 8. See Chris Wilson's corrections in *Harvard Design Magazine* (Fall 1998) p. 88–89.

King Phillip II: Anne Constable, *The Santa Fe Reporter* (March 6, 1996).

61 **"Surprise":** Antonio Lopez, *Pasatiempo (the New Mexican)* (Feb. 27, 1998).

Santa Fe hovers: "Gorgeous adobe villages are ringed with trailer parks," says *The New Mexican*, (Jan. 12, 1997).

Half of New Mexicans are minorities, according to the 1990 census: 38 percent Hispanic, 9 percent American Indian, 2 percent African-American, and 1 percent Asian.

CHRIS WILSON, *The Myth of Santa Fe*, pp. 323–4, 317–318.

62 **cultural tourism:** a marketing-communications expert, in a letter to the editor of *The New Mexican* (Oct. 21, 1996) advised the city to promote itself "as more than an expensive art center," and noted that, of his own enthusiastic out-of-state guests, not one "spent $400 for pottery or jewelry. Yet not one of them wanted to return home."

63 **Museum of New Mexico:** *Ibid.*, p. 115.

Only in the 1990's: Spanish New Mexican Art is exhibited at the Palace of the Governors and the International Museum of Folk Art, both in Santa Fe.

64 DEBBIE JARAMILLO speech delivered in Taos, Jan. 10, 1991; quoted in Chris Wilson, *The Myth of Santa Fe*, p. 165.

Santa Fe style: In 1998, the *median* price of houses in Santa Fe area was $195,350, while the median income was $25,774.

Sanctuario de Guadalupe: Its history is architecturally revealing as it has moved from adobe original to pseudo-original, to a tall, steepled, picket-fenced New England church, to California Mission style; and back to re-invented original. It has also been the literally contested site of confrontations between the foundation that saved the edifice from ruin and has been using it as a cultural center, and its former parishioners, led by an angry priest, demanding that it be returned to its original function. As of this writing, it looks as though the foundation will return it to the Church. The confrontation was sparked by an art exhibition perceived by the artist as respectfully spiritual and by the angry priest as blasphemous.

new tourism director: New Mexico's tourism budget is the thirty-fourth in the Union—lower than those of Arizona, Wyoming, and Oklahoma. In 1996, there were around 75,000 tourist-related jobs in New Mexico, about eleven percent of the entire workforce. Santa Fe's hotel and motel occupancy rates have dropped steadily since the early 1990s; as of this writing they are rising slightly. The O'Keeffe museum has been credited with the way things picked up in the summer of 1997. The recent ad ran in *Preservation* (March–April 1998) and elsewhere.

For a fascinating analysis of the **Santa Fe Fiesta**, see Ronald L. Grimes, *Symbol and Conquest: Public Ritual and Drama in Santa Fe, New Mexico* (Ithaca: Cornell University Press, 1976).

65 RINA SWENTZELL, quoted in *The New Mexican* (May 19, 1996).

ROGER FRAGUA, quoted by Ray Rivera, "Two-Faced Tourism," *The New Mexican* (Aug. 24, 1997).

infrastructure: To an outsider it appears sacrilegious when the entire plaza at Taos Pueblo is filled with tourists' cars, leaving only tiny pockets of space for the dancers and effectively destroying the ambiance tourists come for; this is presumably so that entrance fees can be more easily collected, although for some events two fields just outside the plaza are used for parking, and it is difficult to understand why this is not standard procedure, leaving the plaza visually intact.

67 VALENTINO CORDOVA, quoted by Ray Rivera, *op cit.*

Casino Gambling: According to Cherokee Bradford R. Keeler, president of AIAA, fewer than 25% of the recognized tribes operate casinos and most are not mega-profitable. Indian casino revenues make up less than 10 percent of national gaming revenues (fundraising letter, 1998).

68 DEAN MACCANNELL, *Empty Meeting Grounds*, p. 196.

El Rancho de las Golondrinas was created on the old site by an Anglo woman, Leonora Curtin (who purchased the ranch from descendants of the Baca family, the original settlers in the early eighteenth century) and Y. A. Paloheimo, her Finnish diplomat husband. Both were dedicated to this valuable project, which opened in 1972 and is now owned by a not-for-profit charitable trust.

70 **O'Keeffe diary,** quoted by Peter H. Hassrick, preface to *The Georgia O'Keeffe Museum* (New York: Abrams, 1997), p. 9.

71 CHRIS WILSON, *The Myth of Santa Fe*, p. 9.

WILLIAM DEBUYS, "Threads of Time and Place," p. 21.

Crossroads Everywhere: Cultural Tourism

72 The title is borrowed from JOE WOOD'S essay on artist Renée Green in her *World Tour* (p. 13). The phrase in context: "Since she is hungry for a heaven of eyes, all the eyes she can find, Renée travels a lot—she finds the crossroads everywhere."

73 For details on the **Black Panther Tour** of Oakland, contact Frederika Newton, 6363 Christie Ave., Suite 626, Emeryville, CA, 94608.

Some **"cultural corridors"** are state-sponsored and even designed by legislation; others rise from the grass roots. All over the country, craftspeople have banded together to help their wealthier compatriots dispose of their "disposable income." Most of these co-ops are founded and run by women. The organization Handmade in America, begun by Becky Anderson in North Carolina, publishes a self-guided Heritage Trail booklet leading tourists to four hundred sites where they can see or buy the products of local artisans.

A group of Appalachian women in West Virginia set up Appalachian by Design to avoid the exploitation by outsiders of some sixty knitters around the state. There is the Freedom Quilting Bee in Alabama, the Native Women's Cooperative in Oklahoma, Tierra Wools in Northern New Mexico, and Artes del Valle in Southern Colorado. Loyalty to native places is a major factor in such contributions to sustainable economies.

JAN BROOKS, conversations and correspondence with the author, March 1998.

75 DOUG HUBLEY, "Cultural Tourism: Is there steak in the sizzle?" (Brunswick, ME.) *Times Record* (Jan. 29, 1998). In the spring of 1998, a report appeared on "Tourism and Maine's Future: Toward Environmental, Economic and Community Sustainability." In May, a conference to discuss it with academics and representatives of the local tourist industry took place at Bowdoin College; for an account, see Jay Davis, "Tourism At Its Best," *Maine Times* (May 28, 1998), pp. 4–7.

La Conner: John Villani, "The Creative Tourist," *The New Mexican* (Feb. 8, 1998).

77 **people who live here?:** Conversation with Kathy Vargas of the Guadalupe Cultural Arts Center, San Antonio, April 20, 1998.

78 **"What is really important":** Tony Thurston, "Connecticut Impressionist Art Trail Showcases State's Unique Artistic Heritage," *Arts Reach* (Sept. 1997), pp. 12–14.

81 A more serious version of **"slum tourism"** is the Lower East Side Tenement Museum in Manhattan, which has reconstructed apartments from various periods of immigration and encourages artists to make works in its windows that highlight the area's history from a progressive viewpoint.

82 ERIKA DOSS, "Displaying Cultural Difference: The North American Art Collections at the Denver Art Museum," *Museum Anthropology*, v 20, 1 (1996), pp. 21–36.

BRIAN WALLIS, "Selling Nations: International Exhibitions and Cultural Diplomacy," in Sherman and Rogoff, *Museum Culture*, p. 277.

"cultural diplomacy": quoted by Wallis, ibid., p. 268.

83 **spectacularizing:** Wallis, ibid., p. 278.

Dore Ashton: Ibid., p. 274.

DEAN MACCANNELL, *Empty Meeting Grounds*, pp. 159, 179; Dennis Drabelle, "Sinking Chinese Fortunes," *Preservation* (May–June, 1998), pp. 94–99.

84 REBECCA THOMAS KIRKENDALL, "Who's a Hillbilly?" *Newsweek* (Nov. 27, 1995), p. 22.

Polynesian Cultural Center: As Barbara Kirshenblatt-Gimblett points out, "All of Polynesia is represented on 42 acres… according to a 1985 promotional brochure, 'more people come to know and appreciate Polynesia while touring these beautifully landscaped grounds than will ever visit those fabled islands.'" ("Objects of Ethnography," in Karp and Lavine, *Exhibiting Cultures*, p. 419.) For two very different analyses of the Polynesian Cultural Center, see Max E. Stanton (he teaches at Brigham Young University, which runs the center), "The Polynesian Cultural Center: A Multi-Ethnic Model of Seven Pacific Cultures," Valene Smith, *Hosts and Guests*, p. 247–262, and Andrew Ross, "Cultural Preservation in the Polynesia of the Latter-Day Saints," in his *Chicago Gangster Theory of Life*, pp. 21–98.

LEHUAH LOPEZ of the Native Land Institute, phone conversation, Nov. 3, 1997. Lopez also stressed the fact that cultural pride in places like Hawaii, more than mere armor against tourists, is an important source of self-esteem.

SYLVIA RODRIGUEZ, "Art, Tourism, and Race Relations in Taos," Scott Norris, *Discovered Country*, pp. 144, 146, 156; see also her "Ethnic Reconstruction in Taos," *Journal of the Southwest* (Winter 1990), pp. 541–55.

DEREK WOLCOTT on National Public Radio, Feb. 5, 1995.

85 JAMAICA KINKAID, *A Small Place*, p. 69.

Guide to Black Chicago: *A Resource Guide to Black Cultural, Historical and Educational Points of Interest* (Chicago: independently published, 1996; call 888-840-2345). See also A. Peter Bailey and Edith J. Slade, *Harlem Today: A Cultural and Visitors Guide* (New York: Gumbs and Thomas, 1994), which unfortunately is pretty bland.

WARD CHURCHILL, "An Unwhite Tourist's Guide to the Rocky Mountain West," *Z Magazine* (Sept. 1990), pp. 91–98.

86 NATIONAL INDIAN YOUTH COUNCIL, fundraising letter from executive director Gerald Wilkinson (Cherokee), Albuquerque, n.d. (mid-1990s).

ISABEL LETELIER, quoted in Lucy R. Lippard, *Get the Message?*, p. 175.

DEAN MACCANNELL, *Empty Meeting Grounds*, p. 176.

TRINH T. MINH-HA, "Introduction," *Discourse 8*, (1986).

DEAN MACCANNELL, *The Tourist*, xvi (foreword to 1989 edition).

Exhibitionism

89 DOMINIQUE HARRIS, from *The Children of Melrose*, an
installation by artist Mark Brasz about South Bronx kids in
museums, shown at the New York Public Library on East
Houston Street in New York City, 1995.

90 THOMAS EAKINS, quoted in Catalog Committee of Artists
Meeting for Cultural Change, *an anti-catalog*, p. 17.

SETH KOVEN, "The Whitechapel Picture Exhibitions and
the Politics of Seeing," in Sherman and Rogoff, *Museum
Culture*, pp. 23, 27, 29.

interest in audiences: See Lucy R. Lippard, "This is Art?
The Alienation of the Avant Garde from the Audience,"
Seven Days (Feb. 14, 1977), reprinted in Lippard, *Get the
Message?*, pp. 73–79; and Carol Vogel, "Dear Museumgoer:
What Do You Think?" *New York Times* (Dec. 20, 1992).

DON CELENDER, *The Opinions of Working People Concerning
the Arts* (New York: O. K. Harris, 1975), an artist's book of
interviews compiled by Celender's students at MacCalester
College in St. Paul, Minnesota.

91 REESA GREENBERG, "The Exhibited Redistributed: A Case
of Reassessing Space," in *Exhibited* (Annandale-on-Hudson,
N.Y.: Bard College, 1994), pp. 18–19.

IVONA BLAZWICK, "Psychogeographies," in *On Taking a
Normal Situation and Retranslating it into Overlapping and
Multiple Readings of Conditions Past and Present* (Antwerp,
The Netherlands: MUKHA, 1993), p. 127.

JO ANNE BERLOWITZ, "From the Body of the Prince to
Mickey Mouse," *Oxford Journal* v 13. 2 (1990), pp. 73–77.

92 **museum shops:** *The New Mexican* (Dec. 24, 1997).

J. HOBERMAN, "The Museum Shop in the Age of Mechani-
cal Reproduction," *Village Voice* (Oct. 7, 1981).

TOM ENGELHARDT, "Plugging Culture," *The Nation* (Sept.
8–15, 1997), p. 27.

93 **Broodthaers:** Eleanor Heartney, "Report from Barcelona,"
Art in America (Sept. 1995), p. 40.

For a list of **artists who have made their own museums,**
see Lisa Corrin, *Mining the Museum*, pp. 3–7.

94 **The *anti*-catalog collective** consisted of: Rudolf Baranik,
Sarina Bromberg, Sarah Charlesworth, Susanne Cohn,
Carol Duncan, Shawn Gargagliano, Eunice Golden, Janet
Koenig, Joseph Kosuth, Anthony McCall, Paul Pechter,
Elaine Bendock Pelosini, Aaron Roseman, Larry Rosing,
Ann Marie Rousseau, Alan Wallach, and Walter Weissman.
Quotes below are from pp. 15, 25, 41.

In the late 1960s and early 1970s, the **museums** were consid-
ered complicit in the **Vietnam War** as well as being the
cultural institutions most beholden to artists. The
Artworkers Coalition (AWC) performed a number of
actions at New York's museums from between 1969 and
1971, including an action in which Scott Burton handed out
dimes in ironic memory of John D. Rockefeller at the
Museum of Modern Art; picketing on the issue of the Attica
prison rebellion's suppression (also aimed at the Rocke-
fellers); and a sit-in around Picasso's *Guernica* to recall its
original antiwar message. Actions at the Metropolitan
Museum of Art included a carefully strategized invasion of
a trustees' dinner in part because a whole wing of the
museum was closed off for dinner on the one weeknight
open to the public.

96 **Fraser:** She was preceded by guerrilla tours and random
interviews by members of the Ad Hoc Women Artists
Committee in the 1970 Whitney Annual as part of the
protests to call attention to the low representation of
women artists in the Whitney then-annual surveys.

Philip Morris: Hans Haacke "Museums, Managers of
Consciousness," *Art in America* (Feb. 1984), pp. 9–17.

See PIERRE BOURDIEU and HANS HAACKE, *Free Exchange*,
pp. 70, 105–106.

98 **Artists preoccupied with memory and history:**
See Lucy R. Lippard, *The Lure of the Local*, "Part II,
Manipulating Memory."

FRED WILSON, quoted in minutes of REPOhistory meeting
of Sept. 17, 1992.

"It wasn't so much the objects": Fred Wilson, in Ivan
Karp and Fred Wilson, "Constructing the Spectacle of
Culture in Museums," p. 4.

Guarding the View: Wilson's uniformed figures were head-
less; to the museum's visitors, guards are usually faceless.
In 1993, artist Laurie Parsons made a work for New York's
New Museum of Contemporary Art which attempted to
humanize and call attention to the role played by the
guards. She asked that there be no wall texts, labels, or any
written information; "If you want to know about the artists,
their works, their themes and intentions, just ask the
guards. They know there is more to visiting the Museum
than meets the eye." The New Museum is unique in that its
head guard Augustus Kimball and his lieutenant Elon
Joseph have been integral and conscious participants in the
place since it began. The most visible and popular of the
museum staff, they are known for their knowledge, cour-
tesy, and enthusiasm.

Lisa Corrin's book *Mining the Museum* includes visitors' comments. When **Wilson** was a visiting artist at the Skowhegan School of Art in Maine in the summer of 1996, his students took the cue and subtly altered by addition the displays at the nearby L. C. Bates Museum, itself a work of art, a funky throwback to nineteenth-century natural history accumulations. The next summer, without Wilson, another group of students made works there, and it seems likely to become a tradition.

Parrish Museum: See Kenneth E. Silver, "Past Imperfect," *Art in America* (Jan. 1993), pp. 42–47. Diane Neumaier made a 1991 booklet along the same lines: *Building the Museum* was about the construction of the George Walter Vincent Smith Museum in Springfield, Mass., which opened in 1896 for the Smith collection and museum of natural history.

101 **"It's Saturday night":** Mark Morrison, "The New Public Square," *USA Weekend* (Dec. 12–14, 1997), p. 6.

DONALD KUSPIT, "The Spirit of Business," p. 3.

Curiouser and Curiouser: The Popular "Museum"

103 ROBERT FILLIOU, quoted by Jean-Hubert Martin, in Cooke and Wollen, *Visual Display*, p. 67.

104 BORIS GROYS, "The Struggle Against the Museum, or, The Display of Art in Totalitarian Space," in Daniel Sherman and Irit Rogoff, *Museum Culture*, pp. 144–162.

105 For more on **Greczynski's** work, especially the ground-breaking "Battlefield Project," see Kurt Kollander, "Art Asylum," *Art in America*,(June 1993).

RALPH RUGOFF, "Beyond Belief, the Museum as Metaphor," in Lynne Cooke and Peter Wollen, *Visual Display*, pp. 70–72. See also: David Wilson, "The Museum of Jurassic Technology," *Offramp* v 1. 4 (1991), pp. 43–47; Tyler Stallings's interview with David Wilson in *Art Papers* (Jan.–Feb. 1994), pp. 14–18; Lawrence Weschler's *Mr. Wilson's Cabinet of Wonders*; and the museum's own publications.

107 DAVID LLOYD, "The Recovery of Kitsch," in Trisha Ziff, ed., *Distant Relations* (New York: Smart Art Press/D.A.P.), pp. 146–154.

108 VOLLIS SIMPSON, in Manley and Sloan, *Self Made Worlds*, p. 5.

111 SUSAN STEWART, *On Longing*, p. 149.

Ibid., p. 140. Nelson Graburn sees **souvenirs** as "boundary defining" markers and symbols to the outside world.

112 ALEXANDER WILSON, *The Culture of Nature*, pp. 204–220.

113 MARK SLOAN, "A World of One's Own," in Manley and Sloan, *Self Made Worlds*, p. 2.

BROTHER JOSEPH ZOETTLE, as discussed by Mark Sloan, *ibid*, pp. 44–45.

114 KAREL ANN MARLING, *The Colossus of Roads: Myth and Symbol Along the American Highways* (Minneapolis: University of Minnesota Press, 1984).

115 DONALD KUSPIT, "The Spirit of Business," pp. 2–3.

roadside shrines: See Siegfried Halus, Marie Romero Cash and Lucy R. Lippard, *The Living Shrine* (Santa Fe: Museum of New Mexico Press, 1998).

Charles Willson Peale: See Susan Stewart, "Death and Life, in That Order, in the World of Charles Willson Peale," in Cooke and Wollen, *Visual Display*, pp. 30–53.

Squeamishness Central: Aline McKenzie, *Dallas Morning News* (Nov. 9, 1997). There is now a book devoted to such places: Saul Rubin's *Offbeat Museums* (Santa Monica: Santa Monica Press, 1997).

The city of **Roswell**, a military town accustomed to keeping its mouth shut in a state that has been the stage for all kinds of atomic-age shenanigans, long rejected its potentially lucrative status as a purported UFO center and "kook city." However, the town dropped its guard in July 1997, the fiftieth anniversary of the alleged flying saucer wreck nearby, and thousands of tourists and their dollars were welcomed into the quiet town, which featured a Crash and Burn Extravaganza Derby on Main Street and Alien commodities galore.

MARINA WARNER, "Waxworks and Wonderlands," in Lynne Cooke and Peter Wollen, *Visual Display*, p. 294. See also Ralph Rugoff, "Chamber of Horrors: Madame Tussaud's Demoncratic Wit," in *Harvard Design Magazine* (Winter–Spring 1998), pp. 55–59.

117 PAUL RICOEUR, *History and Truth* (Evanston, Ill.: Northwestern University Press, 1965), p. 27.

GEORGE BROWN GOODE, quoted by Barbara Kirschenblatt: Gimblett in Karp and Lavine, *Museum Culture*, p. 395.

social energies: Lucy R. Lippard, "Hot Potatoes: Art and Politics in 1980," *Block* 4 (1981), reprinted in *Get the Message?*, p. 172.

Tragic Tourism

119 JAMES YOUNG, *The Texture of Memory*, p. 15.

FREDERICK SCHILLER (1795), quoted in *New York Times Book Review* (Sept. 19, 1993).

120 **"It Seems likely":** James Young, *The Texture of Memory*, p. x.

prison cell: A classic and powerful example is the huge old Eastern State Penitentiary in Philadelphia, retired in 1971 after 142 years of social control and now a spectacular historic landmark, riddled with untold narratives. It was the site of *Prison Sentences*, a significant 1995 exhibition of fourteen site-specific artworks curated by Todd Gilens and Julie Courtney. The works were executed in individual cells and other areas of the huge, crumbling, depressing, and impressive structure, parts of which are maintained and may be restored by Venturi and Scott Brown. Some sections are already open to tours, and new site specific works have followed the show.

120 ANDREA ROBBINS and MAX BECHER, "Dachau," *Contact Sheet* 85 (1994), n.p.

122 **"To the extent":** James Young, *The Texture of Memory*, p. 5.

Swiss bank accounts: National Public Radio, Feb. 7, 1997.

ANDRÉ SCHWARZ-BART, quoted by James Young, *The Texture of Memory*, p. 1.

123 **monument at Ground Zero:** Equally peculiar is a visit to the Bradbury Science Museum in Los Alamos, which incessantly bangs the drum for the Bomb without ever mentioning the ramifications of its use in Hiroshima and Nagasaki.

125 **Sister of murdered cop, local minister, and Joseph Sciorra,** quoted in Rick Bragg, "On Walls, Memories of the Slain are Kept," *New York Times* (Jan. 28, 1994). See Martha Cooper and Joseph Sciorra, *R.I.P. Memorial Wall Art*.

126 ROLAND GARCIA: quoted in Bruce Taylor Seeman, "Versace Murder Site Becomes Tourist Attraction," *The New Mexican* (May 17, 1998).

Titanic touring: *The New Mexican* (April 5, 1998).

"Silence equals death" is the powerful slogan of the AIDS activist group ACT-UP (AIDS Coalition to Unleash Power).

ROBERT MUSIL, "Monuments," in *Posthumous Papers of a Living Author* (Hygiene, Colorado: Eridanos, 1987), p. 61.

DREX BROOKS, "snapshot approach," interview in *Light* 4 (1996), pp. 24–27.

128 **Manzenar:** "Tours to Begin at U.S. Camp of Internment," *Portland [Maine] Press Herald* (July 28, 1997).

RALPH APPELBAUM, *I.D. Annual Design Review* (1994), p. 12. Appelbaum has also designed the new Museum of African-American History in Detroit, which includes a life-size diorama of a slave ship.

129 **Oñate monument:** See Kathy Freise's inclusive "Sculpting the Shape of Memory: An Exploration Within New Mexico's Cuarto Centenario," unpublished paper, University of New Mexico (May 1998).

Similar controversies attracting divided loyalties: In Haverhill, Mass. there is a statue next to City Hall of a woman with a hatchet. She is Hannah Duston, a captive who in 1697 allegedly killed and scalped ten Indian people (including women and children) after they had bashed her five-day-old son against a tree and killed him because he was crying. In 1997, a proposal to name an elementary school (of all things) after Duston was being contested by those accused of "political correctness."

JAMES YOUNG, *The Texture of Memory*, p. 345. The latest Holocaust memorial will be Rachel Whiteread's concrete cast of a book-lined room in Vienna. Its execution was delayed for two years while residents wrangled about its desirability and its site turned out to be the location of the remains of a synagogue burned down in 1421 with worshipers inside. It will now stand beside, rather than over, the archaeological site.

LUCY R. LIPPARD, "Within Memory," in *Athena Tacha: Mass Memorials and Other Public Projects* (New York: Max Hutchinson Gallery, 1984), n.p.

LUCY R. LIPPARD, "Calling the Shots," *Village Voice* (Oct. 4, 1983).

131 **Bosnia tourist:** *The New Mexican* (June 8, 1997).

132 HANS MAGNUS ENZENSBERGER, *The Consciousness Industry* (New York: Seabury, 1974).

133 LEIGH BINFORD, *The El Mozote Massacre* (Tucson: University of Arizona Press, 1996).

LUCY R. LIPPARD, "Taking Pictures... and Giving Them Back," *Z Magazine* (June 1990), pp. 76–79.

134 GARY MORMINO, "Trouble in Tourist Heaven," *Forum* (Summer 1994), pp. 11–13.

A new brand of **risk-taking tourism** is "tornado chasing," wherein tourists pay hefty prices to witness (and hopefully not fall victim to) a twister.

ALEXANDER WILSON, *The Culture of Nature*, p. 28.

REG SANER, "Swiss Wilderness," Scott Norris, *Discovered Country*, p. 112.

Armageddon theme park: *The New Mexican* (Feb. 15, 1997).

Parking Places

135 STANFORD E. DEMARS, *The Tourist in Yosemite*, p. 130

136 ALEXANDER WILSON, *The Culture of Nature*, pp. 33–34. Wilson's brilliant book is particularly relevant to this essay.

Mt. Rushmore Visitor Center: Gail Jardine, conversation with author, April 25, 1998.

137 MALEK ALLOULA, *The Colonial Harem* (Minneapolis: University of Minnesota Press, 1986), p. 27, 4.

postcards: Artists have made postcard works for the last thirty years—On Kawara, Eleanor Antin, and Martha Rosler among them.

138 SUSAN STEWART, *On Longing*, p. 138.

WILLIAM LEAST HEAT-MOON, *PrairyErth (A Deep Map)*, (Boston: Houghton Mifflin, 1991).

JUDITH WILLIAMSON, *Decoding Advertisements*, p. 109.

139 **Japanese indoor landscapes:** Mike Sheridan, "The Great Indoors," *Sky* (April 1994), p. 93.

SUSAN G. DAVIS, *Spectacular Nature*, p. 2.

ROBERT ADAMS, quoted by the editors of "Moments of Grace: Spirit in the American Landscape," *Aperture* 150 (Winter 1998), p. 2.

CHARLES BOWDEN, "Blind in the Sun," *Aperture* 150 (Winter 1998), p. 76.

CHARLES BOWDEN, Ibid., p. 76. This comparison is a classic conflation of women and nature. He goes on to say, "In both instances, the communicants have a deep dread of risk and a deep need for the comfort of predictable events. And in both instances, the faithful insist to each other that at last they are looking at the real thing.... I'll take my deserts like my breasts, as they come, not as they are framed."

ROGER MINICK, artist's statement on the series sent to author, March 1998. Artist Jeffrey Kane made a similar series in the mid-1980s, also taking group photos for people and then taking one of his own.

STAN ABBOTT, quoted in Alexander Wilson, *The Culture of Nature*, p. 35.

141 **Zion IMAX:** *New York Times* (July 5, 1992).

average tourist: Quoted in Stanford E. Demars, *The Tourist in Yosemite*, p. 155.

142 **hotels:** Ibid., p. 106.

144 LINDA HASSELSTROM, "Camping Ranches and Gear Junkies," in Scott Norris, *Discovered Country*, p. 70. Here's

her test: "Start a fire with one match, or with flint and steel, and without using lighter fluid or paper: 150 points. Lose ten points for freeze-dried food. Lose twenty points if your tent or outer clothing is bright orange or blue; gain ten for a canvas shelter grimy with age. Let's see you defecate, camper; subtract 150 points for use of toilet paper or failure to bury the waste. Lose 10 for footwear that can be inflated or any item made by a major corporate polluter. Visitors in wilderness would be on their own. Survivors get a decorative shoulder patch ensuring admission to other such areas."

JIM STILES, "New West Blues," in Scott Norris, *Discovered Country*, p. 121.

145 MARGARET CERULLO and PHYLLIS EWEN, "'Having a Good Time': The American Family Goes Camping," *Radical America* (Jan.–April 1982), p. 20.

146 **one travel agent:** Tamara Budowski, quoted in Ron Mader, "Costa Rica's Ecotourism," *Otherwise* (Nov.–Dec. 1995), p. 7.

LANCE ROBERTSON, "'Ecotourism'—A Gold Mine for Ailing Agencies?" *High Country News* (March 30, 1998), p. 4.

"ecolonialism": adapted from Andreana Costa, *Otherwise* (Nov.–Dec. 1995), p. 15.

LISA RUSS, *High Country News* (March 30, 1998), p. 4; see also the special issue of *High Country News* on "El Nuevo West" (Dec. 23, 1996).

wildlife: Alison Deming was curious about why people needed such close encounters with wildlife ranging from bears to dolphins. A field biologist told her "It's not a need, it's a desire. They want to be approved of by another species. It's a kind of penance for all the wrongs we've done against animals" (Deming, "Edges of the Civilized World"). p. 30.

duck pond: Reproduced in Alexander Wilson, *The Culture of Nature*, p. 222. It is a large pond built by Ducks Unlimited ("a conservation organization that rearranges wetlands and builds 'duck parks' for hunters") at Oak Hammock Marsh north of Winnipeg. The pictorial shape is only visible from the air, reminiscent of ancient geoglyphs.

147 MARLENE CREATES, "Nature Is a Verb to Me," in *Rephotographing the Land* (Halifax, N.S.: Dalhousie University, 1992), n.p.

148 STEPHEN T. MATHER, quoted in Stanford E. Demars, *The Tourist in Yosemite*, p. 94.

149 **"Many an old-time":** Ibid., pp. 146, 148.

149 PETER GOIN, *Humanature* (Austin: University of Texas Press, 1996).

150 KATE L. HAUG, "The Human/Land Dialectic: Anthropic Landscapes of the Center for Land Use Interpretation," *Afterimage* v 25. 2 (1997), p. 10.

 DOUG HARVEY, "The Center for Land Use Interpretation," *Art Issues* (Sept.–Oct. 1997), p. 41.

 KENNY BE, "Bombs Away!" *Westword* (Feb. 12–18, 1992), pp. 28–29. Jay Critchley of Nuclear Recycling Consultants in Provincetown, Mass. first suggested a "Three Mile Island Historic Nuclear Park and Planned Community—a Symbol of National Pride," in *Radical America* (March–June 1983), p. 5.

 RICHARD MISRACH with MYRIAM WEISGANG MISRACH, *Bravo 20*, p. 95.

151 **DOE public tours:** In June 1998, the test site offered not only a tour, but a film festival touting "Never before publicly released film footage" of 50-year old atom bomb tests (*High Country News*, May 25, 1998), p. 15.

152 KYONG PARK, "Conversation," *Storefront* (May, 1994), n.p.

Taken Aback, or, the Nostalgia Trap

154 **we are often reminded:** Nick Merriman ("Heritage from the Other Side of the Glass Case") found from his research in Britain that "82% of people in unprompted answers to an open-ended question, saw life in the past as being generally unpleasant and harsh." Variations within this opinion showed that "the elderly and those of low status were much more likely than younger people or those of high status to see favourable elements in an otherwise harsh past." People do not necessarily want a return to the past, but they use it as a means of criticizing the present, "for the absence of certain qualities that they value, such as the closeness of family ties, peace and happiness." He also found that those of "high status" valued world history over local and family history and those of "low status" felt the opposite, perhaps because for those not reached by museums and "heritage" programs, "a sense of the past is mostly found at home within the family and through attachment to place."

 DONA BROWN, *Inventing New England*, pp. 140, 139.

158 **nostalgia may be:** my own version of a statement made by Peter Marris in *Loss and Change* (Garden City, N.J.: Anchor/Doubleday, 1975), p. 88.

 "New England's countryside": Dona Brown, *Inventing New England*, p. 153.

159 SUSAN STEWART, *On Longing*, p. 140.

 CAREN KAPLAN, "Deterritorializations: The Rewriting of Home and Exile in Western Feminist Discourse," *Cultural Critique* 6 (Spring 1987), pp. 188–89, 191.

162 **"mixed bag":** Dona Brown, *Inventing New England*, pp. 107, 109.

 FRANK MATERO: Copy of letter to the editor of *Architecture* concerning an article in the Feb. 1998 issue, sent to the author by Molly Lambert.

163 **"created a New England Village":** Dona Brown, *Inventing New England*, p. 133.

164 **miniaturization, "continuous narrative," "social disease":** Susan Stewart, 66, 139–40, 23.

BIBLIOGRAPHY

NB: All endnote sources are not included below.

Simone Abram, Jacqueline Waldren, and Donald V. L. Macleod, eds., *Tourists and Tourism: Identifying with People and Places*, Oxford: Berg, 1997.

Michael M. Ames, *Cannibal Tours and Glass Boxes: The Anthropology of Museums*, Vancouver: University of British Columbia Press, 1992.

Julia S. Ardery, "Folk Art Tourism: The Search for a piece of the True Cross," *The Outsider*, Summer 1998, 14–19.

Karen Atkinson and Andrea Liss, *Remapping Tales of Desire: Writing Across the Abyss*, Santa Monica: Side Street Press, 1992.

Daina Augaitis and Sylvie Gilbert, eds., *Between Views*, Banff: Walter Phillips Gallery, 1991.

Warren James Belasco, *Americans on the Road: From Autocamp to Motel, 1910–1945*, Baltimore: Johns Hopkins University Press, 1979.

Pierre Bourdieu and Hans Haacke, *Free Exchange*, Stanford: Stanford University Press, 1995.

Eric Breitbart, *A World on Display: Photographs from the St. Louis World's Fair 1904*, Albuquerque: University of New Mexico Press, 1997.

Donald Britton, "The Dark Side of Disneyland," in Bernard Welt, *Mythomania*, Los Angeles: Art Issues Press, 1996, 113–126.

James Brook, Chris Carlsson, and Nancy J. Peters, eds., *Reclaiming San Francisco: History, Politics, Culture*, San Francisco: City Lights, 1998.

Drex Brooks, *Sweet Medicine: Sites of Indian Massacres, Battlefields, and Treaties*, Albuquerque: University of New Mexico Press, 1995.

Dona Brown, *Inventing New England: Regional Tourism in the Nineteenth Century*, Washington, D.C.: Smithsonian Press, 1995.

Jody Burland, "Traveling Correspondence: Notes on Tourism," *Borderlines* 12, Summer 1988, 8–9.

The Catalog Committee of Artists Meeting for Cultural Change, *an anti-catalog*, New York: AMCC, 1977.

The Center for Land Use Interpretation, *Hinterland: A Voyage into Exurban Southern California*, Los Angeles: Center for Land Use Interpretation and Los Angeles Contemporary Exhibitions, 1997.

The Center for Land Use Interpretation/Matthew Coolidge, *The Nevada Test Site: A Guide to America's Nuclear Proving Ground*, Los Angeles: Center for Land Use Interpretation, 1966.

Mel Chin: *Inescapable Histories*, Kansas City: Exhibits USA, 1996. Essays by Lucy R. Lippard and Benito Huerta, and a "composite interview" with Chin.

James Clifford, *Routes: Travel and Translation in the Late Twentieth Century*, Cambridge, Mass.: Harvard University Press, 1997.

Lynne Cook and Peter Wollen, eds., *Visual Display: Culture Beyond Appearances*, Seattle: Bay Press, 1995.

Martha Cooper and Joseph Sciorra, *R.I.P. Memorial Wall Art*, New York: Henry Holt, 1994.

Lisa G. Corrin, ed., *Mining the Museum: An Installation by Fred Wilson*, New York: The New Press, 1994. Includes an interview with Wilson by Leslie King-Hammond.

Douglas Crimp with photographs by Louise Lawler, *On the Museum's Ruins*, Cambridge: MIT Press, 1993.

William Cronon, ed., *Uncommon Ground: Remaking the Human Place in Nature*, New York: W. W. Norton, 1996.

Nancy C. Curtis, *Black Heritage Sites*, 2 vols. New York: The New Press, 1998.

Susan G. Davis, *Spectacular Nature: Corporate Culture and the Sea World Experience*, Berkeley: University of California Press, 1997.

Stanford E. Demars, *The Tourist in Yosemite, 1855–1985*, Salt Lake City: University of Utah Press, 1991.

Alison Deming, "The Edges of the Civilized World: Tourism and the Hunger for Wild Places," *Orion*, Spring 1996, 28–35.

Mark Dery, "Lost in the Funhouse," *World Art* 2, 1995, pp. 46–51.

Donna De Salvo, ed., *Past Imperfect: A Museum Looks at Itself*, Southampton, N.Y. and New York: Parrish Art Museum and The New Press, 1993. Essays by Maurice Berger, Alan Wallach, Judith Barry.

Allan deSouza and Yong Soon Min, *AlterNatives,* Syracuse: Robert B. Menschel Photography Gallery, Syracuse University, 1997.

Luke Dodd, "Sleeping with the Past: Collecting and Ireland," *Circa,* Sept.–Oct. 1991, 28–31. Special issue on "Art in the Museum."

William Cronon, ed., *Uncommon Ground: Remaking the Human Place in Nature,* New York: W. W. Norton, 1996.

Carol Duncan, *Civilizing Rituals: Inside Public Art Museums,* London: Routledge, 1998.

Nelson Graburn, ed., *Ethnic and Tourist Arts: Cultural Expressions from the Fourth World,* Berkeley: University of California Press, 1976.

Renée Green, *World Tour,* Los Angeles: Museum of Contemporary Art, 1993.

Hans Haacke, "Museums, Managers of Consciousness," *Art in America,* Feb. 1984, 9–17.

Richard Handler and Eric Gable, *The New History in an Old Museum: Creating the Past at Colonial Williamsburg,* Durham: Duke University Press, 1997.

Dick Hebdige, "On Tumbleweed and Body Bags: Remembering America," in Ferguson, Bruce, ed., *Longing and Belonging: From the Faraway Nearby,* Santa Fe: SITE Santa Fe, 1995, pp. 70–103. Exhibition includes Tseng Kwong Chi.

High Country News, biweekly from Box 1090, Paonia, Colorado, 81428. Ongoing coverage of tourism's effects on the landscape and social structures of the West.

Louis Hock and Elizabeth Sisco, *Local Interpretations,* Banff: Walter Phillips Gallery, 1991. In conjunction with the artists' project *Corral at Banff, 1991: Community Transactions.*

Bruce Hucko, *Where There Is No Name for Art: The Art of Tewa Pueblo Children,* Santa Fe: School of American Research, 1996.

John Brinkerhoff Jackson, *Landscape in Sight: Looking at America,* New Haven: Yale University Press, 1997, edited by Helen Lefkowitz Horowitz.

John A. Jakle, *The Tourist: Travel in Twentieth-century North America,* Lincoln: University of Nebraska Press, 1985.

Caren Kaplan, *Questions of Travel: Postmodern Discourses of Displacement,* Durham, N.C.: Duke University Press, 1996.

Ivan Karp and Steven D. Lavine, eds., *Exhibiting Cultures: The Poetics and Politics of Museum Display,* Washington, D.C.: Smithsonian Press, 1991.

Ivan Karp and Fred Wilson, "Constructing the Spectacle of Culture in Museums," *Art Papers,* May–June 1993, 2–9.

Jamaica Kinkaid, *A Small Place,* New York: Plume/Penguin, 1988.

Carin Kuoni and Ingrid Schaffner, *A Grand Tour,* brochure for exhibition at the Swiss Institute, New York City, 1993.

Donald Kuspit, "The Spirit of Business, the Business of Spirit: The Postmodern Quandary of the Museum," *Kunst & Museumjournaal,* 4. 4, 1993, p. 1–5.

Lucy R. Lippard, *Get the Message? A Decade of Art for Social Change,* New York: E. P. Dutton, 1984.

Lucy R. Lippard, *The Lure of the Local: Senses of Place in a Multicentered Society,* New York: The New Press, 1997.

Hartman Lomawaima, Dean MacCannell, and Janeen Antoine, "Seeing Us as You Would Like Us to Be: Tourism and Encounters with Others," *Headlands Journal,* 1992, 15–18.

Catherine A. Lutz and Jane L. Collins, *Reading National Geographic,* Chicago: University of Chicago Press, 1993.

Dean MacCannell, *Empty Meeting Grounds: The Tourist Papers,* London: Routledge, 1992.

Dean MacCannell, *The Tourist: A New Theory of the Leisure Class,* New York: Schocken, 1989 (originally published in 1976). Reprint forthcoming in 1999 by University of California Press, with an Afterward by Dean MacCannell and a Foreword by Lucy R. Lippard.

Roger Manley and Mark Sloan, *Self Made Worlds: Visionary Folk Art Environments,* New York: Aperture, 1997.

George E. Marcus and Fred R. Myers, *The Traffic in Culture: Refiguring Art and Anthropology,* Berkeley: University of California Press, 1995.

Karal Ann Marling, *The Colossus of Roads: Myth and Symbol Along the Highway,* Minneapolis: University of Minnesota Press, 1984.

Tina Noel Marrin, ed., *Garden of Eden on Wheels: Selected Collections from Los Angeles Area Mobile Home and Trailer Parks,* Los Angeles: Museum of Jurassic Technology, 1996.

Armand Mattelart, *Transnationals and the Third World: The Struggle for Culture,* South Hadley, Mass.: Bergin and Garvey, 1983.

T.C. McLuhan, *Dream Tracks: The Railroad and the American Indian 1890-1930,* New York: Harry N. Abrams, 1985.

Nick Merriman, "Heritage from the Other Side of the Glass Case," *Anthropology Today,* April 1989, p. 14-15.

James Meyer, "Nomads," *Parkett* 49, 1997, 205–209.

Richard Misrach with Myriam Weisang Misrach, *Bravo 20: The Bombing of the American West,* Baltimore: Johns Hopkins Press, 1990.

Chon Noriega, ed., *From the West: Chicano Narrative Photography,* San Francisco: The Mexican Museum, 1995.

Martha K. Norkunas, *The Politics of Public Memory: Tourism, History and Ethnicity in Monterey, California,* Albany: State University of New York Press, 1993.

Scott Norris, ed., *Discovered Country: Tourism and Survival in the American West,* Albuquerque: Stone Ladder Press, 1994.

Brian O'Doherty, *Inside the White Cube: The Ideology of the Gallery Space,* Santa Monica: Lapis Press, 1986. Revised from 1976 original edition.

Ron O'Grady, *Tourism in the Third World: Christian Reflections,* Maryknoll, N.Y.: Orbis, 1982.

Ruth Orkin: A Retrospective, New York: International Center of Photography, 1995.

Phyllis Passariello, "Tourism and Other Journeys to Empty Places," *Otherwise* 1. 4, Nov.–Dec. 1995, 1, 3–6. Issue includes essays and fact sheet on ecotourism by Ron Mader and Adreana Costa.

Politics of Travel, special issue of *The Nation,* Oct. 6, 1997, 3, 11–38.

Popular Places, special issue of *Harvard Design Magazine,* Winter–Spring 1998.

Mary Louise Pratt, *Imperial Eyes: Travel Writing and Transculturation,* London: Routledge, 1992.

Richard Price and Sally Price, *Equatoria,* New York: Routledge, 1992.

Andrew Ross, *The Chicago Gangster Theory of Life: Nature's Debt to Society,* New York: Verso, 1994.

Hal K. Rothman, *Devil's Bargains: Tourism in the Twentieth-Century American West,* Lawrence: University Press of Kansas, 1998.

Ralph Rugoff, *Circus Americanus,* New York: Verso, 1995.

Ralph Rugoff, *The Eye of the Needle: The Unique World of Microminiatures of Hagop Sandaldjian,* Los Angeles: Museum of Jurassic Technology, 1996.

Susan Schwartzenberg, *Cento: Market Street Journal,* San Francisco: San Francisco Art Commission, 1996.

Daniel J. Sherman and Irit Rogoff, eds., *Museum Culture: Histories, Discourses, Spectacles,* Minneapolis: University of Minnesota Press, 1994.

SITE/seeing: *Travel and Tourism in Contemporary Art,* New York: Whitney Museum of American Art Downtown at Federal Reserve Plaza, 1991. Texts by Karin M. Higa, Pamela M. Lee, Jonathan Caseley.

Valene L. Smith, ed., *Hosts and Guests: The Anthropology of Tourism,* Philadelphia: University of Pennsylvania Press, 1989.

Rebecca Solnit, *A Book of Migrations: Some Passages in Ireland,* London: Verso, 1997.

Michael Sorkin, ed., *Variations on a Theme Park: The New American City and the End of Public Space,* New York: Noonday Press, 1992.

David Spurr, *The Rhetoric of Empire: Colonial Discourse in Journalism, Travel Writing and Imperial Administration,* Durham, N.C.: Duke University Press, 1993.

Joel Sternfeld, *On This Site: Landscape in Memoriam,* San Francisco: Chronicle, 1996.

Susan Stewart, *On Longing: Narratives of the Miniature, the Gigantic, the Souvenir, the Collection,* Durham, N.C.: Duke University Press, 1993.

Rirkrit Tiravanija, *Untitled 1998 (On the road with Jiew Jeaw Jieb Srei and Moo).* Philadelphia: Philadelphia Museum of Art, 1998. Artist's book and CD-ROM.

Tourism: Rethinking the View, special issue of *Border/Lines* 12, Summer 1988.

The Tourist Trap: Who's Getting Caught?, special issue of *Cultural Survival,* Summer, 1982.

Tourists, Voyeurs, and Exiles, special issue of *Whitewalls* 37, 1996.

Tseng Kwong Chi: The Expeditionary Works, Houston: Houston Center for Photography, 1992. Essay by Barry Blinderman.

Grady T. Turner, "The Accidental Ambassador," *Art in America,* March 1997, 80–83. On Tseng Kwong Chi.

John Urry, *The Tourist Gaze: Leisure and Travel in Contemporary Societies,* London: Sage, 1990.

Brian Wallis, "Excavating the 1970s," *Art in America,* Sept. 1997, 96–99, 122. On Renée Green.

Lawrence Weschler, *Mr. Wilson's Cabinet of Wonder,* New York: Vintage/Random House, 1996.

Judith Williamson, *Decoding Advertisements: Ideology and Meaning in Advertising,* London: Marion Boyars, 1978.

Alexander Wilson, *The Culture of Nature: North American Landscape from Disney to the Exxon Valdez,* Cambridge, Eng.: Basil Blackwell, 1992.

Chris Wilson, *The Myth of Santa Fe: Creating a Modern Regional Tradition,* Albuquerque: University of New Mexico Press, 1997.

David Wilson, "The Museum of Jurassic Technology," *Offramp* 1. 4, 1991, 43–47.

MaLin Wilson, "An American Phenomenon: On Marketing Georgia O'Keeffe," in Christopher Merrill and Ellen Bradbury, *From the Faraway Nearby: Georgia O'Keeffe as Icon,* Albuquerque: University of New Mexico Press, 1991, 83–87.

James Young, *The Texture of Memory: Holocaust Memorials and Meaning,* New Haven: Yale University Press, 1993.

M. Catherine de Zegher, *Andrea Robbins and Max Becher,* Kortrijk, Belgium: The Kanaal Art Foundation, 1994, with the artists' captions.

Ellen Zweig, "The Lady and the Camel," *Women and Performance* (9, 1990), pp. 28–52.